Vol. 22
£5
Ahr
14/1

National Gallery Technical Bulletin

Volume 22, 2001

D1332951

National Gallery Company
London

Distributed by
Yale University Press

Series editor **Ashok Roy**

First published in Great Britain in 2001 by
National Gallery Company Limited
St Vincent House, 30 Orange Street, London WC2H 7HH
www.nationalgallery.co.uk

British Library Cataloguing in Publication Data
A catalogue record for this journal is available from the British
Library

ISBN 1 85709 926 5
ISSN 0140 7430
525037

Edited by **Diana Davies**
Project manager **Jan Green**
Design by **Tim Harvey**
Printed in Italy by **Grafiche Milani**

FRONT COVER
Vincenzo Foppa, *The Adoration of the Kings*
(NG 729) (detail of Plate 1, p. 19)

TITLE PAGE
Attributed to Pedro Campaña, *The Conversion of the Magdalen*
(NG 1241) (detail of Plate 1, p. 55)

Contents

Uccello's *Battle of San Romano*

ASHOK ROY AND DILLIAN GORDON

THE FULL TITLE of Uccello's National Gallery panel is *Niccolò Mauruzi da Tolentino at the Battle of San Romano* (NG 583; PLATE 1). The Battle of San Romano took place in the valley of the Arno on 1 June 1432 when the Florentines decisively beat the combined forces of Lucca and her allies, Genoa, Milan and Siena, in a dispute over access to the port of Pisa.[1] Uccello depicted the battle on three separate panels, now in the National Gallery, London, the Uffizi, Florence (PLATE 2) and the Louvre, Paris (PLATE 3) (although see below). The three paintings are recorded in the Camera di Lorenzo, that is, the room belonging to Lorenzo de' Medici, in an inventory of the Palazzo Medici, in Florence, taken at the death of Lorenzo in 1492.[2] By 1598 the three paintings had been moved to a vestibule approaching the chapel in the Palazzo Medici.[3]

Due to the constant Medici provenance, it had hitherto been assumed that they were commissioned by a member of the Medici family, probably Cosimo de' Medici. However, Francesco Caglioti has recently discovered a document showing that the three paintings belonged originally to the Bartolini Salimbeni family.[4] On 30 July 1495 Damiano Bartolini Salimbeni claimed that he and his brother had jointly owned three panels showing the Battle of San Romano. His brother had been persuaded by Lorenzo de' Medici to make over to Lorenzo his share of the paintings but Damiano had refused and they had been forcibly removed from his house by the woodworker Francione who had been sent by Lorenzo to obtain them against the will of Damiano. This probably took place between 1479 and 1486.[5]

The date of execution for the paintings remains uncertain. They have been dated anywhere between 1435 and 1460, and often (and wrongly as it now transpires) linked to the building of the Palazzo Medici which was begun in 1444/6.[6] In 1970 Lionello Boccia showed that the armour is accurately depicted and dates from around 1435.[7] It is now generally

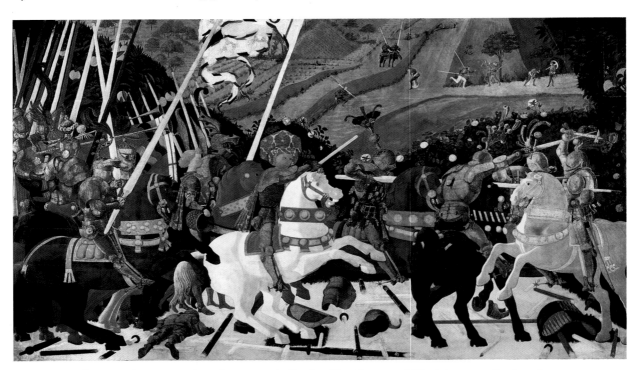

PLATE 1 Uccello, *Niccolò Mauruzi da Tolentino at the Battle of San Romano* (NG 583), *c*.1440. Poplar, 182 × 320 cm.

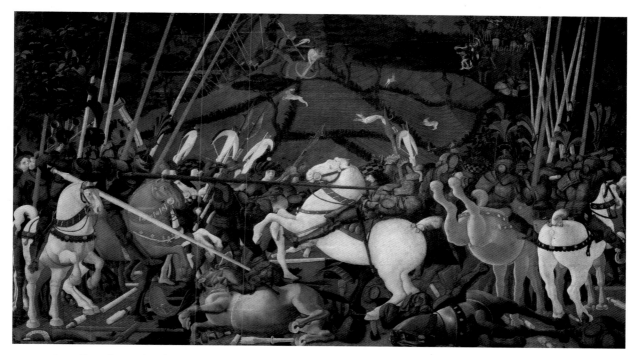

PLATE 2 Uccello, *The Battle of San Romano*, *c*.1440. Poplar, 182 × 323 cm. Florence, Galleria degli Uffizi.

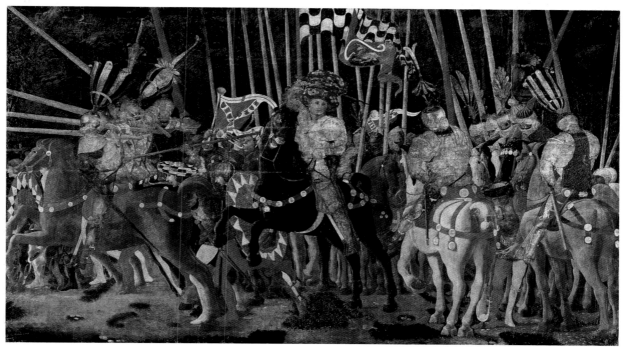

PLATE 3 Uccello, *Michelotto da Cotignola in Battle*. Poplar, 180 × 316 cm. Paris, Musée du Louvre.

considered that the paintings date from the early 1440s, although Pietro Roccasecca has plausibly argued that the paintings in the National Gallery and Uffizi were painted earlier than the Paris painting. He proposed that the latter dates from after 1441 and depicts the Battle of Anghiari.[8]

Uccello's *Battle of San Romano* (NG 583) has been the subject of wide-ranging technical examination and analysis over a number of years: first at the National Gallery during preliminary investigation and conservation treatment in 1959–65, and subsequently in the 1990s in support of investigations

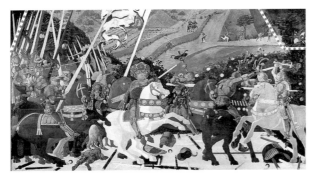

FIG. 1 Uccello, *Niccolò Mauruzi da Tolentino at the Battle of San Romano* (NG 583). Diagram showing the structure of the spandrel additions, probably applied at some time in the fifteenth century.

undertaken for a new catalogue of Italian fifteenth-century paintings to be published shortly.[9] This revised catalogue will present new research on the history and location of NG 583 and particularly its relation to the two associated battle scenes now in Florence and Paris. Certain of the arguments pursued there rely on technical evidence gathered from the London picture and from the collation of similar evidence supplied by colleagues in Florence and Paris. However, since it is not possible within the space allowed in the forthcoming catalogue to present and illustrate in detail a full technical description of the Uccello, we have taken the opportunity to compile this material here as a supplementary account to the catalogue entry, and as a means of placing Uccello's work in a context of contemporary Florentine panel-painting practice. We also hope that the publication of this account will stimulate further investigation of the two other panels of Uccello's series.

This article is divided into two sections. The first deals with the methods of construction and painting of the *Battle of San Romano*. The second part, which relies on information derived from the first, considers the status and date of the corner spandrel additions to the panel of the London picture (see FIG. 1) and which are present also on the paintings in Florence and Paris. The date and origin of these additions have been the subject of considerable discussion and speculation since they are crucial to understanding the locations of the paintings when they were in the possession of the Medici. This was an aspect of the London picture first studied by paint analysis in the late 1950s, and re-examined more recently in the light of increased knowledge of Florentine techniques of the mid-fifteenth century. The additions appear to have been made immediately after the cutting down of the panels from arch-topped formats to their present rectangular profiles in the move from one location to another.

The construction and materials of *The Battle of San Romano*

The National Gallery panel consists of about eight horizontal planks of poplar,[10] butt-joined along the edges, but not doweled, with broad strips of irregularly shaped reinforcing canvas laid vertically over the joins on the front face of the panel. There are large gaps between these pieces of fabric. The support has been altered in a number of ways. Originally it was larger and shaped to fit an architectural setting with carved stone corbels, which were evidently in contact with the upper part of the panel.[11] It also appears to have had an arched top, possibly a Gothic arch, which was cut away, probably in connection with a move in location. The spandrel-shaped remains of the arching corners were made up with new pieces of gessoed poplar, so that all three panels of the series are now rectangular in format (see below). The evidence is that these alterations were made in the fifteenth century (see below). The back of the London picture had been planed down before acquisition by the National Gallery from the Lombardi-Baldi collection in 1857, and the Uffizi panel has also been thinned. That in Paris has a reinforcing thin oak panel supporting the original.[12] Poplar panels from this period in Italy for large pictures were generally rather thick, and the backs left fairly roughly finished. Some idea of the general appearance can be gained from Uccello's *Hunt in the Forest*, of about 1460, now in Oxford (Ashmolean Museum), which retains its original thickness and unaltered reverse surface. A photograph of the back has been published.[13]

In keeping with a thick and heavy panel support and the extensive use of metal leaf in the composition, the gesso preparation layers are also substantial. Measurement on cross-sections indicates a total thickness of over 700 microns, comparable to the thickness of the plaster *intonaco* of some contemporary frescoes.[14] The gesso was applied to Uccello's panel in at least three layers: two of *gesso grosso*, and a final fine layer of *gesso sottile*. X-ray diffraction analysis (XRD) indicates the *gesso grosso* to be largely anhydrous calcium sulphate (anhydrite), which has superior mechanical properties with a glue binding medium, whereas the final *sottile* layer is pure gypsum, which may be applied as a smoother, finer-grained upper layer, very well suited to take bole, and then gold and silver leaf, and the thin flat

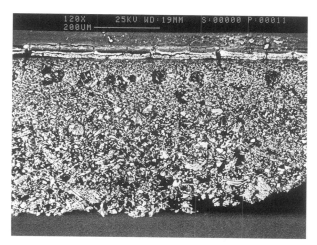

FIG. 2 Cross-section of paint and gesso ground as a back-scattered electron image in the scanning electron microscope, showing coarse gesso and finer gesso at the surface beneath the paint layers. Original magnification 120×; actual magnification 88×.

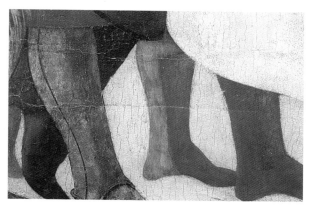

PLATE 4 Detail of the boots of the partially hidden figure, centre left, showing underdrawn outline on the gesso ground beneath the paint.

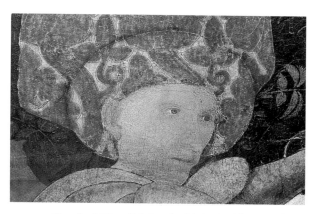

PLATE 5 Detail of Niccolò's head with incised lines at the junction of paint with gold and silver leaf. The lines around the brows, cheeks, nose and lips are painted, not incised.

paint layers of egg tempera paint. The distinction between the gesso layers is revealed clearly in SEM micrographs of cross-sections (FIG. 2), an observation made first by Elisabeth Martin at the Laboratoire of the Louvre.[15] In contrast to the total thickness of gesso on the panel, the layers of bole for gold and silver leaf are exceptionally thin, rarely exceeding five microns (see PLATE 12).

For such an elaborate composition requiring many complex interlocking forms, the detailed construction of perspective and recession, and a highly wrought decorative surface, considerable advance planning and design were clearly necessary; elements of the design were worked up in a certain amount of preliminary drawing in thin fluid dark paint or ink on the gesso surface and using incised lines inscribed freehand, with a straight edge and with compasses. Traces of drawing can be see through the paint outlining the bodies and limbs of the horses, in the lances, in Niccolò da Tolentino's banner, and for elements of the horses' saddlery and harnesses, as well as in smaller details such as the outlines of the red boots of the figure hidden behind the black charger on the left (PLATE 4).

In general, when the passage to be painted adjoins an area of intended gold or silver leaf, the drawing seems to be reinforced with an incised line which continues the outline, although this procedure was not followed slavishly everywhere in the preliminary design. An example can be seen clearly, however, in the outline of Niccolò's head, where incised lines mark the border of his forehead and gold hat, and where his neck and chin meet the silver armour

(PLATE 5). A similar use of drawing continued or reinforced by incision is used for the outline for the page's head. Freehand inscribed lines include many of the outlines defining the structure of the knights' silver armour, the gilded ellipses of decorative medallions on the horses' harnesses, and some of the smaller circular decorations such as the gilded balls attached to the white charger's bit. Freehand straight lines are also inscribed in the gold bands and decorations of the harnesses. There are also incised hatched lines made freehand in the gold leaf of Niccolò's hat, and S-shaped curves in some of the silver plumes of the surrounding knights, but these are decorative rather than part of the preliminary design.

Many other elements, such as the broken lances, were drawn along a straight edge, and ruled straight lines can be seen in the upright lances, the scabbard of the knight at the right and the outstretched silver blade of the sword of the knight challenging him. The tubes of the trumpets at the left are drawn simi-

PLATE 6 Compass points in decorative medallions on the harness of the black charger to the left.

PLATE 8 Detail of the trumpeters, left, showing thin dense lines of paint around their eyes, cheeks and fingers.

PLATE 7 Detail showing Uccello's use of the compass in the hilt of a broken lance, centre foreground.

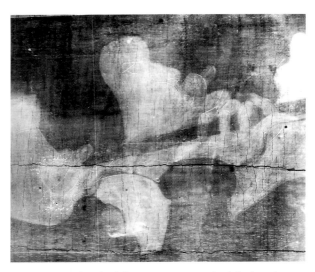

FIG. 3 X-ray detail of the trumpeters to the left showing thin lines of radio-absorbent paint in the eyes, cheeks and hands of the figures.

larly and are continued with freehand curving lines for the bells. Many indentations produced by the points of a compass remain visible through the gold leaf in the circular decorative medallions on the horses' harnesses and a few features which are painted rather than gilded were also defined with the compass, for example the hilts of the broken lances in the foreground (PLATES 6 and 7). Some of the intersecting incised arcs which define the armour were constructed using compasses; others are freehand.

Incised lines, however, were not confined to the earliest stage of design. Certain lines were drawn with a stylus into the early paint layers, particularly the pink paint of the foreground, and incised lines are also used as finishing touches to the design in the paint layers, and are clearly meant to be a visible part of the composition. This technique is familiar for the decoration of gold leaf, but less usual as a device to break the surface of tempera paint. Early incised lines can be distinguished from those applied after a paint layer, or layers, was present by close examination of the paint surface with a hand lens, but they are also sometimes distinguished in the X-ray images

of the painting, the incisions directly on to gesso often appearing light in the X-ray, whereas those that cut through the paint register as dark.[16] The *Hunt in the Forest* (Ashmolean, Oxford) provides a similar case, in which it has been noted that inscribed lines were applied to the finished paint layers as well as to the gesso as the first stage of composition and of the construction of a vanishing point.[17] Similar finishing touches produced by inscribed lines in the still soft paint can be detected in the six scenes on a single panel making up Uccello's *Profanation of the Host* now in Urbino, where the scale of painting is closer to the Oxford picture than to the *Battle of San Romano*.[18]

There are finely painted lines with a pronounced graphic quality at or near the surface, clearly intended to reinforce the design and, in the case of those drawn onto the paint of Niccolò's face – around his brow, nose, lips and cheeks – to render more striking

his tense, determined facial expression (see PLATE 5). These lines are in thin, fluid mid-brown paint, and can be seen also in the faces and hands of the two trumpeters at the left (PLATE 8), and in the curls and ringlets of the white charger's forelock. Unusually, these linear elements register as fine, very clear white features on the X-ray, that is, they are X-ray absorbent (FIG. 3), although they do not appear obviously to follow earlier incisions in the gesso or lower paint layers.[19] A drawn lance-point on the pink foreground between the legs of the large black horse, never completed in paint or silver leaf, also registers in just this way in the X-ray photograph.

It is usual in large panels in which metal leaf plays a prominent role, for the gilding, and silvering, to be carried out at an early stage, usually before any paint is applied. The incised lines marking out these areas are the first stage, followed by the application of a thin layer of bole mixed with an aqueous binder. In places the bole layer can be seen to infill incised lines, where there is a slight overlap in the application of bole. Examination of cross-sectional samples from areas of metal leaf reveals that the colour of the bole layer for the gold leaf differs slightly from that used beneath silver: the former is lighter and more orange-red, while the bole for silver is cooler, browner and contains a small proportion of black pigment. A variation in bole colour, where both gold and silver leaf are used together on a picture, has been noted elsewhere, for example in the panels of Sassetta's Sansepolcro altarpiece of 1437–44 in the National Gallery (NG 4757–63). In the *Battle of San Romano*, the bole layers for both gold and silver, although thin, are sufficiently strongly toned to conceal the whiteness of the gesso below and to influence the colour of the thin metal leaf on top.

Two possible reasons for the variation in bole colour suggest themselves: either a cooler, darker tone was specifically sought for the silver leaf of the knights' armour, or a more practical explanation is involved: that in order to distinguish areas designed to be gilded from those where silver leaf was intended, the difference in bole colour was introduced as a guide to be followed by the workshop. It is likely that all the areas of metal leaf were applied before painting began, but, since the paint has been applied so carefully to pre-planned outlines, there are few clearly detectable areas of paint overlapping metal leaf. An exception is at the periphery of Niccolò's hat, in which the dark green surrounding paint can be seen just to encroach onto the gold leaf. After the metal leaf was burnished, further decoration of gilded and silvered areas – by punching, inscribing and the

PLATE 9 Cross-section of yellow lance, foreground left, painted in lead-tin yellow 'type I' with a surface glaze of yellow lake and golden ochre. The pink paint of the foreground and the gesso ground are visible beneath. Original magnification 275×; actual magnification 235×.

application of glazes – would have followed the painting of the main parts of the composition. This order of execution would have been standard for a panel with significant areas of gilding or silver leaf.

The principal binding medium for the paint layer on the main part of the composition has been shown by analysis to be egg tempera, with the limited use of egg tempera combined with a little drying oil (*tempera grassa*),[20] in this case walnut oil, in certain of the foliage greens.[21] Where drying oil is incorporated with egg as a medium, the paint is a little slower drying and the resulting film glossier and more saturated than one bound in egg alone, although the quantity of egg medium also influences the optical properties of the dried paint. Other factors also play an important part in the optics of the dried paint, particularly the proportion of lead white with which it is combined. It is common to find the use of egg and oil in areas where greater saturation and translucency is required, as in glazes of all kinds, and in the darker colours of foliage greens and landscape. A binder of *tempera grassa* occurs also in the spandrel additions (see below).

Following the application of bole and metal leaf to selected areas, as described, the main broader elements of the painted composition – the pink foreground, the horses' bodies, the black background to the hedge of roses and the distant terraced hilly landscape – were first laid in thin flat unmodulated applications of pure tempera paint. Each is essentially a single layer, with the smaller-scale details worked directly on top, for example the broken lances in the foreground (PLATE 9), the foliage and flowers of the rose hedge, the figures and landscape details in the distance, and the oranges and orange blossom to the

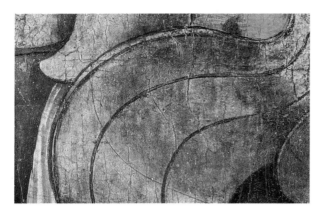

PLATE 10 Detail of the silver-leaf armour of a knight to the left, showing fingerprints in the brownish-black surface glaze.

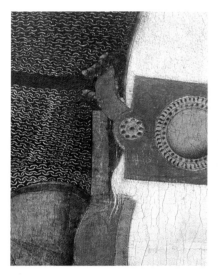

PLATE 11 Detail of darkened vermilion in the white charger's harness.

right. The final stages would have been the highly elaborate detailing of metal leaf, using further incised lines, the application of glazes of various colours and the punching and tooling of the gold and silver leaf to produce both decorative effect and three-dimensional structure. The dark, almost black, translucent glaze-like modelling over silver leaf to create the forms of the armour, identified as a soft-wood pitch combined with walnut oil, was clearly applied, or worked with the fingers: many areas preserve the clear impression of finger and thumb prints to spread and blot the paint and to create the modelling (PLATE 10).[22] So far, no fingerprints have been detected in the red glazes on gold, for example on Niccolò's brocaded hat and cape, nor in the green glazes on the page's surcoat, but these glazed areas are more decorative in function and involve less modelling to represent three-dimensional form.

Close examination of the surface reveals just how varied and detailed the designs are, with the use of at least seven different punches on the metal leaf, used singly and in combined patterns, as well as a great deal of freehand inscription. Perhaps the best way of appreciating this diversity and the intricacy of Uccello's technique in the three associated battle-pieces is to consult the beautifully printed colour details in Pietro Roccasecca's recent book on the battle scenes.[23]

Uccello's palette for the National Gallery *Battle of San Romano* is fairly standard for the period. The results of identification of the materials of the picture from paint samples and cross-sections are collected in the Table, with notes on their manner of use. Overall, the palette employed is rich and powerful in colour, and this is strikingly the case when these strongly coloured materials are seen set against the reflective qualities of burnished gold and silver. Final glazes are also present on the preliminary paint layers: for the shadowed areas of yellow lances in the foreground, the roses, the blue trappings of the horses and the darker foliage of the rose bushes and orange trees, for example. While the condition of the picture could be described as reasonably good given its scale, original function and date, sadly there has been widespread, drastic and distorting colour change in many of the pigments, and, unfortunately of course, considerable tarnishing of the silver leaf of the knights' armour. There is also paint loss, loss of metal leaf, abrasion and damage from repeated cleanings and clumsy retouching and reconstruction, some of which has been allowed to remain on the picture.[24]

Perhaps the most damaging change in pigments, apart from the general diminishment of some of the reflective quality of the silver leaf, is the very extensive darkening of vermilion in the picture, which almost everywhere has developed a purplish-grey metallic-looking cast (PLATE 11).[25] It is particularly serious in the red of the banners seen between the group of knights at the left and in the shafts of the lances behind, in the horses' harnesses and saddlery, including that of Niccolò's white charger, and in the broken lances in the foreground at the right. There is also some darkening of the green glazes containing copper, in the foliage of the rose hedge, and in details in the foreground and more distant landscape. There is fading of red lake pigment in the pink foreground, and in the glazes on the rose blossoms, although it survives well in the thicker, pure glaze-like paint over gold on Niccolò's hat and cape, and on some of the areas of silvered armour. The dark brownish-black

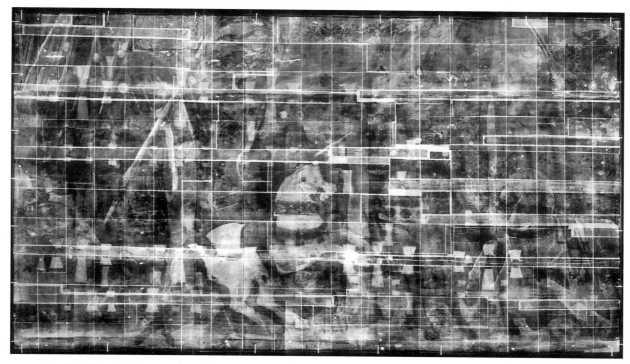

FIG. 4 Uccello, *Niccolò Mauruzi da Tolentino at the Battle of San Romano* (NG 583). X-ray of the whole. Note that the grid of white lines arises from the balsa wood build-up on the back of the thinned original poplar panel.

glazes on the original parts of the silver armour are fairly well preserved, even if rubbed and reinforced in places. The ultramarine blues seem not to have changed much, although surface glazes of pure ultramarine painted over pale blue underlayers of ultramarine mixed with white are abraded. The red lead paint of the oranges has changed and lightened to some degree, particularly at the outer edges of each fruit.[26] It can be presumed that the whites, greys, dull browns and blacks have altered quite little since stable pigments only are present in these paint layers.

The corner additions

The origin and date of the additions to the panel that make up the spandrel corners to produce the present rectangular format are critical to understanding the early history of the painting and, by extension, that of the associated battlepieces in Florence and Paris. Evidence can be gained from the physical construction of the additions, where these are accessible, the X-ray images of the junctions of the main panel with their additions (FIGS. 4 and 5), and the layer structure and materials of the paint on the additions. From sampling and analysis of the National Gallery painting, it is evident that the spandrel additions are very old, and, on the basis of their materials and technique of painting, they can be dated most probably

to the later part of the fifteenth century.[27] It is debatable, however, whether they were applied by Uccello himself, since documentary evidence seems now to point to a date for the additions after the painter's death in 1475.

There is a correspondence in technique between the structure on the additions and the main panel, but there are four important differences. First, the layer of reinforcing canvas covers the whole of each addition rather than just the joins in the wooden members, as on the main panel. Second, the gesso ground layer on the additions is composed solely of gypsum, rather than a sequence of layers utilising anhydrite and gypsum. Third, the paint medium on the additions is *tempera grassa*, but the oil content combined with egg is linseed oil rather than the walnut oil medium mixed with egg for the green paints on the main panel. Fourth, while the foliage greens in the principal composition are based on layers of verdigris, with and without a content of lead-tin yellow, painted over a layer of solid black to give depth of colour to the greens (see PLATES 13 and 14), those on the additions consist of layers of artificial malachite painted over solid black (see PLATE 15). Nowhere on the main panel has artificial malachite been found, and nowhere on the additions was verdigris used in the foliage greens.

The use of the artificial form of malachite, par-

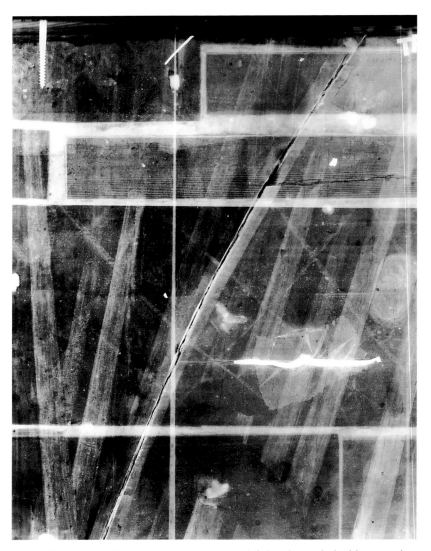

FIG. 5 X-ray detail of the junction between the left-hand spandrel addition and the main panel. Note that one of the original iron fixings used to hang the panel is visible as a white streak to the right of the image.

ticularly for foliage paint, is a fairly common technique in Florentine panel painting of the fifteenth century and occurs also in works from Siena, Ferrara and Venice.[28] It is fairly standard also to find the artificial form of malachite painted over a black underlayer for dark foliage and landscape greens, and, in fact, this is the method used in the main part of the composition in the Paris battlepiece[29] as well as in large passages of the landscape in Uccello's *Hunt in the Forest*.[30] Similar techniques, for example, are used in the landscape of Pesellino's altarpiece *The Trinity with Saints* now in the National Gallery, begun in 1455 and finished by Filippo Lippi and his workshop[31] after 1457, and artificial malachite for landscape, foliage and draperies has been found in a number of works throughout the fifteenth century, including Botticelli's canvas painting, *The Virgin*

adoring the Sleeping Christ Child, probably of the 1480s, acquired recently by the National Gallery of Scotland, where it occurs over a black underlayer in foliage paint.[32] However, this pigment appears to have been abandoned towards the end of the fifteenth century or just at the beginning of the sixteenth century, probably because its use is suited to the optical properties of egg tempera and *tempera grassa*, rather than to oil. The use of artificial malachite on the spandrel additions of the *Battle of San Romano* is consistent with a date in the later part of the fifteenth century, and suggests that the additions were not applied as late as the sixteenth century, when the techniques for depicting foliage had changed with the development in Italy of media involving drying oils as the main binder.

Overall, the painter of the additions, while not

duplicating precisely those of the main panel, employed methods which are generally comparable. The oranges on the main panel are painted in red lead (lead tetroxide) and so are those on the additions. Moreover, in each case a single layer of orange paint is applied over a layer of black, thereby rendering the tonality of the main composition and the addition very similar. At the far right side of the panel, there are also passages of foliage paint of a coarser texture, dull brownish green in colour and painted in a style that differs from the surrounding dark green foliage. This paint is also present on the right-hand addition and since it passes over greens containing artificial malachite on the addition, appears to be a later modification to the right-hand side of the composition, perhaps to correct a disunity that had developed in the continuity of the composition as it traverses the joins in the panel from Uccello's original to the slightly later spandrel.

The fact that the corner additions are fifteenth century almost certainly suggests that they were made when the paintings were moved from the Bartolini Salimbeni town house, now destroyed but originally between Via Porta Rossa and Corso degli Strozzi (now Via Monalda), to the Palazzo Medici in Via Largha, probably between 1479 and 1486.[33] The paintings would not have fitted between the vaults of the Camera di Lorenzo for which they had not been designed, and so were reduced in height as far as was possible without impinging too much on the composition, but probably the hill-tops of the landscape and the sky were lost. In the inventory of 1492 the paintings are stated to be 3½ *braccia* high, including, by implication, their frames.[34] Each currently measures about 180 cm high, that is approximately 3 *braccia*, thus allowing for about 15 cm for frames top and bottom. The unsightly gaps, originally designed to fit around corbels, were probably filled by the woodworker who removed the paintings, Francione,[35] as suggested by Caglioti, since pure gypsum, as a ground, as described above was presumably more commonly used by carpenters and framemakers.

The three paintings almost certainly hung in a row along the east wall, that being the only uninterrupted wall long enough to accommodate them, as well as the best lit.[36] There Lorenzo the Magnificent could glory in the heroic actions of past Florentines, and admire the magnificent decorative effects of gold and silver leaf and the intricacies of armour so accurately depicted in the tapestry-like paintings he had so unscrupulously commandeered.

Acknowledgements

We would particularly like to thank the following for their help in the preparation of this article: Roberto Bellucci, Francesco Caglioti, Alessandro Cecchi, Cecilia Frosinini, Elisabeth Martin, Jill Nadolny and Dominique Thiébaut. At the National Gallery we are grateful to Martin Wyld, who has contributed to interpretation of the structure and condition of Uccello's panel, and to Raymond White and Jo Kirby who have kindly supplied paint medium and lake pigment dyestuff analyses.

Notes and references

1 NG 583 is included in the revision of the catalogue of Italian Paintings in the National Gallery, 1400–1460, to be published in autumn 2001. For the painting see S. and F. Borsi, *Paolo Uccello*, Paris 1992, pp. 126–8, and 308–12, with bibliography, and P. Roccasecca, *Paolo Uccello. Le Battaglie*, Milan 1997. For discussion of the historical sources, the Battle of San Romano and the issues involved see G. Griffiths, 'The Political Significance of Uccello's Battle of San Romano', *Journal of the Warburg and Courtauld Institutes*, 1978, pp. 313–16; Randolph Starn and Loren Partridge, 'Representing War in the Renaissance: The Shield of Paolo Uccello', *Representations*, Vol. 5, 1984, p. 59, note 6; S. and F. Borsi, op.cit., p. 309; W. J. Wegener, ' "That the practice of arms is most excellent declare the statues of valiant men": the Luccan War and Florentine political ideology in paintings by Uccello and Castagno', *Renaissance Studies*, Vol. 7, no. 2, June, 1993, pp. 131ff.; and Roccasecca, op.cit., pp. 10ff. An extremely thorough discussion of the sources with lengthy quotations is to be found in Volker Gebhardt, *Paolo Uccello's 'Schlachten von San Romano'*, Bochumer Schriften zur Kunstgeschichte, 1989, Frankfurt am Main 1989, pp. 53–9 and 189–207.

2 Ed. M. Spallanzi and G.G. Bertelà, *Libro d'Inventario dei Beni di Lorenzo il Magnifico*, Florence 1992, p. 11. The copy of the inventory was made in 1512. Earlier sources simply call them a joust. See *Il Codice Magliabecchiano* (ed. C. Frey), Berlin 1892, p. 100: 'Dipinse (Uccello) e quadri delle giostre del palazzo de medici nella via Largha.'

3 Document transcribed by H.P. Horne, 'The Battle-Piece by Paolo Uccello in the National Gallery', *The Monthly Review*, 1901, p. 138.

4 F. Caglioti, *Donatello e i Medici. Storia del David e della Giuditta*, Florence 2000, pp. 265–81. I am extremely grateful to Professor Caglioti for allowing me to read his chapter on the Battle of San Romano when the book was still in proof.

5 Caglioti, op.cit., p. 274

6 For a summary of views on dating see S. and F. Borsi, cited in note 1, pp. 331–2.

7 L. Boccia, 'Le armature di Paolo Uccello', *L'Arte*, 3, 1970, pp. 58–91, for the armour in the battle scenes, esp. p. 68.

8 Roccasecca, cited in note 1. He dates the NG and Uffizi paintings around 1436 and the Paris painting around 1456–8.

9 Catalogue of Italian Paintings in the National Gallery, 1400–1460, cited in note 1.

10 There is no clear record of the original panel structure for NG 583 in the Conservation Dossier, but examination of photographs taken in 1954 of the reverse and an assessment of the positions of reinforcing wooden butterflies set into the back of the panel suggest that it is made up of eight horizontal planks of poplar. The Uffizi panel has the same number of members, whereas that in the Louvre is made up of just five horizontal planks. The reverse of the National Gallery panel was built up with balsa wood in 1960.

11 The structures and original shapes of the panels of Uccello's series are discussed in detail by U. Baldini, 'Restauri di dipinti fiorentini', *Bollettino d'Arte*, XXXIX, 1954, pp. 226–40.

12 We are grateful to Patrick Le Chanu for this information.

13 A. Massing and N. Christie, '*The Hunt in the Forest* by Paolo Uccello', *The Hamilton Kerr Institute Bulletin*, Vol. 1, 1988, figs. 2 and 3, p. 31.

14 Similar measurements were found for the plaster *intonaco* layer in Domenico Veneziano's transferred fresco in the National Gallery (NG 766, 767 and 1215).

15 A number of SEM micrographs as back-scattered electron images showing the structure of gesso layers and their thicknesses have been published by Elisabeth Martin et al. See E. Martin, N. Sanoda and A.R. Duval, 'Contribution à l'Etude des Preparations Blanches des Tableaux Italiens sur Bois', *Studies in Conservation*, 37, 2, 1992, pp. 82–92.

16 The usual explanation for incised lines appearing as light in X-radiographs of paintings is that they have been made directly on the gesso ground and are subsequently infilled by X-ray absorbent wet paint applied on top; where the incised line is made through dried paint it should appear dark in the X-ray. This interpretation is not always correct and some of the incised lines which are present in the gesso of NG 583 are in fact dark in the X-ray image, and certain continuous lines are dark in places and light in others. This must be a function of the drying properties and fluidity of the tempera paint applied on top.

17 Massing and Christie, cited in note 13, pp. 35–6, and plates 25 and 26, p. 42.

18 Uccello's *Profanation of the Host* is illustrated in Borsi, cited in note 2, pp. 260–5.

19 Close examination of the paint surface reveals that these lines drawn in paint are fairly thickly applied, although narrow in profile. The material used must be highly X-ray absorbent.

20 The origin and use of *tempera grassa* in fifteenth-century Italian painting is discussed by Jill Dunkerton in 'Modifications to traditional egg tempera techniques in fifteenth-century Italy', *Early Italian Paintings: Techniques and Analysis*, Symposium, Maastricht, 1996, ed. T. Bakkenist, R. Hoppenbrouwers and H. Dubois, Limburg Conservation Institute, Maastricht 1996, pp. 29–34.

21 The analysis of the organic components of the paint film, and particularly the binding media used, was carried out by Raymond White using GC–MS and FTIR.

22 The constitution of this glaze containing oil and charred resinous material would have rendered it sticky and difficult to apply with a brush. It would have been natural for the painter to apply and model the glaze with the fingers. The application of glazes in this way, and putting them on with the palm of the hand, is described by Armenini in 1586, see G. B. Armenini, *Deveri precetti della pittura*, ed. Marina Gorreri, Turin 1988, Book II, Ch. 9, pp. 144–5.

23 Roccasecca, cited in note 1.

24 Horne, cited in note 3, p. 135, noted already in 1901 that the paintings had been overcleaned.

25 The darkening of vermilion is a common phenomenon in egg tempera medium, and is thought to be induced either by light or by rubbing and abrasion of the paint surface containing this pigment. Impurities in vermilion may catalyse the process. See R.J. Gettens, R.L. Feller and W.T. Chase, 'Vermilion and Cinnabar', *Artists' Pigments: A Handbook of Their History and Characteristics*, Vol. 2, ed. A. Roy, Washington 1993, pp. 167–9. More recent research has been carried out by R. Grout at the Courtauld Institute, Department of Technology and Conservation, and her unpublished dissertation on the darkening of vermilion is lodged there.

26 The lightening of red lead was first observed in English medieval wall paintings by Helen Howard. See S. Cather and H. Howard, 'St. Gabriel's Chapel, Canterbury Cathedral: its technique, condition and environment reassessed', in *Forschungsprojekt Wandmalerei-Schäden, Arbeitshefte zur Denkmalpflege in Niedersachsen*, 11, Hanover 1994, pp. 141–56. Current research by David Saunders and Marika Spring in the Scientific Department of the National Gallery has demonstrated the role of light and humidity in bringing about the transformation of red lead to lead carbonate and lead hydroxycarbonate in test samples painted out in a variety of media.

27 Alessandro Conti in E.H. Gombrich, O. Jurz, S. Rees Jones, J. Plesters, *Sul Restauro*, ed. A. Conti, Turin 1988, p. 78. Conti suggested the corner additions to the Uffizi painting were fifteenth century.

28 See J. Dunkerton and A. Roy, 'The Materials of a Group of Late Fifteenth-Century Panel Paintings', *National Gallery Technical Bulletin*, 17, 1996, pp. 21–31.

29 Artificial malachite with a spherulitic particle form has been noted in cross-sections taken from the original foreground landscape in the Paris Battlepiece. We are very grateful to Elisabeth Martin for sharing these unpublished results with us.

30 Massing and Christie, cited in note 13, pp. 36, 45 and plates 29 and 30, p. 42.

31 Two distinctive types of green landscape and foliage are present on Pesellino's altarpiece, *The Trinity with Saints*: thin translucent copper-containing glazes in the middle distance landscape, now extensively browned, and thicker, crustier deep green paint for the more substantial

greens of the foreground and trees, which are painted using artificial malachite over a layer of solid black pigment. Stylistic analysis of the altarpiece suggests that the paint containing artificial malachite had been applied by Pesellino, whereas the glaze-like passages were the responsibility of the Filippo Lippi workshop.

32 Cross-sections from the Edinburgh *Virgin adoring the Sleeping Christ Child* by Botticelli were supplied by Michael Gallagher, Keeper of Conservation at Edinburgh, and examined by Marika Spring at the National Gallery. Artificial malachite is used for the darker foliage of the rose hedge surrounding the Virgin, as a single layer over solid black pigment. Interestingly, the deep green lining of the Virgin's cloak makes use of natural malachite.

33 One of the alternatives raised by Caglioti (cited in note 4, p. 268), namely that they could have been adapted when they were moved from the Bartolini Salimbeni's country house in Santa Maria a Quinto (northwest of Florence) to their town house, is less likely. It cannot entirely be discounted that the paintings were not commissioned by the Bartolini Salimbeni family but acquired by them. Caglioti (p. 271, note 192) raises and then dismisses the possibility that they could have been commissioned for the Palazzo Vecchio.

34 See note 3 above.

35 Caglioti, cited in note 4, p. 268.

36 W. Bulst, 'Uso e trasformazione del palazzo mediceo fino ai Riccardi', in eds. G. Cherubini and G. Fanelli, *Il Palazzo Medici Riccardi di Firenze*, Florence 1990, p. 110; P. Joannides, 'Paolo Uccello's *Rout of San Romano*: a new observation', *Burlington Magazine*, 131, 1989, pp. 214–15 and V. Gebhardt, 'Some problems in the reconstruction of Uccello's *Rout of San Romano* cycle', *Burlington Magazine*, 133, 1991, pp. 179–85. Both the latter authors were exploring the possibility first raised by Boccia, cited in note 7, p. 133, and by Conti, cited in note 27, p. 78, that the series had not been designed for the Camera di Lorenzo, and thus not for the Palazzo Medici. Boccia, Conti and Gebhardt suggested they had been intended for the previous Medici home, the Casa Vecchia, nearby, and also in the Via Largha. For the most detailed analysis of the Camera di Lorenzo and its furnishings see A.M. Amonaci and A. Baldinotti in the exhibition catalogue, eds. G. Morolli, C. Acidini Luchinat, L. Marchetti, *L'architettura di Lorenzo il Magnifico*, Florence 1992, pp. 126–8.

See pp. 16–17 for Table.

Table. The Structure and Materials of Uccello's *Battle of San Romano* (NG 583)

THE MAIN COMPOSITION

Support, Ground, Drawing and Paint Medium

Support: Horizontal poplar[1] planks, 182 × 320 cm. Thinned before 1857 and supported by balsa wood build-up applied in 1960.

Ground: Several layers of coarse *gesso grosso* (gypsum + anhydrite), with a thin surface layer of *gesso sottile* (gypsum);[2] animal-skin glue binder.

Drawing: Thin paint or ink containing very fine black pigment, probably lampblack, applied directly to the gesso ground; medium unknown. Much of the composition is marked out by incised lines in the gesso.

Medium: Analysis of the paint binding medium[3] from a number of samples showed the straightforward use of egg tempera paint in much of the picture, the pink foreground, for example, and the oranges in the middle distance to the left. Certain of the red glazes were shown to be rich in egg medium, while the green foliage paints contained egg tempera mixed with walnut oil (*tempera grassa*). Walnut oil was also found in the dark translucent glazes on the silver armour (see below).

Metal Leaf

Gold: Water gilding; gold leaf over thin orange-red bole with an aqueous adhesive. Certain areas are decorated with glazes, for example Niccolò's gold and red hat and cape (red lake glaze, probably lac), and the page's gold and green sleeve (verdigris and oil glaze).

Silver: Silver leaf[4] over thin orange-brown bole with an aqueous adhesive (PLATE 12). The knights' armour is modelled with a brownish-black glaze identified as containing a softwood pitch combined with walnut oil.[5] Red glazes over silver are present elsewhere, as in the page's drum, the fallen shields in the centre foreground and right, and the knights' plumes (identified in a sample as lac lake).[6] A green glaze based on verdigris over silver leaf occurs in the saddle of the knight on the black horse to the right, and ultramarine is used as a glaze over silver for parts of the knights' armour, particularly the central lancer on the dark grey charger. The knights' silver chain mail is worked as a *sgraffito* design in black over a solid layer of silver leaf.

Paint Structure and Materials[7]

Foreground: The pink foreground consists of red lake mixed with white; two layers are present in places. The broken yellow lances are painted directly over the pink foreground using lead-tin yellow ('type I'),[8] and their edges shaded with a semi-translucent glaze of yellow earth mixed with yellow lake. The dark blue-greens of the lance in the foreground and the fallen shield to the right are painted with mineral azurite

Flesh paint: The flesh paints consist of single layers of lead white combined with small quantities of vermilion, and red

and brown earths, painted over a layer of *verdaccio* comprising white, green earth, golden ochre and a trace of red earth.

The horses and their trappings: The body of the black charger to the left is painted in a mixture of charcoal black with a little lead white, over a very thin layer of red-brown earth; that of the white charger is largely lead white with small quantities of black pigment and yellow earth in the greyish halftones. The blue saddlery and harnesses consist of natural ultramarine with white; the darker modelling is applied on top as glazes of purer ultramarine. The reds are finely ground vermilion; many sections are heavily discoloured at the surface resulting in a greyish-purple sheen.

The rose hedge, pomegranates and orange grove, middle distance: The underlayer for all areas of the foliage paint consists of a solid paint of pure charcoal black, with the details of the deep green foliage painted on top (PLATE 13). The green paint comprises a mixture of verdigris and lead-tin yellow, with a larger proportion of lead-tin yellow in the lighter and greener areas. Earth pigments and black are present in varying quantities. The pink roses consist of red lake glazes (abraded) over a layer of white paint; the ruby flesh of the pomegranates is painted in the same way. The oranges are virtually pure red lead pigment (lead tetroxide)[9] (PLATE 14).

Landscape background: The greys and greyish-mauve tones of the distant landscape consist of variable quantities of white, charcoal black and red lake pigment, with a greater proportion of red lake in the mauver tones.

THE SPANDREL ADDITIONS

Support, Ground, Drawing and Paint Medium

Support: Poplar.[10]

Ground: Single layer of gypsum.[11]

Drawing: None detected.

Paint medium: Analysis of the medium[12] of foliage paint and of one of the oranges indicated the use of a mixed medium of egg tempera and oil (*tempera grassa*), in this case linseed oil.

Paint Structure and Materials

Foliage and oranges: The dark greens of foliage consist of a layer of artificial malachite[13] over a layer of solid charcoal black paint. This dark layer is present also beneath the oranges (PLATE 15), which, as on the main panel, consists just of red lead pigment (lead tetroxide).[14]

Notes

1 Microscopical identification.
2 X-ray diffraction analysis (XRD).
3 Paint media examined by gas-chromatography linked to mass-spectrometry (GC–MS) and by Fourier-transform infra-red microspectrophotometry (FTIR). Some earlier

PLATE 12 Cross-section showing a very thin layer of silver leaf for armour, with orange-brown bole beneath. A brownish-black glaze is present at the surface. Original magnification 400×, actual magnification 345×.

PLATE 14 Cross-section of one of the oranges, left, painted in red lead (lead tetroxide) over green foliage. No gesso is present in the sample. Original magnification 275×; actual magnification 235×.

PLATE 13 Cross-section of dark green tuft of grass, foreground right, comprising verdigris and lead-tin yellow over a layer of solid charcoal black. The pink paint of the foreground lies beneath. Original magnification 400×; actual magnification 345×.

PLATE 15 Cross-section from one of the oranges on the spandrel addition, right-hand side, painted in red lead over a layer of charcoal black. Beneath this the foliage paint consists of artificial (synthetic) malachite, also over a layer of charcoal black. Original magnification 350×; actual magnification 300×.

 results were obtained using heating and solubility tests and by staining reactions.

4 Electron micro-beam probe analysis and energy dispersive X-ray microanalysis (EDX).

5 GC–MS; FTIR.

6 Identified by high performance liquid chromatography (HPLC).

7 Paint samples were examined using standard microscopical methods as paint cross-sections, thin sections and dispersed samples. Analyses were carried out microchemically, by XRD and using EDX.

8 XRD.

9 XRD.

10 Microscopical identification.

11 XRD.

12 GC–MS and FTIR.

13 The green pigment present on the spandrel additions was identified as malachite microscopically and by XRD. The spherulitic particle form of the pigment is characteristic of a manufactured origin.

14 XRD.

Vincenzo Foppa's *Adoration of the Kings*

JILL DUNKERTON AND CAROL PLAZZOTTA

THE *Adoration of the Kings* by Vincenzo Foppa (NG 729; PLATE 1) is the largest and most impressive of the National Gallery's exceptional and wide-ranging holding of fifteenth- and sixteenth-century paintings of the Lombard School. Acquired in 1863 as by Bramantino, and restored by Raffaelle Pinti (a private restorer, based in London, who frequently worked on acquisitions made by Sir Charles Eastlake, Director of the Gallery from 1855 to 1865), it was recognised as a work of Foppa by Crowe and Cavalcaselle in 1871.[1] This attribution has been generally accepted in the literature on the artist, with one exception, in which it is suggested that it may be the product of the late workshop of the painter.[2] As will be demonstrated, technical examination has disclosed a flexibility of approach that seems uncharacteristic of a workshop product.

Nothing is known of the destination of this grand altarpiece, which is first recorded as late as 1839 in the posthumous inventory of the collection of Cardinal Joseph Fesch (1763–1839), although the work probably entered Fesch's possession early on, before his move from France to Rome in 1815.[3] No trace of the painting's presence has emerged in Brescia, where Foppa was based, but he is known to have worked on important commissions for churches elsewhere in Lombardy, and also in neighbouring Liguria, and it is possible that the altarpiece was made for a more remote location. The *Adoration* is always described as a late work,[4] sometimes dated as late as the first decade of the sixteenth century, though, since there are relatively few fixed dates in Foppa's chronology, it is perfectly possible that the National Gallery altarpiece is a work of the 1480s or 90s. The dating of a painting such as this is made more difficult by the tendency to conservative taste among patrons in Lombardy and north-west Italy during this period, above all in the enduring predilection for large areas of decorative gilding. Furthermore, in common with many other works by Foppa, the *Adoration of the Kings* seems to reflect, both in its design and in its sumptuous decoration, celebrated wall paintings and panels by Gentile da Fabriano and Jacopo Bellini that were then to be seen in Brescia.[5]

It is possible that Gentile da Fabriano's murals in the Chapel of the Broletto, Brescia, painted for Pandolfo Malatesta in 1414–19, included a scene showing the Adoration of the Kings[6] and that this, rather than a putative journey to Florence, may account for elements of Foppa's *Adoration* that appear to reflect Gentile's altarpiece of the same subject painted for Palla Strozzi in Florence and dated 1423, now in the Uffizi. Details such as the motif of the page kneeling to adjust the spur of the standing king, Balthazar, and the general design, with the Virgin and Child on the left and the vertical accumulation of the exotic retinue winding its way through the hilly landscape from the walled city of Jerusalem, appear to suggest a Gentile prototype. Although common in Lombard painting, the lavish use of gilded *pastiglia* and the wide variety of different patterned textiles can also be associated with Gentile. The young page riding one of the Magi's horses (with his feet resting in the leathers, his legs being too short to reach the stirrup irons) brandishes a stick to strike at the horse behind, who nips the rump of his mount. Similar anecdotal detail appears in the Gentile altarpiece, but also in drawings of the same subject by Jacopo Bellini, whose influence can be detected especially in Foppa's earliest works.[7]

Remarkably, given its dimensions, the panel of the National Gallery altarpiece appears to be constructed from only four vertical planks of poplar, three of exceptional width and a narrower one at the right edge (as seen from the front). The panel has been planed down to a considerable extent and a cradle applied to the back. The wide spacing between its members is characteristic of a cradle of the first half of the nineteenth century, and the application of two Roman customs stamps to one of the cradle bars confirms that the reinforcement was applied before the panel left Italy in 1845. In spite of this treatment, the panel has remained in a stable condition. The front surface was prepared in the usual way, with layers of gesso consisting of the slaked dihydrate form

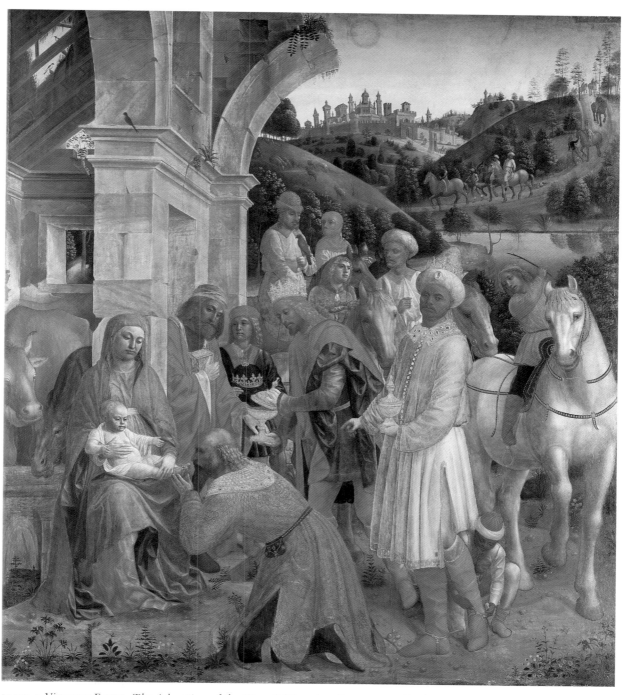

PLATE 1 Vincenzo Foppa, *The Adoration of the Kings* (NG 729), 1480s or 1490s. Poplar, 241 × 212.8cm.

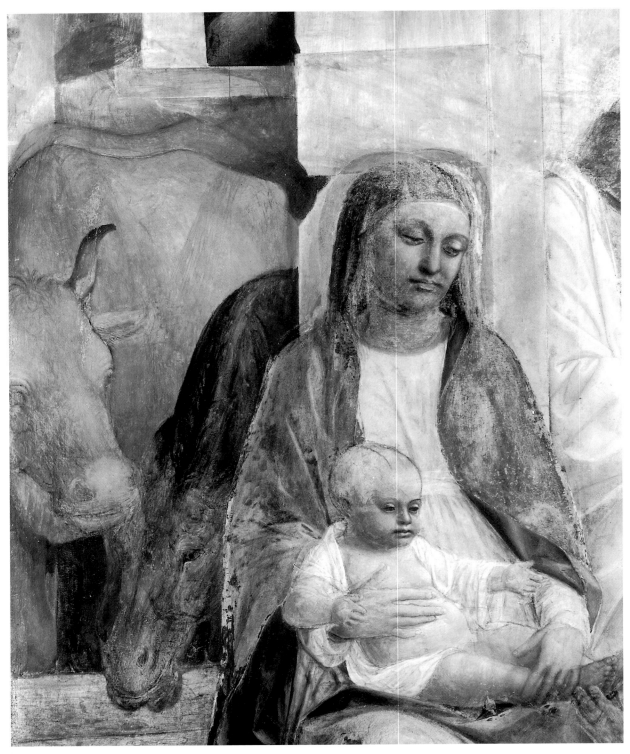

FIG. 1 *The Adoration of the Kings*, infra-red photograph detail.

of calcium sulphate bound with glue.[8] A border about one cm wide was left ungessoed around all four sides, confirming that the picture retains its original dimensions. The presence of a raised barbe at the edge of these borders indicates that some form of moulding (possibly temporary) was in place when the gesso was applied. Cross-sections reveal that a thin and rather translucent *imprimitura*, mainly consisting of lead white and colourless mineral particles (very slightly tinted with particles of black), was applied to the areas to be painted, presumably to reduce the absorbency of the gesso.[9]

The underdrawing revealed by infra-red photography[10] shows a varied approach to establishing the design on the panel. Some figures, for example the Virgin and Child (FIG. 1), and the page boy buckling on Balthazar's spur (FIG. 2), are drawn with a brush in a fluid medium, often with long confident strokes. This is most evident in the drawing of the kneeling page's lower left leg, somewhat to the right of its painted position. Here, the drawing is used to establish contours alone and there is no evidence of the hatched shading observed particularly on Foppa's earlier works.[11] Panels from the Fornari polyptych of 1489 in the Pinacoteca Comunale, Savona, and from the Della Rovere polyptych, completed in collaboration with Ludovico Brea in 1490 (now in the oratory of Santa Maria di Castello, also in Savona), include passages of underdrawing with a fluid outlining of forms and drapery folds similar to that detected on the *Adoration*.[12]

In complete contrast to the relatively free underdrawing present in the National Gallery altarpiece is the use of carefully pounced cartoons for some of the heads, most clearly visible in the figures of Joseph and Balthazar (FIG. 3) (the technique may have been used on some of the other heads but their abraded condition makes recognition of the characteristic dots more difficult). The pounce marks in Balthazar's head are so clear and well-defined as to suggest that they might have been made with a liquid medium, perhaps dotted through the holes of the cartoon with a brush instead of the usual powdered charcoal or black chalk.[13] The dots – so closely spaced that it was unnecessary to join them up into continuous lines – define the eyes, nose, cheek bones, and furrows of the brow in formulaic curves reminiscent of the simplified forms of fresco cartoons. *Spolvero* of precisely this character can be observed on some of the heads in Foppa's wall paintings in the Portinari Chapel in the Church of Sant' Eustorgio, Milan, probably completed in 1468.[14] The fact that pounced cartoons were used so selectively in this altarpiece raises the possibility that the designs were being reused from a previous project, although there is no evidence from surviving works that this is the case. In generic terms, Foppa's male heads are all quite similar and it would have been easy for him to re-use cartoons in this way. Another possible explanation for the selective use of cartoons is that the design of figures such as Balthazar and Joseph had to be established with greater certainty than the more freely delineated Virgin and Child group because they were to incorporate areas of gilding and *pastiglia* and therefore could not be modified during

FIG. 2 *The Adoration of the Kings*, infra-red photograph detail.

the course of painting.

There is no visible evidence for Foppa's method of constructing the perspective of the setting – perhaps the receding orthogonals were snapped with string and powdered charcoal as in mural painting – but the basic structure of the ruins must have been indicated at an early stage. As always seems to be the case in Foppa's panel paintings, the architectural elements are extensively incised (FIG. 4), but in this altarpiece the incised lines consistently stop short of the drawn contours of the figures and animals, which must therefore already have been in place. The ruled incisions for architectural details such as the mouldings of the cornice often extend further than necessary, a tendency that can be traced as far back as Foppa's early *Crucifixion*, signed and dated 1456 (Bergamo, Accademia Carrara). Surprisingly for a painting of this date, some drapery folds were also incised, including those of the Virgin's blue mantle.[15] This technique is more often associated with earlier painting, when the dark underlayers often employed for blue pigments would have obscured any drawing.

The use of incision is also found in areas that were to be gilded: for example, the overlapping scales on the collar of the kneeling king (FIG. 5) were first

FIG. 3 *The Adoration of the Kings*, infra-red photograph detail.

incised before the *pastiglia* decoration was built up in liquid gesso (of the same dihydrate form as that used for the ground). The relief of the collar is graduated from flat scales marked only by incisions at the left through to the highest relief at the point nearest to the viewer, an adaptation of the traditional technique of *pastiglia* for illusionistic effect. A similar attempt to suggest recession can be seen in the *pastiglia* composing the braid along the edge of the collar. The mounts in the jewelled border of the collar were also built up in gesso and, once the bole and gold leaf had been laid, the gems could be indicated in different coloured glazes.[16] The same technique was used for Balthazar's collar, buttons, crown and the enormous jewel in his turban (PLATE 2). *Pastiglia* is associated only with the Three Kings, being used also to ornament the crown of the central king and all three of their gifts. Further back into the picture however, golden objects such as the crown on the kneeling king's headdress, held by his page, and the bit and studded harness of the horse on the right, are depicted in yellow paint (identified on the crown as lead-tin yellow).

Since the tunic of Balthazar, the prominently positioned intercessor figure, was to be executed with the technique of *sgraffito*, gold leaf had first to be laid under the whole area (PLATE 3). It is applied

over a fairly substantial layer of orange-red bole (the *imprimitura* used elsewhere on the picture is absent). To avoid losing the lines of underdrawing, the outline of the sleeve and the principal folds of the tunic were scored into the ground before the application of the bole. The appearance of the painting suggests that it was painted principally with an oil medium, and analysis of a sample of light-coloured paint from the stone of the ruin identified heat-bodied walnut oil as the main component.[17] For *sgraffito*, however, egg tempera is a more suitable medium, making a paint which can be scratched cleanly away from the underlying gold leaf if allowed to dry to the point where it remains slightly soft and cheesy, before it becomes too hard and brittle; and analysis of a sample from the tunic has confirmed that Foppa did indeed employ an egg medium for these areas. The gold threads of the tunic were exposed by short horizontal marks, and for the cone of Balthazar's headdress a chequered pattern was scratched through the red paint. The original richness of effect has been diminished as a result of the loss of intensity of the purple colour of the tunic, on account of the fading of the red lake and the possible discoloration of the azurite, which, mixed with lead white and a little carbon black, made up the colour.[18] The red lake of the Virgin's dress is also likely to have faded to some extent. It now appears somewhat desaturated in comparison with the rich and well-preserved reds elsewhere on the picture.

The Virgin's mantle too is no longer in its original condition. When the painting was cleaned in 1935–6, nearly all of the many nineteenth-century and earlier repaints were removed, but it was found that the Virgin's robe was 'mostly reduced to the underpaint and partly made up with the addition of painted folds at some remote period'.[19] It was decided to leave these old reconstructions. This underpaint consists of azurite and lead white, hence the green appearance of this area of blue when compared with those elsewhere on the picture (although the various overpaints and retouchings also contribute to the uneven effect). The original upper layer of ultramarine and white has survived in only a few places – a few particles of lapis are visible at the right end of the cross-section illustrated (PLATE 4). It can be seen from the areas of blue elsewhere on the painting that the ultramarine pigment has deteriorated, resulting in a blanched and chalky effect, suggesting the possibility that an early restorer may have scraped the degraded pigment off the Virgin's mantle to reveal the brighter and better preserved azurite beneath. A sample from the blue tunic of the mounted page behind the mid-

dle king shows that here the ultramarine was applied over a thick underlayer of black (PLATE 5). Perhaps Foppa originally intended to underpaint the Virgin's mantle in this way, which might explain the incision of the folds. A black underpainting also occurs in a sample of green paint from the bush behind the horse on the right (PLATE 6). A few particles of verdigris are mixed with the black, perhaps added as much to improve the drying of the pigment (carbon black pigments do not dry particularly well, especially when used in walnut oil) as to colour it. Over this is a rich dark green layer of verdigris and then a lighter green consisting of verdigris and lead-tin yellow, used to depict a leaf.[20]

Foppa's method for painting the darker-complexioned male faces is now apparent because some have been much damaged by abrasion, notably the turbanned attendant behind Balthazar, and the heads of Joseph and the kneeling king.[21] They appear to have been painted directly over the *imprimitura* using reddish-brown mixtures.[22] For the paler flesh tints of the Virgin and Child, however, Foppa employed a more complex layer structure (PLATE 7). Adapting the traditional technique of underpainting areas of flesh with green earth or *verdaccio*, he first undermodelled

FIG. 4 *The Adoration of the Kings*, detail photographed in raking light.

FIG. 5 *The Adoration of the Kings*, detail photographed in raking light.

PLATE 3 *The Adoration of the Kings*. Cross-section of a sample from Balthazar's purple tunic. The lowest layer is the gesso ground, followed by the bole and gold leaf and then the paint layer consisting of lead white, azurite, red lake and a little carbon black. Original magnification 320×, actual magnification 275×.

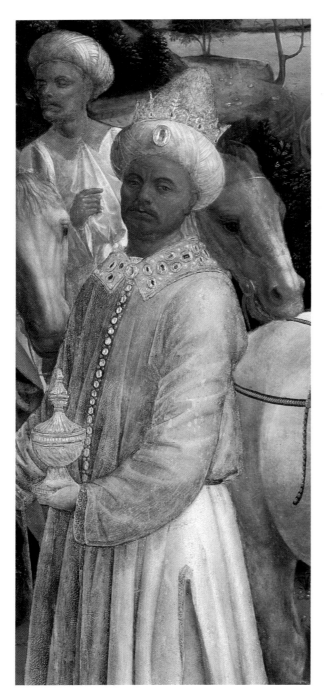

PLATE 2 *The Adoration of the Kings*, detail.

these areas with a slightly translucent greenish-brown mixture of lead white, carbon black, red and Cassel earths and a small amount of green earth.[23] The appearance of these areas in infra-red indicates that the underpaint was modelled rather than having been applied as a flat unmodulated layer as in tempera techniques. Furthermore, in the sample from the Child's knee (PLATE 8), an alteration results in four layers of paint being present, with the underpainting repeated over the first thin layer of pale

pink, confirming that the underlayer was part of the process of constructing the volumes.

The upper layer consists mainly of lead white, with only an occasional particle of vermilion and yellow earth. However, when the sample is viewed under ultra-violet illumination a few very faintly coloured particles of red lake can also be discerned (the presence of aluminium from the substrate has been confirmed by EDX). The red lake has evidently faded and this, combined with an increase of transparency with age of the upper paint layers, must be responsible for the silvery-grey cast so often noted in the flesh tints of paintings by Foppa. This cannot have been intentional: the complexions of female figures in his frescoes in the Portinari Chapel are notably healthy and rosy in colour. Originally, the scumbled flesh tints of the panel paintings must have had a luminous, almost opalescent appearance; and a similar sensitivity to effects of translucency can be seen in the beautifully painted and better preserved soft yellow fabric with veiled white highlights that drapes the Child, and is also worn by the figure behind Balthazar.

Given the care with which the composition was drawn out on the panel, the general increase in transparency of the paint layers has made evident a surprising number of pentimenti.[24] Some are no more than minor adjustments made in the course of painting, such as, for example, the alteration to the right hand of the mounted page dressed in blue. Others occur where the painter decided not to follow precisely the underdrawing, as in the repositioning of

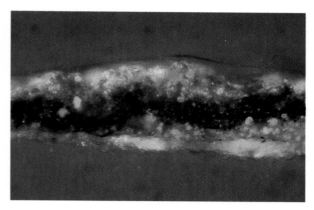

PLATE 4 *The Adoration of the Kings*. Cross-section of a sample from the Virgin's blue mantle, showing the gesso, *imprimitura* and the underpainting with azurite and lead white. The surface has clearly been eroded. At the right end of the sample there are the remains of a layer of ultramarine and lead white. Some retouching and slightly discoloured varnish are also visible at the surface. Original magnification 450×, actual magnification 390×.

PLATE 5 *The Adoration of the Kings*. Cross-section of a sample from the tunic of the mounted page behind the middle king, showing the gesso, a few particles of carbon from the underdrawing, the *imprimitura*, the black underpainting and the final layer of ultramarine and lead white. Some of the particles of ultramarine at the upper surface have lost their colour. Original magnification 450×, actual magnification 390×.

the left leg of the page strapping on Balthazar's spur (FIG. 2). A pentimento made in the course of painting can also be seen in the adjustment to this page's right hand; and his right knee, presumably originally conceived as being behind the king's leg, has had to be painted over the sand-coloured paint of the foreground already brushed boldly around the more definitely established forms. All these changes show the artist grappling with the complex pose of this bending figure around the necessarily fixed position of Balthazar's legs.[25]

A more significant alteration, in terms of the narrative of the picture, is that made to the head of the Christ Child (FIG. 1), originally drawn tilted back but later painted in a more upright pose in order for the Child to engage with the king who kneels at his feet. In addition, some adjustments seem to have been made to his lower legs and feet. The Virgin's left hand appears to have been painted, without any reserve, on top of the baby's legs, which may also constitute a pentimento, although no alternative in the underdrawn position can be detected.[26] Her head was first drawn further to the right and some underpaint may have been applied to the mantle in this position before the decision was made to shift the head slightly to the left (however, damage to this area makes the exact sequence difficult to determine). Later, a further adjustment was made to reduce her head in size by painting more of the background colour over the blue at the back of her mantle.

The most radical revision in the altarpiece is the artist's repositioning of the ox and ass. Infra-red

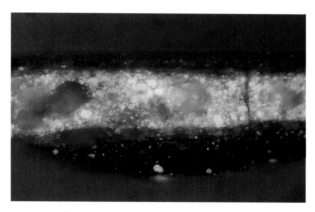

PLATE 6 *The Adoration of the Kings*. Cross-section of a sample from the bush behind the horse on the right, showing the black underpainting, with the inclusion of a few particles of verdigris, followed by a layer of almost pure verdigris and finally a layer of verdigris and lead-tin yellow. The gesso and *imprimitura* are not present. Original magnification 320×, actual magnification 275×.

photography shows that originally both animals were considerably higher up, with the back of the ox drawn approximately level with the bottom of the window. Immediately below the ox's prominent withers can be discerned traces of the sketching-in of the animal's left horn and ear, and to the right of this, the neck and mane of the ass. Further down, the original position of its muzzle can also be seen. When Foppa came to paint the animals, he moved them down to their present position, but even then he made another late adjustment, now visible on the surface of the painting, reducing the height of the

PLATE 7 *The Adoration of the Kings*, detail.

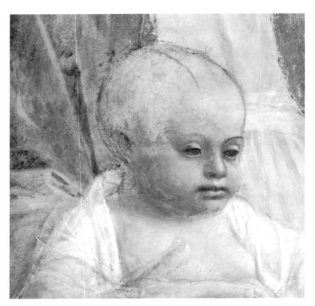

FIG. 6 *The Adoration of the Kings*, infra-red photograph detail.

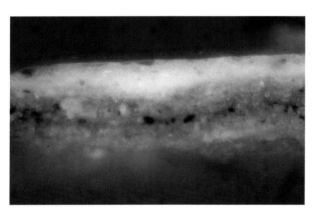

PLATE 8 *The Adoration of the Kings*. Cross-section of a sample from the knee of the Child. The lowest layer is the undermodelling containing lead white, carbon black, red earth, Cassel earth and green earth. This is followed by a thin pale pink layer, and then a more substantial layer of the same undermodelling mixture. The final layer consists of lead white with a few particles of vermilion, yellow earth and red lake (now faded). Original magnification 450×, actual magnification 390×.

ox's back. The animals' poses echo exactly those in a smaller panel showing the Nativity (PLATE 9) now in the Chiesanuova, Brescia (but probably the central panel of the former high altarpiece of the church of SS. Nazaro e Celso, where it was replaced by Titian's celebrated polyptych), except with the ox and the ass reversed to take account of the different positioning of the Child.

While scholars have noted the influence of Northern painting in the Chiesanuova *Nativity*, and in two panels depicting *Saint John the Baptist* and

Saint Apollonia (Brescia, Pinacoteca Tosio Martinengo) believed to be from the same altarpiece,[27] many features which have their origins in Netherlandish painting are also evident in the National Gallery altarpiece, especially in the landscape. Both the *Nativity* and the *Adoration* have paths winding into the distance, with the recession suggested by the diminishing hill-top buildings and the increasingly faint and feathery trees. In the *Adoration* the three horsemen coming over the brow of the hill on the right are thinly painted over the sky, creating a sense of aerial perspective (albeit exaggerated by the increased transparency of the paint over time). Carefully observed details such as the swallows in the eaves of the ruin, and the reflections of the bushes in the water – even if not consistently applied – and above all the assorted plants in the foreground demonstrate Foppa's experience of painting from the other side of the Alps, at that time much in vogue in the Ligurian cities for which he executed so many important commissions.

In technique as well as style, the *Adoration of the Kings* is a fascinating synthesis of all that was most up-to-date in Italian painting of the last two decades of the fifteenth century with methods associated with much older traditions of tempera painting. Foppa's experiments with Northern naturalism and his accomplished use of the oil medium, as well as his command of perspective in the complex architecture of the ruins, all point to a discerning awareness of recent developments in contemporary painting. However, his continued use of incision for drapery folds, black underpaints for areas of green and blue,

and ornamental gilding in the form of *pastiglia* and *sgraffito*, locate the origins of his style and technique in painting of the earlier part of the century. This substantial commission for an as yet unidentified patron permitted Foppa to combine material splendour and painterly skill in equal measure, resulting in one of the most sumptuous of his surviving altarpieces.[28]

Acknowledgements

We are grateful to Ashok Roy and Emily Gore for their work on the preparation, analysis and explanation of the paint samples and cross-sections; to Catherine Higgitt for the examination and analyis of the gesso and paint media; and to Luke Syson for his observations at the initial stage of investigation.

Notes and references

1 J.A. Crowe and G.B. Cavacaselle, *A History of Painting in North Italy*, II, London 1871, pp. 7–8 ; ed. T. Borenius, II, 1912, p. 324.

2 See V. Terraroli, 'Brescia', in V. Terraroli, ed., *La pittura in Lombardia. Il Quattrocento*, Milan 1993, pp. 210–42, p. 240. For a summary of opinions on the picture see M.G. Balzarini, *Vincenzo Foppa*, Milan 1997, p. 179.

3 M. Davies, *National Gallery Catalogues. The Earlier Italian Schools*, London 1959, pp. 196–7. For the entry in the Fesch inventory (Rome, Archivo di Stato) see D. Thiébaut, *Ajaccio, Musée Fesch. Les Primitifs italiens*, Paris 1987, p. 168. The item was one of those asterisked in the Fesch sale catalogue of 1845 (Galerie de feu S.E. Le Cardinal Fesch, Palazzo Falconieri, Rome, 18 March, vol. 4, pp. 193–4, no. 875), indicating works that had been in the Cardinal's possession before his move to France, and therefore not subject to the strict export restrictions imposed by the Papal States. On this, see F. Haskell, *Rediscoveries in Art: Some Aspects of Taste, Fashion and Collecting in England and France*, London 1976, pp. 81–2, note 60.

4 See Balzarini, cited in note 2.

5 For paintings in Brescia in the first half of the fifteenth century see Terraroli, ed., cited in note 2.

6 Umbertino Posculo's 1458 description of Gentile's murals refers only to a Saint George and the Dragon, but a later description of the chapel, apparently by then reworked by Calisto da Lodi, also records a Life and Passion of Christ. See K. Christiansen, *Gentile da Fabriano*, London 1982, pp. 134–5.

7 Ffoulkes and Maiocchi, in the first monograph to be written on Foppa, recognised the importance of Jacopo Bellini for Foppa, even suggesting that Foppa received his early training with him. See C.J. Foulkes and Monsignor R. Maiocchi, *Vincenzo Foppa of Brescia, Founder of the*

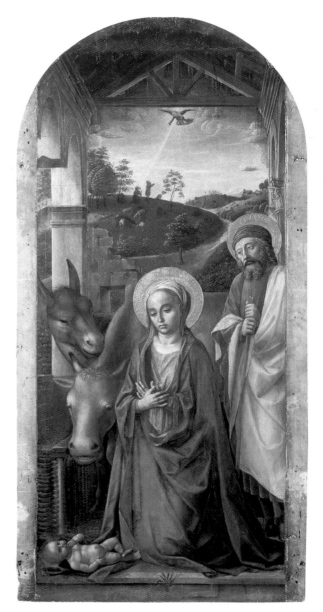

PLATE 9 Vincenzo Foppa, *The Nativity*, possibly late 1480s. Oil and tempera (?) on panel, 175 × 84 cm. Brescia, Chiesanuova, Parrocchiale di Santa Maria Assunta.

Lombard School, His Life and Work, London 1909, pp. 9–18.

8 A sample of gesso was examined by FTIR microscopy. Too little medium was present for precise identification, but it is assumed to be an animal-skin glue.

9 To date very little has been published on Foppa's painting technique, the exception being B.A. Price, T.A. Lignelli and J.H. Carlson, 'Investigating Foppa: Painting Materials and Structure' *Art et Chimie, la couleur*, Actes du congrés, Paris 2000, pp. 209–12. They report that the *imprimitura* of a *Portrait of an Elderly Gentleman* usually dated to about 1495–1500 (Philadelphia, John G. Johnson Collection) contains lead white and carbon black, while that of *The Virgin and Child before a Landscape* in the same collection, probably painted in

about 1490, is pigmented with carbon black and a red earth pigment. The colour and appearance of the *imprimiture* are not described, but they are probably thin, translucent and only slightly coloured in the same way as the *imprimitura* of the National Gallery panel.

10 Only infra-red photographs have been taken, because the large size of the panel makes it inconvenient for infra-red reflectography. The latter might have revealed more drawing under some colours, for example areas of green. However, the black underpainting discovered in a cross-section of green foliage would obscure any such drawing.

11 See M.C. Galassi, 'Sul percorso di Vincenzo Foppa: un avvio all'analisi del disegno sottostante', *Commentari d'arte*, anno II, n. 5, 1996, published 1998, pp. 27–42.

12 Galassi, op.cit., pp. 37–8. The underdrawing on these polyptychs varies considerably from area to area, and Galassi suggests that the simple quality of the line might be evidence for the use of tracings to transfer parts of the design. This is unlikely to be the case with the National Gallery altarpiece, where the lines are too free, fluid and continuous, with none of the hesitancy of an artist seeking to reinforce the usually faint and sometimes discontinuous marks that result from transfer by tracing.

13 For discussion of pouncing using a liquid drawing material see C.C. Bambach, *Drawing and Painting in the Italian Renaissance Workshop. Theory and Practice, 1300–1600*, Cambridge 1999, p. 77.

14 See Balzarini, cited in note 2, p. 87, plate 38, for a good illustration of a head transferred by pouncing, and L. Mattioli Rossi, ed., *Vincenzo Foppa. La Cappella Portinari*, Milan 1999, pp. 264–71, for diagrams showing the presence of *spolvero*, especially for many of the heads.

15 The use of incision as well as other forms of underdrawing is also a feature of the Fornari polyptych of 1489 (personal communication from Franca Carboni who recently restored the altarpiece).

16 The same technique was used for the jewels of the crown of the Virgin in the most lavishly decorated of Foppa's surviving polyptychs, that for Santa Maria delle Grazie in Bergamo (now Milan, Pinacoteca di Brera), dated to about 1485–90.

17 The analysis was by GC–MS. A trace of pine resin was also found but this is thought to represent contamination by later varnish layers. Franca Carboni (see note 15) believes the Fornari polyptch to be painted principally in oil. In the case of the two small panels in Philadelphia (see Price, Lignelli and Carlson, cited in note 9) examination by FTIR, supplemented by GC–MS in the case of a few samples, indicated that they were painted mainly in egg (*The Virgin and Child*), or egg and oil mixtures (*tempera grassa*) (the portrait), and completed with oil glazes.

18 Crowe and Cavalcaselle, cited in note 1, p. 324, n. 1, described Balthazar's costume as a 'grey dress'.

19 National Gallery Conservation Record. The painting was cleaned and restored by Helmut Ruhemann. The report, made by the curator, Martin Davies, recorded that it was 'a striking example of unnecessary repainting. Former restorers had not confined themselves to mending, but had gone over the whole, softening the direct quattrocento qualities, emphasizing certain places with

new gold etc., and dimming the tone of the whole with a heavy coloured varnish'. The new gold included haloes for the Holy Family, gold highlights for the cloth-of-gold of the kneeling king, actually executed entirely in paint, and lavish gold borders for the mantle of the Virgin, which had first been entirely repainted in a dark blue. Although Raffaelle Pinti was more often employed by the National Gallery to make adjustments to previous restorations and to tone varnishes, the sum he was paid for his work on the Foppa (£95 11s. 0d.) suggests that he may have been responsible for much of this repainting and that it was therefore carried out under the direction of Sir Charles Eastlake and the Keeper, Ralph Wornum.

20 The basic copper sulphate, brocantite, was detected on the trees and the lining of the Virgin's mantle of the Philadelphia *Virgin and Child* (see Price, Lignelli and Carlson, cited in note 9, p. 211), but EDX analysis of a sample from the foliage of the National Gallery altarpiece found only the more usual verdigris.

21 This damage is largely responsible for the sense of a Leonardesque 'chiaroscuro fumoso', generally used to argue for a very late date for the altarpiece. See Balzarini, cited in note 2, p. 179.

22 These are probably similar to the mixtures of lead white, black, red and yellow earths found in the *Portrait of an Elderly Gentleman* in Philadelphia, also painted with a relatively simple direct technique. See Price, Lignelli and Carlson, cited in note 9, p. 209.

23 A green underlayer is present in the flesh painting of the Philadelphia *Virgin and Child* (see Price, Lignelli and Carlson, cited in note 9, p. 209).

24 Price, Lignelli and Carlson, cited in note 9, p. 210, mention extensive underdrawing and several pentimenti on both Philadelphia panels.

25 In the *Adoration of the Kings* at the centre of the predella of the Della Rovere polyptych, the kneeling page is placed to the right of the king. Therefore the pose is a less complex one.

26 The reading of X-radiographs made of this area of the picture is considerably disrupted by the presence of the cradle on the reverse.

27 See L. Castelfranco Vegas, *Italia e Fiandra nella pittura del Quattrocento*, 1983, p. 272, Milan.

28 The Fesch sale catalogue entry, cited in note 3, is particularly eloquent on the sumptuous quality of the work: 'La beauté de leurs [the kings'] costumes ne saurait se décrire: leurs robes éntincèlent d'or et de pierreries, et leurs riches couronnes sont encore rehaussées par l'éclat des diamants. Les gens de leur suite, dont quelques-une descendent la montagne, sont vêtus avec une magnificence digne des maîtres qu'ils servent. La somptuosité des costumes et des détails, le faste de la composition, font de ce tableau un morceau très remarquable.'

Two Panels by Ercole de' Roberti and the Identification of *'veluto morello'*

LORNE CAMPBELL, JILL DUNKERTON, JO KIRBY AND LISA MONNAS

THE TWO SMALL PANELS of *The Adoration of the Shepherds* (NG 1411.1) and *The Dead Christ* (NG 1411.2) are attributed by most authorities to Ercole de' Roberti, who was from 1486 until his death in 1496 in the service of Ercole I d'Este, Duke of Ferrara, and his wife the Neapolitan princess Eleonora of Aragon (PLATE 1).[1] Both panels are 9 mm thick; the painted surfaces are intact but the unpainted edges have been slightly trimmed. They were once concealed under applied frames. The reverses are covered in purple velvet. In or after 1809 and perhaps before 1836, an attempt was made to brand the reverses with the letters CGBC: the initials of the owner, Conte Giovanni Battista Costabili.[2] When the brand did not burn through the velvet, areas of the textiles were ripped away to expose surfaces of wood large enough to be branded effectively (PLATE 2).

The two panels were first recorded at Ferrara in the collection of Francesco Containi (1717–78).[3] Martin Davies, in 1961, noticed a possible connection between them and two folding *anconette* described in 'an Este inventory of 1493'.[4] In 1992, Joseph Manca quoted the two entries and pointed out that the inventory was a list of the possessions of Eleonora of Aragon, Duchess of Ferrara, who had died in October 1493. He proposed that the two panels might have been one of Eleonora's diptychs.[5] The inventory has since been republished. The two consecutive entries are:

> *Una anchoneta che se assera, cum uno presepio da un lato et uno Christo nel sepolchro da l'altro lato;*
>
> *Una anchoneta che se asserra a modo de libro coperto de veluto morello, cum broche et azulli de argento dorati; da un lato il presepio et da l'altro un Christo nel sepolchro.*[6]

Eleonora may have owned two similar diptychs; or the compiler of the inventory may have made a mistake and included two differing descriptions of the same object. The second entry may be translated: 'a little "altarpiece" which closes like a book covered in *morello* velvet, with silver-gilt bosses and clasps; on one side the Nativity and on the other a Christ in the tomb.'[7]

Since the reverses of the National Gallery panels are covered in purple velvet, the diptych could be likened to 'a book covered in *morello* velvet'.[8] In order to substantiate the theory that the two panels could indeed be Eleonora's diptych, the velvets and the backs of the panels have been studied: first to establish whether the velvets are of the appropriate manufacture for a fifteenth-century date; and secondly to discover whether there are any traces of the metal fittings described in the inventory.

The weave of the velvet

The fabric glued to the back of the panels is a solid cut-pile silk velvet on a five-shaft satin ground, with a striped effect formed by a variation in colour in the pile warps (PLATE 3). A velvet is a pile fabric whose tufts are held in place by a supporting structure known as the *ground weave*. The ground weave is formed by one set of warps (*main warps*) which tie a set of wefts (*ground wefts*). A supplementary warp, the *pile warp*, forms the velvet tufts. These tufts are formed by the insertion of fine grooved metal rods beneath the pile warps on the face of the cloth during weaving (FIG. 1). The warp forms a loop over the rod, which is secured between two wefts passed in the same shed. To create a cut pile, a blade is passed across the groove in the rod, which is then withdrawn leaving a row of pile tufts across the width of the cloth. The ground weave of a velvet can be formed of *tabby* (a simple one-over/one-under interlace) or *twill*, in which the warp passes over more than one weft at a time, or *satin*, a broken twill, with staggered binding points,[9] in which the warp passes over four or more wefts at a time.

The velvet covers of two Books of Hours (PLATES 4 and 5), dating from about 1450 and about 1533, have also been studied to compare with the velvet on the National Gallery panels. The first is an illuminated manuscript on vellum in Latin and French, use

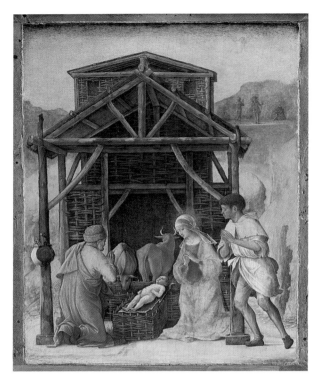

PLATE 1 Ercole de' Roberti, *The Adoration of the Shepherds* (NG 1411.1), left, and *The Dead Christ* (NG 1411.2), right, *c*.1490. Panel, 18.9 × 14.5 cm, painted surface 17.8 × 13.6 cm (left); and 18.8 × 14.7 cm, painted surface 17.8 × 13.7 cm (right).

PLATE 2 The diptych as seen from the back: left, *The Dead Christ* (NG 1411.2), reverse; right *The Adoration of the Shepherds* (NG 1411.1), reverse.

PLATE 3 Detail of velvet on the reverse of *The Dead Christ* (NG 1411.2), showing striated effect.

PLATE 4 Book of Hours in Latin and French, use of Troyes, mid-15th century. Christie's sale, London, 11 July 2000, Lot 41, from the library of William Foyle. Detail of velvet cover, showing striated effect; a nail hole, perhaps from a clasp now missing, can be seen. The leather edging is not original.

of Troyes, the second is a printed volume in Latin and English, use of Sarum;[10] both were in the library of William Foyle, recently auctioned at Christie's, London.[11] Both volumes have covers of purple velvet with a striped effect in the warp. These two velvets and that of the National Gallery panels are strikingly similar in appearance, but although all three are solid cut-pile velvets they differ in the details of their structure. Unlike the satin ground of the velvet adhering to the National Gallery's panels, the velvets covering the two Books of Hours each have a ground based on two different variations of a 3/1 twill. (Compare FIGS. 1–4, showing the weave of the velvet on the Ercole panels and on the Book of Hours, use of Troyes; see Appendix for textile analyses. It was, unfortunately, not possible to produce an accurate weave diagram of the velvet cover of the second Book of Hours.)

The ground of the velvet on the National Gallery panels is a *five-shaft satin*: each ground warp passes over four and under one ground wefts (FIGS. 1 and 2).[12] This weave is typical of the fifteenth century, although it can be found in later velvets. The main warps of the velvet have an S-twist (FIG. 3). This is characteristic of Italian figured velvets after the first quarter of the fifteenth century, and may, by extension, be a clue to the dating of plain velvets. Both the weave structure and thread twist of the velvet adhering to the two panels are consistent with a date after

PLATE 5 Book of Hours in Latin and English, use of Sarum, *c.* 1533. Christie's sale, London, 12–13 July 2000, Lot 367, from the library of William Foyle, showing decorated velvet binding.

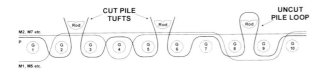

FIG. 1 Velvet on the reverse of the panels: cross-section of the velvet weave in the warp direction, rods in place, showing two tufts of velvet that have been cut and one pile loop before it has been cut.

FIG. 3 Threads twisted in 'S' and 'Z' directions.

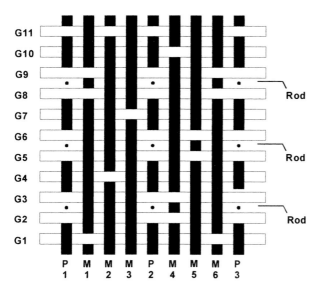

FIG. 2 Velvet on the reverse of the panels: diagram to show the weave, right side up, position of the rods to create the velvet pile indicated. M: main warp; P: pile warp; G: ground weft; Rod: grooved rod for creating velvet tuft.

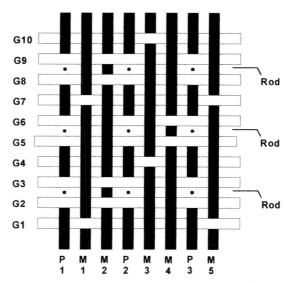

FIG. 4 Book of Hours in Latin and French, use of Troyes, mid-15th century. Christie's sale, London, 11 July 2000, Lot 41, from the library of William Foyle: weave of the velvet cover. M: main warp; P: pile warp; G: ground weft; Rod: grooved rod for creating velvet tuft.

the second quarter of the fifteenth century, meaning that they could have formed the original backing for these panels.

The dyeing of the velvet

The striated appearance of the velvet is given by very narrow, darker, bluish-purple stripes and slightly broader reddish-purple stripes, closely and slightly irregularly spaced (see PLATE 3). Microscopic examination of a pile warp ('tuft') from a darker stripe shows that most of the threads are purple or bluish-purple in colour, with a few pale orange strands (PLATE 6); the pile warps in the redder stripes consist largely of bluish-crimson or pink threads (PLATE 7). If the red colorant is extracted from each of the two differently coloured pile warps, most of the residual silk fibres from the darker purple pile can be seen to have been dyed blue with a dyestuff almost insoluble in the reagent used, 4% boron trifluoride/methanol;

this dyestuff is discussed below.[13] In the case of the redder purple the residual threads are largely colourless. Analysis of both extracts by high performance liquid chromatography (HPLC: see Appendix) reveals that, in each case, the principal constituent of the red dyestuff is carminic acid; a minor, but still substantial, amount of kermesic acid is also present. Traces of alizarin were also identified, suggesting the presence of a very tiny proportion of madder dyestuff (from *Rubia tinctorum* L.), probably used to dye the orange fibres.

The pattern and relative proportions of carminic and kermesic acids present appear to be consistent with those found in the dyestuff produced by Polish cochineal, *Porphyrophora polonica* L., an Old World cochineal insect.[14] Other scale insects known to contain carminic acid as the principal constituent of their colouring matter, such as the Mexican cochineal insect (*Dactylopius coccus* Costa) and another Old World species, Armenian or Ararat

PLATE 6 Detail of a deeper purple pile warp taken from the velvet on the reverse of *The Dead Christ*, showing purple threads, dispersed in odourless kerosene. Photomicrograph, photographed at a magnification of 137.5×, actual magnification 85×.

PLATE 7 Detail of a reddish-purple pile warp taken from the velvet on the reverse of *The Dead Christ*, showing pale bluish-crimson threads, dispersed in odourless kerosene. Photomicrograph, photographed at a magnification of 137.5×, actual magnification 85×.

cochineal (*Porphyrophora hameli* Brandt), contain hardly any kermesic acid. However, a similar pattern of constituents would be given if the velvet had been dyed with a mixture consisting of one or other of these latter insects and some kermes (*Kermes vermilio* Planchon); kermesic acid is the principal constituent of the kermes dyestuff. If Mexican cochineal had been used, the textile could not predate 1493, the date of the inventory, as this dyestuff was not available in Europe until the following century. To confirm the identification of Polish cochineal as the source of the colorant a quantitative examination was necessary to estimate the relative amounts of carminic and kermesic acids present and to establish the presence or absence of certain minor components of the dyestuffs.[15] Quantitative HPLC examination of a sample of the pile, carried out at the Koninklijk Instituut voor het Kunstpatrimonium (Institut Royal du Patrimoine Artistique), Brussels, where the results could be compared with those obtained from textiles, confirmed not only that the source of the dye was indeed the Polish cochineal insect, but also that the scale insect dyestuff was the principal colouring matter present.[16]

Ellagic acid was also identified in both dark and light purple areas, suggesting that the silk threads were treated with some tanning agent during the dyeing process. Ellagic acid-containing tannins are found in many species of shrubs and trees and it is impossible to characterise the source further. Presumably the aim of the treatment was to improve the take-up of the dye, or to modify the colour: for example, the fifteenth-century Florentine *Trattato dell'Arte della Seta* includes recipes for dyeing silk using *grana* – kermes – in which the silk was treated with galls (a source of tannins) during the procedure. This was not done when dyeing the same colours with *chermisi* (an Old World cochineal).[17] The dyestuff from this insect source must have given a deep enough colour on its own.

The blue dye present on the deeper purple threads was identified as indigo by HPLC analysis, mass spectrometric analysis and by microspectrophotometric examination of a blue-dyed thread after extraction of the red dye.[18] The source of indigo could have been woad, *Isatis tinctoria* L., or, indeed, imported indigo itself – it is not possible to determine the actual origin, as the end product, the colouring matter, is the same whatever the plant source. It is worth noting that madder could be used as a fermenting agent in indigo vats and, although the madder dye detected probably derived largely from the orange thread, it is conceivable that the plant could also have been so used here.[19] The silk thread used for the darker purple pile warps was thus dyed in two stages: first, in an indigo vat, then the blue thread obtained was mordant-dyed with Polish cochineal dyestuff to give a bluish purple.

Varieties of insects known under names signifying 'crimson' – *chermisi*, *cremexin* and other spellings – were imported into Italy from the fourteenth century onwards. Initially all would have been Old World insects; the New World cochineal insect was imported by way of Spain early in the 1540s.[20] Some varieties of the Old World insect were imported directly by, for example, Venetian merchants trading in Constantinople and other eastern markets. Polish cochineal also reached Venice and other Italian cities, including Genoa and Florence, by way of German (and Polish) exporters.[21]

Polish cochineal was employed over a long period, even after the Mexican species became available.[22] The presence of its dyestuff on the velvet on Ercole de' Roberti's two little panels cannot therefore confirm a fifteenth-century dating; however, it is entirely appropriate for that date. The use of Polish cochineal dyestuff alone for the redder purple stripes is comparable with recipes in both the *Trattato dell'Arte della Seta* and a later Venetian manual of dyeing, the *Plictho*, written by Gioanventura Rosetti in 1548: according to the instructions given for dyeing *pagonazzo*, in the first case, and *morello*, in the second, only scale insect dyes were required.[23] Obtaining a purple colour by using a scale insect dye over silk previously dyed blue with indigo is not described in either source, nor is it mentioned in an earlier, fifteenth-century, Venetian dyeing manual. However, in a series of recipes for dyeing with *cremexin*, this treatise mentions the addition of a little indigo in the last red dye-bath, to '*pavonizar el lavor*'.[24] Venetian regulations approved in 1454 ruled that, to make purple shades, the crimson dyestuff from Old World cochineals could only be combined with indigo, so this combination may have been fairly common.[25]

Morello, *paonazzo* and the sources of 'crimson'

In the Este inventory of 1493, the velvet on the back of Eleonora's '*anchoneta*' is described as '*morello*'. During the fifteenth century, the word 'purple' (*purpura* in Latin, *porpore* in Italian) was not generally used to denote colour in a fabric, perhaps because it was still associated with a type of cloth rather than its colour.[26] Instead, terms such as '*morello*' or '*violeto*' or '*paonazzo*' (also spelt *paghonazzo*, *pavonazzo*, and other variants) were used to denote various shades of purple. '*Morello*' – derived from the Latin *morum*, mulberry, and meaning, literally, 'mulberry-coloured' – is defined in written sources of the fourteenth and fifteenth centuries as 'violet'.

The term *morello* was not new in the fifteenth century, and it was applied equally to wool or silk. In England, *morello* was translated as '*murrey*' and in France, '*moré*' (variously spelt). In an order for two pieces of the woollen cloth known as 'scarlet' for the Duchess of Burgundy, in 1335, one is described as '*vermoille*' (vermilion) and the other as '*paonace qui se traie aussi comme sur morey, c'est a dire qu'elle ait colour [sic] de droite violete*'.[27] *Morello* and *paonazzo* were thus clearly similar shades. This is confirmed by descriptions of the colours in written sources such as Tomaso Garzoni's *La piazza universale di tutte le professioni del mondo* (Venice 1585): in his discourse on painters, *morello* is described as mulberry-coloured and *pavonazzo* as a dark *morello*.[28]

In 1457 the Venetians had introduced striping in their selvedges to indicate the dyestuffs used for particular colours of silks; a similar practice was introduced in Genoa in 1466, following statutes of 1432 establishing the colours of the selvedges for cloths dyed with particular dyestuffs. In the 1466 Genoese regulations, the colour of the *morello* silks is described as '*morello sive violeto*'. These regulations distinguish between the use of two red insect dyes: *chremisi* and *grana*. Fabrics made from silk dyed *morello* with *chremisi* were to have yellow selvedges; those from silk dyed *morello* with *grana* were to have selvedges with a green stripe.[29] It is not easy to identify fifteenth- or sixteenth-century colouring matters – all called *grana* or *chremisi* (or some variant), and further characterised according to the region from which they came – with any species of scale insect known today. This is partly because species like Polish cochineal, and possibly other, now little-known, insects, that produced substantial harvests then are very scarce now. The scanty description of two types of *chermisi* – *minuto* and *grosso* – given in the *Trattato dell'Arte della Seta* suggests that the *minuto* variety may be identified with Polish cochineal. This is reinforced by a recipe in the *Plictho* for dyeing silk a 'perfect crimson colour', '*in color chremesino perfetto*', which required the use of 'crimson minute and German', '*chremesino menuto e todescho*', the name by which the scale insects imported from the regions around Eastern Germany and Poland were known in Italy.[30]

One might expect contemporary authors with an antiquarian, biological or medical interest in sources of dye to be able to clarify matters; in practice their descriptions are ambiguous. In his commentary on the works of Dioscorides, published in 1548, Pietro Andrea Mattioli mentioned *cremesino* in the context of 'grains' found on the roots of '*pimpinella*' (pimpernel). Polish cochineal usually occurs on the roots of the perennial knawel, *Scleranthis perennis* L., but several species have been recorded as hosts to the insect in different areas of its habitat, which at this time extended from north-eastern Germany through Silesia, Poland and neighbouring countries to Bavaria.[31] Possibly Mattioli had no first-hand knowledge of the insects for, in a later edition, he mentioned the variety of '*grana*' [sic] collected in Poland, but did not link it to any insect found on plant roots. However, even in 1548 he drew attention to the new, and widely used, variety of *cremesino* imported into

Italy by way of Spain: in other words, Mexican cochineal. This insect, like the Old World varieties, contains carminic acid, a dyestuff that gives a bluer crimson than the kermesic acid present in kermes. The fact that the colour from all types of *cremesino* tended towards purple was also noted at that time.[32]

The original appearance of the velvet covering and the structure of the diptych

The velvet on the reverse of the two panels was not a cheap fabric: the high pile warp count and the purple colouring, incorporating a costly insect dyestuff, are both indicative of expense. Moreover, there is evidence that the reverses were once richly ornamented. Where the velvet is still present circular patches of disturbed pile can be seen towards the corners and at the centre of each half of the diptych (see PLATE 2). (The roughened pile at the centre of the upper edge of each panel is the result of later fittings used to fix the panels in their modern frames.) In each of the circles there are three small holes, slightly smaller and less rounded in cross-section than the woodworm exit holes scattered randomly across the panels. The same distribution of holes, always in the formation of similarly sized isosceles triangles, can be seen at the corners of the panels in the areas of wood exposed by the removal of the velvet. Three of the holes contain shafts of pins (PLATE 8), made of a white metal and apparently rather soft, for occasionally only two instead of the expected three holes are present, suggesting that sometimes the pins may have become bent and failed to penetrate both velvet and panel. These pins must have been used to attach the bosses, or *broche*, of silver-gilt. At the centres of the outer edges of the two panels, that is, the left edge of *The Dead Christ* and the right edge of *The Adoration of the Shepherds* when they are viewed from behind in their correct relationship, a nail hole and the remains of a pin indicate that two more fixtures were applied. The other nails, probably also arranged in an isosceles triangle, are likely to have been in the wood now lost through the trimming of the edge. These nails would have held the clasps, or *azulli*, which closed the diptych.

The closed diptych would have looked very like a book, bound in purple velvet, something like that illustrated in PLATE 5. There are no traces of marks on the 'hinge' side of either panel. Although it is possible that the panels were trimmed slightly more along this edge than on what would have been the 'clasp' side, the continuation of the rocks of Saint Jerome's cave into the Nativity landscape, and the

FIG. 5 Reverse of *The Dead Christ*, showing positions of nail holes from the fixtures originally present. Solid circles indicate that the remains of the nails are still present.

PLATE 8 Detail of the reverse of *The Dead Christ* showing metal pin originally attaching the boss in the lower right corner.

extension of the more distant bluish mountain in the latter into the former, work only when the images are separated by no more than about two cm. Therefore it seems unlikely that the width of wood removed was sufficient to allow the presence of hinges attached to it and no hinges are mentioned in the inventory. Instead the panels may have been joined by their velvet binding. On both panels it can be seen that the velvet has been glued with the warp threads, evinced by the stripes, at the same slight angle to the

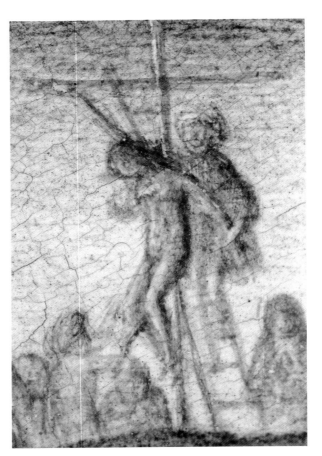

PLATE 9 Detail of the right-hand edge of *The Adoration of the Shepherds* showing *barbe* and line of blue paint defining inner edge of frame. Photomacrograph.

PLATE 10 Detail from the top left of *The Dead Christ*, showing the Descent from the Cross. Photomacrograph.

longer sides. This would suggest that a single piece of velvet was laid across both the reverses and that the cloth in the space between the two panels served to hinge them together, just as the spine of a book joins its covers. The central strip of velvet along the spine could have been reinforced, with a heavier fabric, leather or card.

To prevent the painted surfaces from rubbing against one another when the diptych was closed some form of frame must have been applied. A splinter of wood found along one edge confirms that the mouldings, evidently relatively narrow and probably shallow in profile, were of wood. Examination of the edges and *barbes* of the painted surfaces shows that mouldings were in place when the grounds were applied, but that the frames were gilded after the pictures had been completed. Blue lines (under magnification the pigment has the appearance of azurite) were painted, in two layers, to define the inside edges of the frames (PLATE 9). Since it is highly unlikely that the expensive velvet binding was applied before the panels were painted, it seems possible that the mouldings present when the panels were prepared

with gesso (and these may always have been temporary) were subsequently removed so that the edges of the velvet could be glued round the sides and onto the front edges of the panels, exactly as in a book binding. The mouldings could then be re-attached, covering the raw edges of the fabric. The blue lines might also have helped to disguise the cracks in the gesso likely to have been caused by this operation.

The paintings are attributed to Ercole, Eleonora's court painter. Because their history is incomplete, absolute proof is lacking but it seems established beyond reasonable doubt that the two National Gallery panels are indeed Eleonora of Aragon's *anchoneta* 'which closes like a book covered in *morello* velvet'. An inventory of Eleonora's library was also made in 1493, soon after her death in October of that year.[33] It shows that she took great delight in beautiful and costly bindings. Many of her books were bound in black, crimson, blue or green velvet; several were in purple silk; a great number had bosses and clasps of silver or silver gilt. Her large breviary, bound in purple silk, had a cover of purple cloth of gold lined with crimson silk and clasps of

enamelled gold;[34] the little breviary 'which she used every day' was covered in blue silk and had two silver clasps and a cover of purple velvet lined with blue damask and tied with a little golden cord.[35] Eleonora's *anchoneta* would have looked very like her books.

The elaborate covering complemented perfectly Ercole's two paintings, painted with a desaturated palette and minuteness of technique that emulate manuscript illuminations (PLATES 10 and 11). Many details were delicately touched with shell gold. This is now difficult to see, but traces of gilding survive on the haloes, the glories of light around the Child and the angel who makes his announcement to the shepherds, the rays which stigmatise Saint Francis, and even on the Virgin's mantle. This is now inappropriately drab, most probably as a result of the fading of a once deep red lake pigment applied in the thinnest and most translucent of layers.[36] Although the original richness of both painting and binding has been lost, it is still possible to imagine how the diptych would have looked: closed, it was like a book, and open, it could have been used in much the same way as a devotional manuscript. It must have been an exquisite object to delight the refined tastes of the pious duchess.

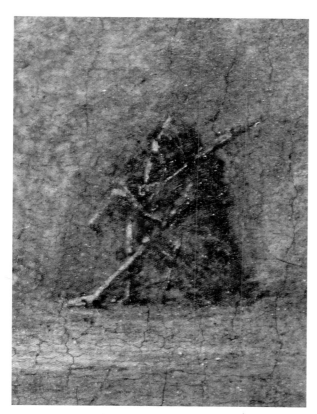

PLATE 11 Detail of a shepherd in the background of *The Adoration of the Shepherds*. Photomacrograph.

Appendix

Weave analysis of the textiles

1. Ercole de' Roberti, *The Adoration of the Shepherds* and *The Dead Christ*

Panels measuring 18.9 × 14.5 cm and 18.8 × 14.7 cm respectively, thickness 9 mm. Glued to the reverse surfaces of the panels are two pieces of solid cut-pile purple silk velvet with a striped effect in the warp direction.

STATE: faded, discoloured, balding in places. In the bald parts, many of the main warps are torn.

WEAVE: solid cut-pile velvet, on a ground of regular five-shaft satin (counting the two wefts which secure the pile tuft in one shed as one), interruption 2.

MATERIALS:

Warps:	Main warps: silk, ivory, slim threads, light S-twist
Pile warps:	i) silk, purple, without visible twist
	ii) silk, more reddish purple, without visible twist
Wefts:	silk, cream, without visible twist, slightly thicker thread than the main warps

PROPORTIONS:
3 main warp threads to each pile warp thread
3 main weft threads to each rod

THREAD COUNT:
Main warps per cm 84–90
Pile warps per cm 28–30
Ground wefts per cm 45
Rods per cm 15

2. Book of Hours in Latin and French, use of Troyes, mid-fifteenth century (Christie's sale, 11 July 2000, the Library of William Foyle, Lot 41)

Text illuminated on vellum; cover of contemporary silk velvet, over pasteboard, rebacked and edged with brown leather in the nineteenth century.

The velvet has a solid cut silk pile on a ground of extended 3/1 twill. The colour is a striated purple with pinkish tones.

STATE: worn, balding in places and faded.
WEAVE: solid cut-pile velvet, on a ground of extended 3/1 Z-twill (counting the two wefts securing the pile tuft (the 'vice shed') as one).

MATERIALS:

Warps:	Main warps: S-twist, slender threads, pale and darker fibres combined to give a greyish appearance.

Pile warps:	Silk, without visible twist, purple. (It is likely that the pile warp threads were composed of slightly different coloured silk yarns to create the striated effect, but it was not possible to make a sufficient analysis to determine this.)
Wefts:	Silk, without visible twist, pale and dark fibres, bluish tinge

PROPORTIONS:
2 main warps to each pile warp
3 ground wefts to each rod

THREAD COUNT:
Main warps per cm 54/56
Pile warps per cm 27/28
Ground wefts per cm 45
Rods per cm 15

Analysis of the dyestuff

Analysis was carried out using Hewlett-Packard (now Agilent) HP1100 series binary pumps and vacuum degasser, modified for use with a capillary microbore column by the incorporation of an LC Packings Acurate™ microflow processor between the pumps and the injector; this mixes the eluents and splits off a calibrated proportion of the solvent stream, appropriate to the internal diameter of the column. The Cheminert™ injector was fitted with a 5 μL sample loop. A 25 cm 800 μm i.d. Zorbax ODS (C18) column, with 5 μm packing, was used, necessitating 20 % of the solvent stream to be split off; a flow rate of 100 μL min⁻¹ at the pump is thus reduced to 20 μL min⁻¹ at the injector. The eluents used were (A) 99.9% water/ 0.1% trifluoroacetic acid; (B) 99.9% acetonitrile/ 0.1% trifluoroacetic acid. The gradient programme was as follows: initial concentration of B 30%, held for 10 minutes at a flow rate of 20 μL min⁻¹; increased to 45% B in 15 minutes; flow rate reduced to 12 μL min⁻¹ at 45% B in 5 minutes; 45–52% B in 50 minutes; 52–65% B in 182 minutes, increasing the flow rate to 20 μL min⁻¹ at 57–8 minutes; 65–75% B in 10 minutes; held at 75% for 20 minutes; 75–95% in 10 minutes, held at 95% for 18 minutes, 95–30% in 10 minutes; post-run equilibration time 15 minutes. Detection was performed using the HP1100 diode array detector, monitoring signals at 254, 275, 330, 491 and 540 nm. A flow cell of path length 10 mm and volume 0.5 μL was used; the slit width was 4 nm. HP Chemstation software was used to process the data. The column was supplied by Presearch; the HPLC equipment (including the microflow processor), computer and software have been most generously lent to the National Gallery Scientific Department by Hewlett-Packard Ltd.

Note

Lisa Monnas is an independent textile historian.

Acknowledgements

The authors wish to express their thanks to Dr Kay Sutton and Susannah Morris, Christie's, London, for allowing the examination and photography of the Books of Hours; to Dr Jan Wouters, Koninklijk Instituut voor het Kunstpatrimonium (Institut Royal du Patrimoine Artistique), Brussels, for helpful discussions and confirmatory examination of the dyestuff; to Colin Harvey, National Gallery Photographic Department, for photography of the book bindings; to David Saunders, Scientific Department, for redrawing the diagrams of the textiles; to Rachel Billinge, Conservation Department, and Marika Spring, Scientific Department, for macrophotography and photomicrography of details of the velvet on the Ercole de' Roberti panels.

Notes and references

1 M. Davies, *National Gallery Catalogues, The Earlier Italian Schools*, revised edn., London 1961, p. 462 (as 'Ascribed to Ercole de' Roberti'); J. Manca, *The Art of Ercole de' Roberti*, Cambridge 1992, pp. 143–5; catalogue of the exhibition *Ercole de' Roberti, The Renaissance in Ferrara*, The J. Paul Getty Museum, Los Angeles 1999 (also published as a supplement to the *Burlington Magazine*, CXLI, April 1999), pp. xxxvi–xxxvii (No. IX). See also L. Syson, 'Ercole de' Roberti: the making of a court artist' in the same catalogue, pp. v–xiv.

2 Costabili was created a count in 1809 but was made a marchese in 1836: see E. Mattaliano, G. Agostini, L. Majoli, O. Orsi and B. Fiorelli, *La Collezione Costabili*, Ferrara 1998, p. 17.

3 In the inventory taken after his death they were described as 'due quadreti dipinti sopra il legno, con cornice all'antica a vernice d'oro, l'uno rappresentante la natività del Salvatore e l'altro la Resurrecione dal sepolcro' (Mattaliano et al. 1998, cited in note 2, pp. 18, 50). They passed with the rest of Containi's collection to his nephew, Giovanni Battista or Giambattista Costabili (1756–1841), and in a manuscript catalogue of his pictures dated 1835 they were described as '373, Un presepio con bella Architettura. Piccolissimo ed eccellente quadretto in tavola in piedi pure di Lorenzo Costa. Era in Casa', and '372, Nostro Signore morto sostenuto da due Angeli sopra il sepolcro con S. Girolamo in ginocchioni. Piccolissima ed eccellente tavola in piedi del Costa. Era in Casa' (ibid., pp. 50–1). The number 372, deleted, appears on a paper stuck to the reverse of *The Dead Christ*. The corresponding label on the reverse of *The Adoration of the Shepherds* is torn and the area where the number

would have appeared has been lost. In Laderchi's printed catalogue of the Costabili pictures published in 1838, the National Gallery panels were Nos. 59 and 60. On 26 October 1858 Sir Charles Eastlake offered to buy the two panels – by then renumbered 66 and 67 – from Costabili's nephew and heir, the Marchese Giovanni Costabili. On 6 November 1858 the Marchese refused Eastlake's offer (ibid., p. 23); but Eastlake eventually, possibly by 1860 and certainly before his death in 1865, succeeded in acquiring them. They were bought for the National Gallery at Lady Eastlake's sale at Christie's on 2 June 1894 (Lot 71).

4 Davies 1961, cited in note 1, p. 462. He referred to the 'Estratto dell'inventario di guardaroba estense' (1493) published by G. Campori, *Raccolta di cataloghi ed inventari inediti ...*, Modena 1870, pp. 1–3, the relevant entries being on p. 2.

5 Manca 1992, cited in note 1, p. 144.

6 A. Franceschini, *Artisti a Ferrara in età umanistica e rinascimentale, Testimonianze archivistiche*, II, ii, *Dal 1493 al 1516*, Ferrara 1997, p. 37.

7 'Broche' and 'azulli' were terms used in book-binding. Broche were *borchie* or bosses; *azulli* was an Emilian word for clasps (G. Bertoni, *La Biblioteca Estense e la coltura ferrarese ai tempi del duca Ercole I (1471–1505)*, Turin 1903, pp. 270–1; G. Fumagalli, *L'arte della legatura alla corte degli Estensi, a Ferrara e a Modena, dal sec. XV al XIX. Col catalogo delle legature pregevoli della Biblioteca Estense di Modena*, Florence 1913, p. xi).

8 The possible significance of the velvet went unnoticed until it was pointed out to the authors of the Getty exhibition catalogue cited in note 1. There the textiles are mistakenly described as 'faded remains of the red velvet' (p. xiii) and as 'traces of red velvet' (p. xxxvi).

9 A binding point is the point of intersection between a warp and a weft.

10 J. Plummer, '"Use" and "Beyond Use"', in R.S. Wieck, *The Book of Hours in Medieval Art and Life*, London 1988, pp. 149–52.

11 *The Library of William Foyle, Part I: Medieval and Renaissance manuscripts*, catalogue of sale held at Christie's, London, 11 July 2000, Lot 41, pp. 122–5; and *Part III: English Literature and Travel Books*, Christie's, London, 12–13 July 2000, Lot 367, pp. 70–2. We are indebted to Kay Sutton and Susannah Morris for kindly allowing us to study and photograph these covers.

12 In a velvet, the two wefts passed through the same shed to secure the tuft are counted as one.

13 This reagent breaks up the polymerised paint film by transmethylation, also dissolving out the dyestuff from the lake pigment: see J. Kirby and R. White, 'The Identification of Red Lake Pigment Dyestuffs and a Discussion of their Use', *National Gallery Technical Bulletin*, 17, 1996, pp. 56–80, esp. p. 60.

14 D. Cardon, *Les 'vers' du rouge: insectes tinctoriaux (Homoptera: Coccoidea) utilisés dans l'Ancien Monde au Moyen-Age*, Paris 1990 (Cahiers d'Histoire et de Philosophie des Sciences, n.s. no. 28), pp. 55–75. See also D. Cardon and G. du Chatenet, *Guide des teintures naturelles: plantes, lichens, champignons, mollusques et insectes*, Neuchâtel 1990, pp. 370–4; A. Verhecken and J. Wouters, 'The Coccid Insect Dyes: Historical, Geographical and Technical Data', *Bulletin de l'Institut Royal du Patrimoine Artistique*, XXII, 1988/89, pp. 207–39.

15 J. Wouters and A. Verhecken, 'The scale insect dyes (*Homoptera: Coccoidea*). Species recognition by HPLC and diode-array analysis of the dyestuffs', *Annales de la Société Entomologique de France*, (N.S.) 25, 4, 1989, pp. 393–410, esp. pp. 406–7; J. Wouters and A. Verhecken, 'The coccid insect dyes: HPLC and computerized diode-array analysis of dyed yarns', *Studies in Conservation*, 34, 4, 1989, pp. 189–200, esp. pp. 195–8.

16 The National Gallery collection contains no other example of a dyed textile, thus analytical results had to be compared with those obtained from pigments. Extraction of the dyestuff using a methylating agent is not ideal for textile samples: dissolution may be slow to go to completion and a quantitative examination of the dyestuff components is rendered more difficult due to the possible presence of methylated derivatives as well as the original, unmethylated, forms. The method generally used for extraction of red and yellow dyes from textiles is acid hydrolysis: see, for example, J. Wouters, 'High performance liquid chromatography of anthraquinones: analysis of plant and insect extracts and dyed textiles', *Studies in Conservation*, 30, 1985, pp. 119–28. We are most grateful to Dr Jan Wouters for the confirmatory analysis and interpretation. The sample sent consisted of pile attached to fragments of old paper backing tape removed from the reverse of one of the panels. It was not possible to separate the darker and lighter purple stripes. The equipment used consisted of a Waters model 616 pump and controller model 600S; a Rheodyne 7725i injector with a 20 μL sample loop; a Waters model 996 PDA detector. A Merck 125 mm Lichrosorb cartridge column, internal diameter 4 mm, packing particle size 5 μm, was used for the analysis. Running conditions are discussed in the references cited above and in note 14.

17 G. Gargiolli, *L'Arte della seta in Firenze; trattato del secolo XV*, Florence 1868, pp. 31–7, 48–50. The text (based on Gargiolli's edition) has also been published in M. Bussagli, *La seta in Italia*, Rome 1986, pp. 241–94, see pp. 259–61, 266, 269, 280. For a discussion of the treatise and its manuscript versions see R. Schorta, 'Il trattato dell'Arte della Seta: A Florentine 15th century treatise on silk manufacturing', *Bulletin de Liason du Centre International d'Etude des Textiles Anciens*, 69, 1991, pp. 57–83. See also G. Rosetti, [*Plictho de larte de tentori*] *The Plictho of Gioanventura Rosetti*, trans. S.M. Edelstein and H.C. Borghetty, Cambridge, Mass., and London 1969 (includes facsimile of 1st edn., Venice 1548), pp. 45, 136, for a reference to galling silk to 'take the colour inside – *piglia il color drento*'; confusingly this instruction also occurs in a recipe for dyeing with *grana*, kermes, although it seems to refer to dyeing black.

18 The solubility of indigo in 4% boron trifluoride/methanol is extremely low, but sufficient reacted for it to be identified during the HPLC examination of the red dyestuff carried out at the National Gallery. The presence of indigo

was confirmed by mass spectrometry using a programmable heated direst insertion probe, carried out by Raymond White, and microspectrophotometric examination of the blue threads by Emily Gore. The dyestuff was also identified by HPLC analysis carried out at the Koninklik Instituut voor het Kunstpatrimonium.

19 Gargiolli 1868, pp. 66–7; Bussagli 1986, p. 279, both cited in note 17.

20 For a historical background to the use of scale insect dyes from the late fourteenth to the late sixteenth centuries, largely derived from Venetian archival sources, see L. Molà, *The Silk Industry of Renaissance Venice*, Baltimore and London 2000, pp. 107–37. Molà has used the translation 'grain' for *grana* (i.e. probably *Kermes vermilio* Planchon) and 'kermes' for *cremisi* and its variants (the cochineals).

21 U. Dorini and T. Bertelè, *Il libro dei conti di Giacomo Badoer (Constantinopoli 1436–1440)*, Rome 1956, pp. 182–3, 296–7, 472–3, 550–4, 602–3, 648–9 for *cremexe rosesco*, *cremexe di vini* and *cremexe savaxi* bought by Badoer and sent to Venice between 1437 and 1439; H. Simonsfeld, *Der Fondaco dei Tedeschi in Venedig und die deutsch-venetianischen Handelsbeziehung*, 2 vols., Stuttgart 1887, Vol. I, p. 227 (a complaint, dated 26 February 1437, was lodged by the Nuremberg authorities on behalf of a local trader that *cremessyn* bought in Breslau (now Wroctaw) was found, when it reached Venice, to be of poor quality); K.O. Müller, *Welthandelsbräuche (1480–1540)*, Wiesbaden 1962 (first published Stuttgart 1934; Deutsche Handelsakten des Mittelalters und der Neuzeit, Vol. V), pp. 36–7, 41–2, 54, 150 (no. 54), 179 (no. 121). This book publishes notebooks of trading records of the Paumgartner family; trade in Polish cochineal (named *schirwitz* or *scherwitz*, from its Polish name *czerwiec*) to Genoa and Florence is recorded.

22 For example, both types were available at the Fondaco dei Tedeschi in Venice in 1572: see Simonsfeld 1887, cited in note 21, Vol. II, pp. 197–8; *Tariffa oder Uncostbüchlein von allen Wahren in Venedig so auss und ein gefürt mögen werden durch Teutsche und andere Nationen* [by S.V.], Nuremberg 1572, pp. 20ʳ, 32ᵛ–33, 219ᵛ–221ᵛ. See also Molà 2000, cited in note 20, pp. 120–31.

23 Gargiolli 1868, pp. 48–50; Bussagli 1986, pp. 266, 269; Rosetti 1969, pp. 34, 125, all cited in note 17.

24 G. Rebora, *Un manuale di tintoria del Quattrocento*, Milan 1970, pp. 77–9, esp. p. 78 (MS. 4.4.1, Civica Biblioteca di Como). It is unclear what effect this may have had: see Verhecken and Wouters 1988/89, cited in note 14, p. 227. Subsequently the cloth was treated with the purple lichen dye orchil (*orizelo*).

25 Molà 2000, cited in note 20, p. 114. Rosetti does include recipes for obtaining *morello* by dyeing with the less blue-toned madder or brazil wood dyes over blue: Rosetti 1969, cited in note 17, pp. 31–3, 121–3; see also pp. 146–7.

26 'Purpura' was a fabric more typically produced during the Middle Ages, and would have been regarded as quite old-fashioned by the late fifteenth century in Italy. For references to medieval 'purple' fabrics, see F. Michel, *Recherches sur les étoffes de soie et d'or et d'argent …*

pendant le Moyen Age, Paris 1852, Vol. I, p. 188: a 'purpura quae vulgariter dicitur samyt, vel baldekin' (1278). See also R. Barsotti, *Gli antichi inventari di Pisa*, Pisa 1959, p. 47: 'palium unum de purpura venetica multorum colorum cum rotis et papagallis magnis' (1369). By the early sixteenth century, 'purple' was coming back into use as a term to describe the colour of a fabric, and it was certainly used in this way in England, see, for example, the lists of purple-coloured textiles in *The Inventory of Henry VIII*, Vol. I, ed. D. Starkey, London 1998, items 9967–9979, 10027–10035, 10180–1, 10192.

27 C.C.A. Dehaisnes, ed., *Documents et extraits divers concernant l'histoire de l'art dans la Flandre, l'Artois et le Hainaut avant le XVᵉ siècle*, Lille 1886, Vol. 1, pp. 300–1: 'paonace, which is treated the same as for murrey, that is to say it has the colour of true violet.' For *paonazzo*, see also S.M. Newton, *The Dress of the Venetians, 1495–1525*, Aldershot and Vermont 1988, pp. 18–24.

28 T. Garzoni, *La piazza universale di tutte le professioni del mondo*, ed. G.B. Bronzini, 2 vols., Florence 1996 (based on the edn. of 1587; first published Venice 1585), Vol. 2, no. XC, *De pittori e miniatori e lavatori di mosaico*, pp. 812–21, esp. p. 815: 'del morello dalle more, del pavonazzo che è morello scuro.'

29 Molà 2000, cited in note 20, pp. 112–17; L. Monnas, 'Loom widths and selvedges prescribed by Italian silk weaving statutes 1265–1512 : a preliminary investigation,' *Bulletin de Liason du Centre International d'Etude des Textiles Anciens*, 66, 1988, pp. 35–44, esp. p. 40. The velvet cover of the volume forming Lot 367 from the Library of William Foyle (see note 11 above) does present a selvedge that is yellow with a green stripe. Unfortunately, it was not possible to examine the dyestuffs present.

30 Gargiolli 1868, pp. 31–2; Bussagli 1986, p. 259; Rosetti 1969, pp. 54, 147, all cited in note 17; see also Rebora 1970, cited in note 24, pp. 77, 108. See also Cardon 1990, pp. 72–3 for a discussion of possible interpretations, and pp. 76–91 for other *Porphyrophora* species; Verhecken and Wouters 1988/89, pp. 226–7, both cited in note 14.

31 P.A. Mattioli, *Il Dioscoride dell'eccellente dottor medico M.P. Andrea Matthioli da Siena, co i suoi discorsi…*, Venice 1548, pp. 535B6; and idem, *I discorsi … nelli sei libri di Pedacio Dioscoride …*, Venice 1568, pp. 1084–5: the 'grains' are not mentioned in the author's discussions of 'pimpinella'. See also Cardon 1990, pp. 67–72, and Verhecken and Wouters 1988/89, p. 224, both cited in note 14.

32 P.M. Caniparius, *De atramentis cujuscunque generis*, Venice 1619 (rep. Rotterdam, 1718), pp. 282–8, esp. pp. 285–6, 288. Drawing upon Classical and recent authors (including Mattioli) Caniparius discussed the insects, including Mexican cochineal, not only in the context of the crimson colour *cremesinus* (*cremesino*), but also as a historically recent equivalent to the Antique (and chemically quite distinct) Tyrian or shellfish purple. This is a reddish purple.

33 Printed by Bertoni 1903, cited in note 7, pp. 229–33.

34 'Uno Breviario grande de charta de capreto scripto a penna meniato et instoriato coperto de raso morello et la

sopracoperta de brocato d'oro morello fodrata de raso cremesino. Cum due azuli de oro smaltati': Bertoni 1903, cited in note 7, p. 229 (3).

35 'Un altro Breviario picinino de capreto scripto a penna miniato: coperto de raso alexandrino; la sopra-coperta de veludo morello fodrata de dalmasco biretino cum una cordellina de oro intorno: cum dui azuli de argento. Il quale adoperava madama ogni giorno': Bertoni 1903, cited in note 7, p. 229 (5).

36 No analysis of the pigment was possible, but microscopic examination of the picture by Ashok Roy suggested that a trace of pink coloration remained in the Virgin's mantle, which would suggest the presence of a red lake pigment, now totally faded. Another hypothetical – if implausible – explanation for the robe's present colour is that a now deteriorated blue colorant extracted from flowers was used; this is said to have been used for manuscript illumination and recipes for the extraction of the blue colouring matter from suitable flowers and berries certainly exist. It should be said at once that the use of a pigment of this type is highly unlikely. The colorant tends to turn reddish as alkaline conditions are required for it to remain blue; it also fades very rapidly. It was not recommended for easel paintings and it is not known ever to have been so used.

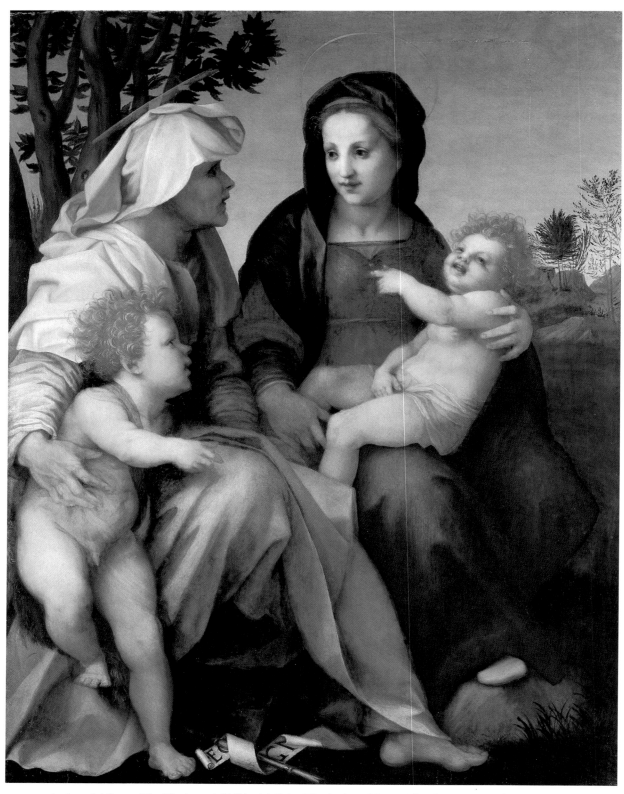

PLATE 1 Andrea del Sarto, *The Virgin and Child with Saint Elizabeth and Saint John the Baptist* (NG 17), *c*.1513. Panel, 106 × 81.3 cm.

Andrea del Sarto's *The Virgin and Child with Saint Elizabeth and Saint John the Baptist*: Technique and Critical Reputation

LARRY KEITH

The Virgin and Child with Saint Elizabeth and Saint John the Baptist by Andrea del Sarto (NG 17; PLATE 1) was acquired by the National Gallery in 1831 and was the first picture by that artist to enter the collection.[1] Brought to England from the Aldobrandini collection in Rome in 1805, the picture initially enjoyed a high critical reputation but by the later nineteenth century was less well regarded. Recent research undertaken for the revised scholarly catalogues of the Gallery's collection led to the re-examination of the picture; the existence in the Hermitage Museum in St Petersburg of another similar picture (PLATE 2), but with the addition of Catherine at the right of the composition – the so-called *Tallard Madonna* – was of major importance for the understanding of the London painting.[2] Academic opinion, although not unanimous, generally tended to favour the St Petersburg painting, while the National Gallery version was seen by some scholars as a workshop copy until the publication in 1962 of the National Gallery catalogue *The Sixteenth Century Italian Schools* by Cecil Gould, who argued that a significant part of the National Gallery painting was likely to be from the hand of del Sarto himself.[3] Restoration of the picture undertaken in 1992 allowed for technical study through cross-sections, medium analysis, and infra-red reflectography, while more recent infra-red reflectography of their painting by the Hermitage has allowed the question of the paintings' relationship to one another to be reconsidered.

The Virgin and Child with Saint Elizabeth and Saint John the Baptist was painted on a poplar panel constructed of four vertical planks with one horizontal plank attached across the top. The whole structure was reinforced with two tapered cross-grain dovetailed battens, now missing, which were let into channels cut across the reverse of the vertical planks. The addition of the horizontal plank, glued and nailed into the tops of the vertical sections, placed the panel structure under severe strain because the upper ends of the vertical members were totally restricted in their cross-grain movement in response to changes in relative humidity, whereas the lower ends were free to move. This difference eventually caused cracks and disruptions in the surface level when parts of the upper planks split away from their constraints and assumed something of a more natural convex warp.

This type of complex construction is only rarely encountered in Florentine panels of the period, and surely must have been known empirically to be inherently unstable. It can be seen, however, in at least one other work by del Sarto – the *Disputa sulla Trinità* (Palazzo Pitti, Florence, inv. 1912, n.172), where a horizontal plank was attached across the bottom of the panel's vertical sections. Incorporating important

PLATE 2 Andrea del Sarto, *The Virgin and Child with Saints Catherine, Elizabeth and John the Baptist (The Tallard Madonna)*, variously dated between 1511 and 1518. Canvas (transferred from panel), 102 × 80 cm. St Petersburg, State Hermitage Museum (inv. no. 62).

FIG. 1 Andrea del Sarto, *The Virgin and Child with Saint Elizabeth and Saint John the Baptist* (NG 17) (see PLATE 1). Composite infra-red reflectogram.

FIG. 2 Andrea del Sarto, *The Virgin and Child with Saint Elizabeth and Saint John the Baptist* (NG 17). Infra-red reflectogram detail, showing the head of the Virgin.

design elements of drapery pattern and having the same build-up of preparation as the main panel section, this strip was undoubtably an original part of

the panel structure.[4]

Once the panel had been constructed, the National Gallery panel was coated with gesso and size layers, upon which was then applied a translucent *imprimitura* layer comprised of various earth and lake pigments mixed with a little lead white, probably in an oil medium. This layer was applied both to further isolate the absorbent gesso ground from the subsequent oil paint and to tone down the intensity of the pure white ground, and the warm tones of its pigment composition are wholly in keeping with sixteenth-century written accounts of painting practice by Vasari, Borghini and Armenini, all of whom advocate broadly similar pigment mixtures.[5]

Thus prepared, the panel was ready for painting. Infra-red reflectography clearly shows a thorough and systematic underdrawing of all of the main features of the composition (FIGS. 1–4). This is characterised by the schematic concentration on the main contours and outlines of the compositional elements, with little or no indication of modelling[6] and no signs of correction or modification. Individual elements such as Christ's left knee are generally rendered in an extremely perfunctory way, and contours are rarely unbroken across the span of a single drapery fold or anatomical element. This type of underdrawing strongly indicates that the principle elements of the design were transferred from a separate and fully worked-up cartoon, no trace of which now survives, using the so-called *calco* method in which the design is traced from the cartoon onto the panel either by blackening the reverse of the cartoon with charcoal or using a blackened interleaf sheet between cartoon and panel,[7] as described by Vasari:

> After spreading the said composition or pigment [*imprimitura*] all over the panel, the cartoon that you have made with figures and inventions all your own may be put on it, and under this cartoon another sheet of paper covered with black on one side, that is, on the part that lies on the priming. Having fixed both the one and the other with little nails, take an iron point or else one of ivory or hard wood and go over the outlines, marking them firmly. In so doing the cartoon is not spoiled and all the figures and other details on the cartoon become very well outlined on the panel or framed canvas.[8]

The apparent lack of spontaneity and the hard, rather schematic nature of the National Gallery underdrawing are the direct result of the transfer process. The resulting traced design served only to

FIG. 3 Andrea del Sarto, *The Virgin and Child with Saint Elizabeth and Saint John the Baptist* (NG 17). Infra-red reflectogram detail, showing Saint Elizabeth's arm and the head of Saint John the Baptist.

FIG. 4 Andrea del Sarto, *The Virgin and Child with Saint Elizabeth and Saint John the Baptist* (NG 17). Infra-red reflectogram detail, showing the change in the position of the profile of Saint John the Baptist; his head has been significantly raised from the original underdrawn position (see also FIG. 7).

position the pre-existing composition onto the prepared panel; the subtle nuances of tone, light and shade were fully developed in the cartoon, which could be referred to as the painting progressed.

That cartoon, itself the summation of all the problems posed and solved in a series of preliminary drawings, was the more definitive document of the artist's invention, as described by Armenini:

> Now it remains for us to deal with cartoons, held by us to be the last and most perfect way by which one can express the whole of one's powers through the artifice of design. To those who diligently practise the true methods and who zeal-

ously endeavour to execute the cartoons well, cartoons so facilitate the completion of works the artist is about to undertake that little additional effort seems necessary. The sketches, the drawings, the models, the living models, in sum, all other labours previously realized have as their only purpose that of being brought together perfectly on the spaces of the aforesaid cartoons ... Among other things, cartoons are most worthy of esteem, for in them one sees expressed all things which entail extreme difficulties, if properly done. So that following the cartoon, one proceeds in the most secure ways with a most perfect example and a model for everything that has to be done. In fact, one can say that for the colours the cartoon is the work itself.[9]

While Armenini, writing some fifty years after del Sarto's activity, reflects a more self-consciously academic attitude about drawn studies more common in the later sixteenth century, the essential validity of his writing for the time of del Sarto is supported by the documented fame and importance of such contemporary cartoons as those of Leonardo's *Virgin and Child with Saint Anne and Saint John the Baptist* (today in the National Gallery; NG 6337) or Michelangelo's *Battle of Cascina* (now destroyed), both studies for final works that were never realised in paint.[10]

The painter of the National Gallery picture showed some flexibility in his use of the cartoon, to judge from the numerous modifications that were made from the traced design as the painting progressed. The simple, straight fold of shadowed drapery running down towards the ankle of the underdrawing of Saint Elizabeth's extended leg has been made into a more complex zigzagging construction in the final painting, while the vertical drawn fold in the red fabric of the Virgin's upper right arm has been omitted entirely from the painted execution. The position of the fingers of the right hands of both the Virgin and Saint Elizabeth have been significantly altered, those of the former being more extended than the more curled-under pose of the underdrawing, while those of the latter are more curved under one another than in the more extended underdrawn fingers. Perhaps the most significant alteration is to be found in the Baptist's left arm, which in the underdrawn version is clearly shown extended down the left side of his body with the hand resting on his left thigh; the final painting shows the hand hidden behind the thigh, with only a sliver of forearm and wrist now visible behind the painted sash. The posi-

FIG. 5 Andrea del Sarto, *The Virgin and Child with Saints Catherine, Elizabeth and John the Baptist (The Tallard Madonna)* (see PLATE 2). Infra-red reflectogram detail, showing the head of the Virgin.

FIG. 6 Andrea del Sarto, *The Virgin and Child with Saints Catherine, Elizabeth and John the Baptist (The Tallard Madonna)*. Infra-red reflectogram detail, showing Saint Elizabeth's arm and the head of Saint John the Baptist.

tion of the profiles of the faces of both Saint Elizabeth and the Baptist have been placed higher up in the final painting than in the first underdrawn versions, the Baptist's significantly so; the positioning of his left foot has also been slightly altered.

The significance of these changes, largely invisible before the advent of infra-red photography and reflectography, is easily underestimated when considering the National Gallery painting alongside the traditionally more highly regarded version now in the Hermitage. In addition to the obvious differences of the inclusion of the signature and the figure of Saint Catherine in the St Petersburg painting, early comparisons between the pictures concentrated on the stylistic relationships between various details in the two versions, some of which have been clearly taken to a higher and more refined level of finish in the Russian picture. Although the surface of the latter has been greatly compromised by its 1866 transfer from panel to canvas, the paint layers remain in good condition and retain passages of high quality relative to the London painting. Its landscape, for example, is more ambitious in the inclusion of background architectural elements and more detailed in the rendering of the flowers and foliage of both the lower right foreground and upper left tree, while Saint Catherine's wheel is very convincing in the depiction of the different textures of metal and wood. Some elements of the painting of the Virgin are also more highly resolved in the Hermitage version, most notably in the depiction of the foreshortened bare foot as opposed to her strangely and unconvincingly shod foot in the National Gallery; other elements such as the stronger modelling of the folds of her dress below the waist or the addition of the gold border of her mantle are also features found only in the Russian picture.

Such differences were the basis on which the primacy of the Hermitage version was established throughout much of the nineteenth and early twentieth centuries when, with the notable exception of Bernard Berenson, the National Gallery painting was generally thought to be a studio replica or outright copy.[11] Writing in 1854, Waagen gave the London picture to a pupil of del Sarto, probably Domenico Puligo, and was particularly scathing in his description:

This heavy, exaggeratedly brown tone is not to be found in any of his authenticated pictures. If the smile of his children can be sometimes affected, it never degenerates into the distortion of caricature, as here in the infant Jesus, whose excessively clumsy body but ill agrees with the surname given to the master, 'Andrea senza errore.' The eyes of the Virgin have quite a sickly appearance.[12]

The relationship between the two pictures is not so simple, however, and for all of its perceived weaknesses in execution, the National Gallery version also contains passages of great quality relative to its counterpart. The sense of volumetric sculptural form in the grouping of Elizabeth and John the Baptist is

markedly greater in the National Gallery picture; the more complex folds of Elizabeth's drapery, particularly between her lower legs, are illuminated with greater tonal contrast, which gives a more convincing sense of space-filling weight. That same sense of higher contrast and richer interplay of light and shade also provides a more convincing rendition of her face emerging from the shadows of her head-dress, and of her right arm resting on and around the body of the Baptist.

The presence of the numerous pentimenti previously outlined in the National Gallery picture also makes it clear that it was no simple copy or reduction of the Hermitage version. In fact it is the Russian picture which precisely follows the final realisations of several of the London painting's pentimenti, such as the positioning of the left hand of the Baptist behind his thigh and the repositioning of the fingers of the Virgin and Saint Elizabeth.

Interestingly, both pictures contain an identical compositional weakness. The boundary between the sleeves of Elizabeth's and the Virgin's respective left and right arms is spatially unclear, making it ambiguous as to which limb is further forward; while it is logically apparent that Elizabeth's arm is in front of the Virgin's, the contour between them has an interlocking two-dimensional quality that tends to collapse the sense of receding space so convincingly depicted elsewhere. The fact that this awkward jamming together of the two women is present even in the National Gallery version, where the omission of Saint Catherine gives greater scope for a less cramped spacing, implies a comparable dependence on the same preparatory work for both paintings. This impression is further reinforced by the repeat of the same cropping of the figure of Saint Elizabeth at the picture's left border in the London picture, although the composition displays ample space on the right whereby it could have been avoided.

Recent study of the Hermitage painting with infra-red reflectography (FIGS. 5–8) has also shown a clear and consistent underdrawing of the figures in a broadly similar style to the National Gallery version, although there is noticeable variation in the fine details of the selection of lines depicted and in the degree of drawn elaboration of the cartoon's design. Even given the more sketch-like qualities of some of the Hermitage underdrawing, other features (FIG. 6) such as the unconnected schematic rendering of the folds of Elizabeth's sleeve and the unlinked and slightly jagged contours of some anatomical features like the Baptist's right arm, belie their origin in the traced cartoon, albeit a tracing that appears to be in

PLATE 3 False-coloured overlay of the compositions of the London and St Petersburg pictures (PLATES 1 and 2), adjusted to scale. The yellow areas show where the compositions coincide, suggesting a similar figure scale and the use of a common cartoon for both paintings.

parts more fully and fluidly elaborated with further drawing after the actual design transfer.

The differences in the detail of the two under-drawings are not as important as their similarly based origin in the process of cartoon transfer, particularly given the context in which cartoons were routinely used for the transfer of established designs onto the final panel even where no multiple versions were to be executed. Significantly, the illusion provided by the more open composition of the London picture has given rise to the incorrect assumption that its figure scale is considerably larger than that of the more cramped Russian picture. A coloured overlay of the two compositions (PLATE 3), adjusted to the scale of their relative dimensions, makes it clear that the figures are in fact to the same scale and this, combined with the other evidence from infra-red reflectography, suggests that both paintings were probably developed from the same cartoon.

However, the establishment of the use of the same cartoon, even if more highly elaborated in the Hermitage picture, brings us no further in developing either a chronology or a stylistic hierarchy between the two works. The fact that both pictures contain the same significant change in the direction

47

FIG. 7 Andrea del Sarto, *The Virgin and Child with Saints Catherine, Elizabeth and John the Baptist (The Tallard Madonna)*. Infra-red reflectogram detail, showing the change in the position of the profile of Saint John the Baptist; like the National Gallery picture, his head has been significantly raised from the original underdrawn position (see FIG. 4).

FIG. 8 Andrea del Sarto, *The Virgin and Child with Saints Catherine, Elizabeth and John the Baptist (The Tallard Madonna)*. Infra-red photograph detail, showing the change in the placement of Christ's head in order to bring the figure of Saint Catherine into his field of vision; this alteration is presumably the result of her addition to the originally conceived composition.

of the Baptist's gaze, with the raising of the head clearly visible in the changed silhouette of the initial reserve painted around the facial profile, argues strongly against one picture being based after the completed version of the other (FIG. 7).[13] The Hermitage painting includes one major change that is absent from the London picture, namely the positioning of Christ's head (FIG. 8); in the Hermitage

PLATE 4 Andrea del Sarto, *The Virgin and Child with the Infant Baptist (The Wallace Madonna)*, c.1517–18. Panel, 106 × 81 cm. London, Wallace Collection (inv. P9).

version the head has been tilted back from its original pose so that the Child's gaze could include Saint Catherine. Quite apart from the slightly awkward and added-on appearance of the Saint Catherine within the finished composition, this alteration suggests that the original cartoon did not include the figure of the saint, but was probably much closer to the composition of the National Gallery picture.[14]

The reuse and modification of cartoons was by no means unusual at this time, and there are numerous examples of artists resorting to this practice.[15] Del Sarto's workshop was particularly inclined to the reproduction and variation of successful compositions, a typical example of which can be found in the Wallace Collection's *Virgin and Child with the Infant Baptist* (PLATE 4) – the prime version of a composition that is known in at least twenty-four variants and copies. While several of these versions are markedly inferior and obviously considerably later in date, enough remain to indicate that the composition was repeated frequently by the workshop itself. Like the National Gallery picture, the Wallace painting contains significant pentimenti from its underdrawing that were repeated in the other finished versions. Also of interest is the fact that some of the versions of the Wallace painting were made without inclusion

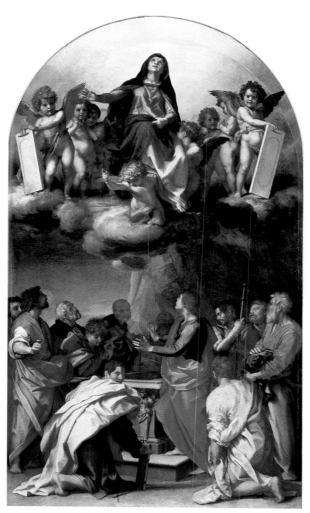

PLATE 5 Andrea del Sarto, *The Assumption of the Virgin* (*Assunta Panciatichi*), *c*.1522–5. Panel, 362 × 209 cm. Florence, Pitti Palace, Galleria Palatina (inv. no. 1912, n.191).

PLATE 6 Andrea del Sarto, *The Assumption of the Virgin* (*Assunta Passerini*), *c*.1526–7. Panel, 379 × 222 cm. Florence, Pitti Palace, Galleria Palatina (inv. no. 1890 n.225).

of the two peripheral background angels – a variation roughly analogous to the omission of Saint Catherine from the National Gallery picture.[16]

One of the more noteworthy examples of del Sarto's recycling of a cartoon can be found in the comparison of the two versions of the *Assumption of the Virgin* (PLATES 5 and 6), both of which are now in the Pitti Palace in Florence. These two altarpieces, painted for the Panciatichi and Passerini families and generally dated to about 1522–5 and 1526–7 respectively, have been shown to rely upon the same cartoon for the lower part of the image where the apostles have gathered around the tomb. Del Sarto has made extensive modifications to the composition of that cartoon in the later Passerini picture, most strikingly seen in the kneeling apostle on the left holding the book. Infra-red and cross-section analyses undertaken during its 1986 restoration show that most of these changes were made shortly after the initial

transfer of the cartoon; the Panciatichi picture reveals a more elaborate underdrawing in areas which have been changed, implying a more improvised invention on the panel, while the unchanged areas show the more schematic underdrawing to be expected for figures thoroughly elaborated in the cartoon itself.[17]

The Panciatichi and Passerini *Assumptions* show a very flexible approach to the reuse of cartoons by del Sarto, and there are several other examples of him repeating compositions in different media or reproducing clearly autograph works of markedly different dimensions where, although evidently derived from the same source, the reuse of a single cartoon was clearly an impossibility. A panel of the *Virgin and Child with Saint John the Baptist* from a private collection in Italy showing clear signs of cartoon transfer in its underdrawing has recently been shown to derive from his now-destroyed fresco of the

PLATE 7 Andrea del Sarto, *The Sacrifice of Isaac*, c.1526–9. Panel, 178.2 × 138.1 cm. Cleveland Museum of Art (inv. no. 37.577).

PLATE 8 Andrea del Sarto, *The Sacrifice of Isaac*, c.1528–9. Panel, 213 × 159 cm. Dresden, Gemäldegalerie (inv. no. 77).

same subject, the so-called *Tabernacle of Porta a Pinti*.[18] The three versions of *The Sacrifice of Isaac* from the late 1520s now in museums in Cleveland, Dresden (PLATES 7 and 8) and Madrid are described by Shearman as largely or wholly autograph and, while the Cleveland and Dresden versions are approximately the same dimensions, the Madrid picture is approximately one half the size of the other versions;[19] it basically follows the composition of the later Dresden painting and is probably a commissioned *ricordo* of it.[20] The earliest and unfinished version in Cleveland shows significant pentimenti, particularly in the size and placement of the angel; the roughly similarly sized picture in Dresden is virtually identical in the depiction of Abraham and Isaac but shows further adjustment to the angel and wholesale changes in the surrounding landscape that are at least as radical as the changes made to the apostles of the Panciatichi *Assumption*. Even in the absence of recorded underdrawing from the Dresden painting it seems certain that the same cartoon was used for the figures of Abraham and Isaac in both the Dresden and Cleveland pictures; again, a scaled overlay (PLATE 9) of the two paintings shows an almost exact alignment of the two sets of protagonists,

while the lesser but significant changes observable in the face and foot of Isaac are wholly in keeping with the sort of modifications shown to have been commonly made by del Sarto in the course of reworking his existing compositions.

Thus a picture of the del Sarto workshop emerges which shows that, like many of its contemporaries, the studio was often engaged in the repetition and modification of successful compositions. Nonetheless its innovation and flexibility in the reworking of established designs are noteworthy; in addition to supervising the production of simple studio reproductions, del Sarto was often closely involved in those cases where the recycled composition was extensively modified. It is reasonable to suggest that the so-called studio reproductions display considerable variation in quality both compared to one another and within some individual pictures, and may represent a Rubens-like hierarchy of participation around del Sarto himself. In this context questions of the primacy of a particular version or the autograph status of a particular work are sometimes substantially blurred, and the relationship between the National Gallery and Hermitage paintings is undoubtably better understood when evaluated

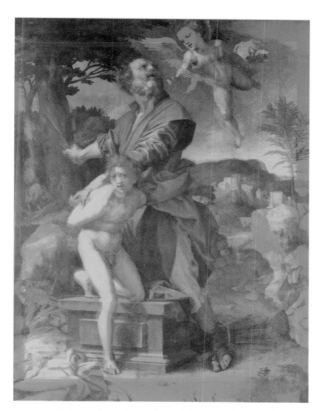

PLATE 9 False-coloured overlay of the Cleveland and Dresden *Sacrifice of Isaac* compositions (FIGS. 7 and 8), showing a similar figure scale for the principal figures, again suggesting the use of a common cartoon source.

within this framework. While one picture may ultimately be judged to be more successful than the other on aesthetic grounds, with the weight of critical opinion in the main favouring the Hermitage painting, the divergence of scholarly opinion over the centuries indicates that this issue is not so easily resolved. However, the confusing combination of the paintings' close technical similarities and significant stylistic variations is entirely consistent with the more complex picture of the workings of the studio that is revealed through a more technically informed consideration of its production.

Acknowledgements

I would like to thank Carol Plazzotta, Myojin Curator of Sixteenth-Century Italian Painting at the National Gallery, for her insight and advice in preparing this text; Dr Alexander Kossolapov of the State Hermitage Museum, St Petersburg, for kindly sharing the results of his infra-red examination of the *Tallard Madonna*; and Rachel Billinge, John Cupitt and Joseph Padfield for providing the other infra-red reflectograms and image overlays used in this article.

Appendix: The 1992 cleaning of *The Virgin and Child with Saint Elizabeth and Saint John the Baptist*

By 1992 the varnish layers of the painting had become highly discoloured as well as foggy and poorly saturating, and the decision was made by the Conservation and Curatorial Departments to restore the picture. While removal of at least two readily distinguishable discoloured varnish layers (PLATE 10) and retouchings from previous restoration was accomplished in a relatively straightforward manner, with the picture showing the same old damages as those documented in the last cleaning of 1932, after cleaning the painting nonetheless retained an unusually darkened and discoloured surface, not unlike the appearance of tempera paintings with old egg-white varnishes sometimes encountered on earlier Italian pictures. Medium analysis by the Scientific Department proved that this upper surface layer was

PLATE 10 Andrea del Sarto, *The Virgin and Child with Saint Elizabeth and Saint John the Baptist* (NG 17). Ultraviolet photograph taken during cleaning. Two fluorescing varnish layers are visible at the edges of the cleaning test to the right of the figure of Christ; the upper layer is the lighter and more yellow colour while the lower varnish is a darker and more orange tone. Both layers have been removed in the darkest areas of the photograph, such as the figures of Saint Elizabeth and Saint John the Baptist. The later linseed oil layer that covers the entire picture is undisturbed.

PLATE 11 Andrea del Sarto, *The Virgin and Child with Saint Elizabeth and Saint John the Baptist* (NG 17). Cross-section detail from Saint Elizabeth's headdress. The *imprimitura*, comprised of lead-white and earth pigments, is visible as the off-white layer between the lowermost gesso layer and the two lighter applications of lead-white and charcoal black paint of the headdress itself. Magnification *c*. 450×.

not in fact egg white or any other proteinaceous layer, but instead was composed of a layer of pure linseed oil which had not only discoloured but had also absorbed a considerable amount of surface dirt, both factors contributing to its markedly grey tone. Further medium analysis of the underlying paint layers showed all sampled areas to be composed of walnut oil, a medium widely employed throughout Italy at this time and generally preferred to linseed oil because of its non-yellowing properties. The linseed oil layer, while seemingly applied relatively early in the painting's history, was not thought to be original: not only was there a discernible accumulation of surface dirt visible in cross-section (PLATE 11) between the top of the walnut oil paint layers and the upper layer of linseed oil, indicating the passage of considerable time between completion of the painting and application of the linseed oil, but it was also highly improbable if not inconceivable that del Sarto, having consciously selected a non-yellowing medium for the paint itself, would then choose to apply a patchy and inconsistently thick layer of the yellowing linseed oil over its surface.

This layer was not removed, however, as the aged and hardened linseed oil could not safely be removed from the paint layers below. The bond between them may indeed even have been strengthened as the result of a treatment undertaken on the picture in 1864, the so-called Pettenkofer process. In the early 1860s Professor Max Pettenkofer[21] of the University of Munich developed a process for the regeneration of aged, cracked and therefore poorly saturating natural resin varnishes in which the painting was exposed within a small enclosed chamber to alcohol vapour, which had the effect of swelling and thereby regenerating the resinous varnish layers. Tested on approximately eighty paintings in Munich by 1863 and subjected to the investigation of a specially convened Committee for Inspection of Restored Paintings in Bavaria, the process was eventually granted the Committee's approval and was later recommended by Sir Charles Eastlake, Director of the National Gallery, for use on a selection of paintings from the Gallery. The del Sarto *Virgin and Child with Saint Elizabeth and Saint John the Baptist* was among sixteen paintings from the collection known to have been treated by this process in 1864.[22]

As Pettenkofer developed his process he began to combine the alcohol vapour treatment with the introduction of copaiba balsam, an oleoresin obtained from the South American tree *copaifera landsdorfii*[23] which was applied directly onto the picture surface. While greatly aiding the reforming process, copaiba balsam could have a bad effect on the paint layers, swelling the paint and rendering paintings difficult to clean. Pettenkofer was sometimes known to be less than forthcoming about the addition of this resin application to the solvent vapour process, but the National Gallery treatments were restricted to the use of alcohol vapour only, and indeed a main advantage of the process as described in the 1865 annual report was that 'the picture does not require to be touched; the effect being entirely produced by the action of the vapour.'[24] The accuracy of the report is backed up by the fact that no trace of copaiba balsam was found in any of the medium analyses undertaken by the Scientific Department, nor was any sign of unusual solubility of varnish or paint layers observed in any part of the 1992 treatment.

Notes and references

1 See Cecil Gould, *National Gallery Catalogues; The Sixteenth Century Italian Schools*, London 1987, pp. 233–4.

2 See Tatiana Kustodieva, *The Hermitage Catalogue of Western European Painting; Italian Painting, Thirteenth to Sixteenth Centuries*, St Petersburg 1994, pp. 44–5.

3 Gould, cited in note 1, pp. 233–4.

4 For a technical description from its 1985 restoration see *Andrea del Sarto 1486–1530; Dipinti e disegni a Firenze* (exh. cat. Palazzo Pitti, Florence), 1986, pp. 115–17.

5 For contemporary written sources see Raffaello Borghini, *Il riposo*, Florence 1584, p. 174; the preface to the 1568 edition of Giorgio Vasari's *Lives* ed. G. Milanesi, Florence 1878, vol. I, p. 186; *Vasari on Technique* (preface

to the original 1568 edition; translated and edited by Louisa Maclehose), reprinted 1960, pp. 230–1; Giovanni Battista Armenini, *De' veri precetti della pittura*, Ravenna 1586, p. 125, or *On the True Precepts of the Art of Painting* (translation of 1586 edition by Edward Olszewski), New York 1977, p. 192; for other examples in the work of del Sarto see *Andrea del Sarto 1486–1530; Dipinti e disegni*, cited in note 4, p. 337.

6 The only visible indications are to be found in the hatchings on the drapery immediately around the Virgin's right hand, presumably to distinguish it from the folds belonging to Elizabeth's gown, and a few parallel hatchings on one fold of Elizabeth's drapery to the left of her lower left leg.

7 For an overview of use and transfer of cartoons see J. Dunkerton, S. Foister and N. Penny, *Dürer to Veronese: Sixteenth-Century Painting in The National Gallery*, London 1999, pp. 224–31, and Carmen Bambach, *Drawing and Painting in the Italian Renaissance Workshop; Theory and Practice, 1300–1600*, Cambridge 1999, with specific reference to Andrea del Sarto and the *calco* or 'carbon-copy' method on p. 12 and p. 376 n. 49. See also D. Bertani, E. Buzzegoli, M. Cetica, L. Giorgi, D. Kunzelman and P. Poggi, 'Andrea del Sarto in riflettografia', in *Andrea del Sarto 1486–1530; Dipinti e disegni*, cited in note 4, pp. 341–58; N. Bracci, M. Ciatti and A. Tortorelli, 'Il restauro delle *Assunte* Panciatichi e Passerini di Andrea del Sarto', *OPD Restauro*, 2, 1987, pp. 17–26; M. Ciatti and M. Seroni, 'Il San Giovanni Battista di Andrea del Sarto: tecnica pittorica, indagini e restauro', *OPD Restauro*, 1, 1986, pp. 72–9.

8 Vasari/Milanese, cited in note 5, p. 186; Vasari/Maclehose, cited in note 5, p. 231.

9 Armenini, cited in note 5, pp. 99–100; Armenini/Olszewski, cited in note 5, pp. 170–1.

10 See Bambach, cited in note 7, on the Leonardo, pp. 37, 43, 250, 263, 265–6, 268, 272–3 and on the Michelangelo, pp. 36, 39, 48, 50, 249, 257, 271, 276, 285, 292, 390 n.60.

11 Gould, cited in note 1, p. 234.

12 Dr Gustav Friedrich Waagen, *Treasures of Art in Great Britain*, I, 1854, p. 322, where the picture is attributed to Puligo.

13 One possible conclusion is that the works may have been painted more or less simultaneously; for a similar example see J. Dunkerton, N. Penny and A. Roy, 'Two Paintings by Lorenzo Lotto in the National Gallery', *National Gallery Technical Bulletin*, 19, 1998, pp. 52–63.

14 The only known pre-cartoon preparatory work for either picture is a contemporary copy of a drawn study for the figure of Catherine now in the British Museum; its survival as an independent composition may therefore be significant.

15 Another contemporary example of a recycled cartoon used in a variation of the original composition can be found in the National Gallery's *Salome* by Giampietrino (NG 3930); see L. Keith and A. Roy, 'Giampietrino, Boltraffio and the Influence of Leonardo', *National Gallery Technical Bulletin*, 17, 1996, pp. 6–10.

16 John Ingamells, *The Wallace Collection Catalogue of Paintings I: British, German, Italian and Spanish*, London 1985, pp. 332–8.

17 See A. Forlani Tempesti, C. Castelli, M. Ciatti, M. Seroni, A. Tortorelli, 'Andrea del Sarto nel restauro', in *Andrea del Sarto 1486–1530; Dipinti e disegni a Firenze*, cited in note 4, pp. 330–40.

18 See Raffaele Monti, 'Un ritrovamento sartesco', *Critica d'arte*, 5, 2000 (Anno LXIII), pp. 45–62.

19 See John Shearman, *Andrea del Sarto*, Oxford 1965, Vol. I, pp. 110–11, and Vol. II, pp. 269–70 and pp. 280–2.

20 Shearman, op. cit. pp. 282–3.

21 For an overview of the work of Pettenkofer seen Sibylle Schmidt, 'Examination of Paintings Treated by Pettenkofer's Process', *Cleaning, Retouchings, and Coatings: Preprints of the Contributions to the Brussels IIC Congress*, 1990, pp. 81–4.

22 *Report of the Director of the National Gallery, 1865*, London 1865, p. 141.

23 Rutherford Gettens and George Stout, *Painting Materials: A Short Encyclopedia*, New York 1965, p. 15.

24 *Report of the Director of the National Gallery*, cited in note 22, pp. 138–41.

Colour change in *The Conversion of the Magdalen* attributed to Pedro Campaña

MARIKA SPRING, NICHOLAS PENNY, RAYMOND WHITE AND MARTIN WYLD

Introduction

The small *Conversion of the Magdalen* in the National Gallery, attributed to Pedro Campaña (NG 1241; PLATE 1)[1] is derived from a composition by Federico Zuccaro, known from drawings for a fresco on the side wall of Cardinal Giovanni Grimani's chapel in S. Francesco della Vigna, Venice.[2] Federico Zuccaro (*c*.1540–1609) came from Rome to Venice to work for Cardinal Giovanni Grimani in 1562.[3] The altarpiece which he painted for the cardinal's chapel is dated 1564, and the frescoes on the side walls must have been painted at the same period. One of these, representing the Raising of Lazarus, survives, but the other, showing the Conversion of the Magdalen, is now lost and known only from the painter's drawings.[4]

In his will, dated 29 August 1592, Grimani mentions some small pictures framed in ebony, two of which were by 'Pietro di Fiandra' (Peter from Flanders). One of these was after the altarpiece of the chapel in S. Francesco della Vigna. In the other 'the story is of Christ seated and preaching to the people and to the Magdalen' (*la historia è Jesu Christo che siede et predica al populo et alla Madalena*). This painting, which he bequeathed to 'Signor Commendatore Lippomani', can be identified as the picture now in the National Gallery.[5] It does not look like a straightforward copy of the fresco by Zuccaro; there are numerous minor pentimenti and additions to the composition when compared with Zuccaro's surviving drawings. These are most evident in the 'people' who seem to consist in large part of portraits. There are over a dozen of these, among them no doubt Grimani, certainly many members of his family, and perhaps the artist.

The picture came to the National Gallery from the famous collection of Philip Miles at Leigh Court near Bristol. Miles had acquired it from Richard Hart Davis who bought it from Thomas Moore Slade, who acquired it with the Vetturi collection in Venice in the 1770s.[6] The painting already had an attribution to Pedro Campaña, and since this artist was not at all famous (certainly not in Italy), there must have been a reason for this attribution (perhaps because of some reference to Campaña in a manuscript catalogue or in an inscription on a frame).[7]

Pedro Campaña could have been styled 'Pietro di Fiandra' by the Italians, but the question remains, was he the artist of the National Gallery painting? The attribution has, in fact, been doubted and does present problems.[8] Pedro Campaña (Peeter de Kempeneer) was born in Brussels in 1503. He went to Spain (in some accounts from Italy) and was active in Seville between 1537 and 1539 and then again between 1546 and 1561. He returned to Brussels in 1563, when he became a tapestry designer for the city, and he died there in 1580.[9] His talent as a portraitist is apparent from the donors included in his Spanish altarpieces, and he also had a reputation for precious work on a small scale. Allowing for the hybrid character of a copy (or partial copy) there seems no obstacle to this painting being by his hand, although it would have to date from around 1562 (at the very date the fresco was being planned) during a brief, and undocumented, visit to Italy prior to his return to Brussels – unless, as seems unlikely, he travelled again in his last years.

Bert W. Meijer has recently proposed, however, that Grimani's 'Pietro di Fiandra' is in fact Pieter Cornelisz. van Rijck and this is supported by the fact that he was a pupil of Huybrecht or Hubertus Jacobsz., who must be the 'Uberto Fiandrese' also mentioned in Grimani's will as executing a small picture after Federico Zuccaro.[10] Stylistic comparisons with other works by this Pieter are not conclusive and the matter cannot at present be settled. What cannot be doubted is that the National Gallery's panel is the one painted for Cardinal Grimani in Venice – either shortly before he made his will in 1592 or soon after the fresco by Zuccaro was completed in the early 1560s.

That the painting enjoyed a certain reputation is suggested by the existence of an early modified copy in the Borghese Collection (PLATE 2) in which some heads have been made less portrait-like, while other

PLATE 1 Attributed to Pedro Campaña, *The Conversion of the Magdalen* (NG 1241). Pear wood, 29.8 × 58.4 cm.

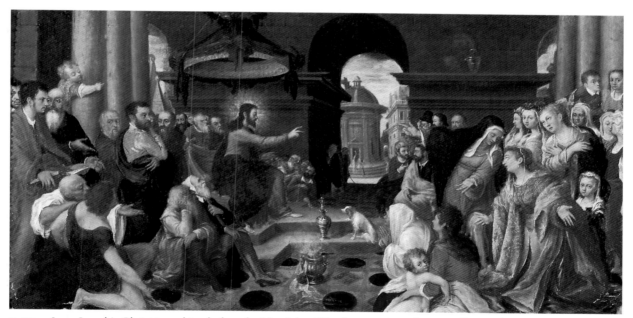

PLATE 2 Luca Longhi, *Christ preaching before the Magdalen*. Wood, 30 × 58 cm. Rome, Villa Borghese.

portraits have been added, and the type of Christ has been changed. This was attributed to Zuccaro himself in the seventeenth century and since then to Carletto Caliari and Luca Longhi.[11] Because the colours of the National Gallery's painting have clearly changed, the better-preserved Borghese picture provides a fascinating opportunity for comparison. It is to the nature of these colour changes that this article is devoted.

The pigments and binding medium in areas of colour change

Many of the draperies of the figures in the painting are now brown or yellow-brown. They have discoloured so severely that there is no hint of the original colour. Samples of discoloured paint from some of the principal figures were analysed to identify the pigments, and to investigate whether there was any peculiarity in the technique and materials that could have caused such serious degradation. Three principal

PLATE 3 **Summary of analysis of samples from discoloured areas**[1]

a CROSS-SECTION THROUGH CHRIST'S YELLOW-BROWN CLOAK
The lowest layer contains smalt and lead white, over which is a layer of smalt (now completely colourless) with a very small amount of lead white. The thin brown layer at the surface is not part of the original paint. EDX analysis of the smalt particles detected Si and small amounts of K, Co, Fe, As and Bi.

The smalt particles are more easily visible in ultraviolet light, and the surface accretion is distinguishable from original paint. Original magnification 400×, actual magnification 350×.

b CROSS-SECTION THROUGH THE BROWN DRAPERY OF THE FIGURE CROUCHING IN THE BOTTOM LEFT CORNER
The uppermost layer of priming is visible at the bottom of the sample, followed by a thin purple underpaint of azurite and red lake, mixed with a little lead white. The thick brownish layer above consists of red lake and smalt, now entirely discoloured. A brown surface accretion similar to that on Christ's drapery is visible at the top of the sample.

The separate brown layers, and the red lake and smalt in the original paint, are more easily visible in ultraviolet light. Original magnification 500×, actual magnification 300×.

c CROSS-SECTION THROUGH THE BROWN DRAPERY OF THE STANDING BEARDED MAN (WITH A YELLOW ROBE) NEAR THE COLUMN ON THE LEFT
The lowest layer in the sample is the first lead white preparatory layer, over which is a second off-white layer (lead white, a little yellow earth and black). The first green underpaint layer is a mixture of azurite, lead-tin yellow and yellow lake (on a calcium-containing substrate). A second green underpaint contains more lead-tin yellow, mixed with ultramarine and yellow lake. The uppermost dark brown layer is a discoloured copper-containing glaze (copper detected by EDX analysis), originally green. A small amount of Cl was also detected in this layer. Original magnification 940×, actual magnification 467×.

d CROSS-SECTION THROUGH A WHITE HIGHLIGHT ON THE RED CLOAK OF THE LARGE FIGURE AT THE EXTREME LEFT EDGE
The two preparatory layers (lead white followed by an off white layer) are visible at the bottom of the sample. Above these is a layer of vermilion (the base colour for the red drapery), then the white paint of the highlight. A very thin red lake glaze has been applied over the white, just visible in the cross-section. This has faded so that the highlights appear white rather than pink.[2] Original magnification 500×, actual magnification 300×.

1 The pigments were identified by EDX analysis in the Scanning Electron Microscope.
2 The faint pink fluorescence of the thin glaze at the surface in ultraviolet light confirms that this thin yellowish layer is, in fact, a faded red lake glaze.

types of pigment deterioration are responsible for most of the changes: deterioration of the pigment smalt, fading of a red lake pigment, and discoloration of green copper-containing glazes. The samples are illustrated and described in detail in PLATE 3.

The discoloration of smalt

Smalt is a potassium silicate glass, coloured blue with cobalt oxide, which is crushed and ground for use as a pigment.[12] It is not, however, a stable pigment; discoloration of smalt on sixteenth-century paintings is not at all unusual. Earlier studies have implicated a number of factors in the degradation.[13] The low refractive index and tinting strength could result in it being disproportionately affected by the change in refractive index of the oil medium as it ages. Conditions of high humidity could cause leaching of metal salts from the silicate network, particularly the alkaline potassium and sodium salts, which are added to glass as network modifiers. Potassium glass is more vulnerable to leaching than sodium glass, a process which, as well as causing deterioration of the glass itself, could cause saponification or condensation reactions in the oil medium, and would account for the excessive yellowing often observed in paint samples containing deteriorated smalt. Concurrent loss of cobalt into the medium has been proposed, but because the percentage of cobalt in smalt is very low – typically less than 10% – this has proved difficult to confirm by analysis. Some kind of interaction between the cobalt and the oil medium must be occurring however, since it accelerates drying of the oil.[14]

The composition of smalt varies, depending on the conditions and ingredients of manufacture. It often contains impurities that reflect the source of the cobalt ore used.[15] These impurities would almost certainly have had an influence on the hue of the pigment, and could also affect the stability of the glass.[16] The smalt in this painting contains impurities of arsenic, iron, nickel and bismuth in concentrations almost equal to cobalt, but at levels that are not unusual in smalt on sixteenth-century paintings.[17] The level of potassium in the smalt particles in the paint from Christ's cloak is rather low (of the same order as cobalt) and elemental mapping by EDX of the cross-section indicates that there are, in fact, higher levels in the matrix around the smalt particles and on the surface of the sample, which may be an indication that some alkali leaching has taken place.

The pigment is usually relatively coarse, as it becomes pale when finely ground, making it neces-

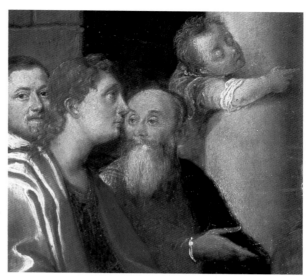

PLATE 4 *The Conversion of the Magdalen*. Detail of the two standing figures at the left edge of the painting.

sary to use a high proportion of oil to make a paint of acceptable working properties. This is manifested in this painting by the rather lumpy texture of the areas containing smalt, distinguishing them from the green paint which has discoloured to a similar brown. Smalt has often survived better when mixed with lead white, probably because the paint is less medium-rich. In Christ's cloak only a very small amount of lead white was mixed with smalt, however, and in the purple draperies of other figures smalt was mixed only with red lake.

Deterioration of smalt has also affected the appearance of the Virgin's blue cloak, although in a more subtle way. The smalt-containing underpaint, now a brownish-yellow colour, is visible at the surface where the well-preserved upper layer of ultramarine-containing paint was thinly applied. Smalt was also used, mixed with red lake, for purple draperies such as the robe of the man sitting in the left corner, which is now brown. It was clear, from looking at the surface of the smalt-containing areas with a stereomicroscope, that originally a wide variety of purple and purplish-blue hues had been used. The robe of the figure in a red cloak at the extreme left edge must have been a dark purple, as it was painted with a layer of smalt over a dark red lake underpaint. The robe of the bearded figure immediately beside him was painted in a similar way, but appears to have been a lighter purple (PLATE 4). The cloak of the figure in front of the column on the left, behind the man in a dark brown cloak, was perhaps a purplish blue, since the underpaint contains discoloured smalt, with red lake only in the shadows.

The upper layer appears to contain only smalt. These paints are all very translucent, which has probably exacerbated the effect on the appearance of any changes in the pigments. The cloak of the woman with her arms crossed on the right of the composition, also originally purple, is painted with a mixture of ultramarine, lead white and red lake in highlights, with strokes of smalt in areas of shadow. The mid-tones contain a great deal of red lake, with some blue pigment, so the cloak perhaps originally had a reddish-purple hue. These descriptions of the pigment mixtures observed with the stereomicroscope highlight the problem of determining with any degree of accuracy the original colour of paint mixtures that have deteriorated.

PLATE 5 *The Conversion of the Magdalen.* Photomicrograph of Christ's sleeve. The original deep pink colour, which survives below the surface, is visible through small paint losses.

Fading of red lake

Severe fading of the red lake pigments in this painting has occurred, and this must also have affected the purples described above. Christ's robe is now a very pale pink, but the unfaded deep pink colour that still survives beneath the surface is visible with a stereomicroscope through cracks in the paint (PLATE 5). The fading has exaggerated contrasts in the modelling of the drapery, as red lake fades more quickly when mixed with lead white.[18] The fading is so extreme in this case that the highlights and mid-tones are now the same colour, and the still-red shadows look very stark as they no longer blend in to the colour of the mid-tones. Fading of red lake has also affected many of the other figures. The similarly high contrast of the shadows on the orange cloak of the old bearded figure sitting on the step indicates that it has been affected by fading of red lake. The Virgin's dress, painted with red lake and white, and salmon-pink strokes which probably contain vermilion, is now rather greyish. The Magdalen's cloak has also faded, as has the diamond pattern on the floor tiles and the dress of the woman sitting in the foreground with a child, which appears to have been painted with only a thin translucent glaze of red lake directly on the ground layer.

Less obvious is the fading of a red glaze on the cloak of the figure at the extreme left edge. The solid vermilion colour has survived well, but the highlights, now completely white, are glazed with red lake that has now faded and would originally have blended in to the darker orange-red colour of the rest of the cloak (PLATE 3).

A sample of red lake pigment from the dress of the woman at the extreme right edge was analysed and found to contain a dyestuff derived from the cochineal insect.[19] It seems very likely that the same red lake pigment was also used elsewhere in the painting.

Discoloration of copper-containing glazes from green to brown

The cloak of the bearded man in a yellow robe near the column on the left was originally green. The lower layers (yellow lake, ultramarine, azurite and lead-tin yellow) remain green but are totally obscured by a copper-containing glaze which is now dark brown (PLATE 3). The modelling in the green draperies has been lost as a result, since the modelling in the underpaint would originally have been visible through the transparent green glaze. This method of painting is not dissimilar to the 'new way for making green drapery' described by Armenini in 1587, using a mixture of yellow lake and smalt for the underpaint, then applying a thin glaze of verdigris mixed with 'common varnish' (a mixture of linseed oil and resin).[20]

Verdigris can react with the oil or resin in the medium, forming a transparent green glaze in which no discrete pigment particles are visible. This type of glaze has often been referred to as 'copper resinate' (whether or not the presence of a copper-resin acid salt has been confirmed by analysis),[21] but recent studies of treatises on painting technique indicate that the mixtures of the type described by Armenini were most often used.[22] Transparent copper-containing green glazes can be very well-preserved, but often show different degrees of discoloration, sometimes browning only slightly at the surface or, as in this painting, becoming brown throughout. It is not clear

why they survive so well in some paintings while in others they discolour. Light clearly plays a part, since in some paintings the original green colour has survived where the paint has been protected by the frame rebate, but has become brown where exposed.[23] The composition of the glaze may also be significant, and is worth examining in detail.

Copper was detected in the brown glaze by EDX analysis, but no pigment particles were visible in a thin section under the microscope, nor was there any sign of the original green colour, and the copper was evenly dispersed throughout the layer (PLATE 3). The organic components identified in the glaze were linseed oil and a little resin, in similar proportions to that found in a red lake glaze, confirming that resin is present as an addition to the medium in the green glaze rather than as a 'copper resinate' pigment. The FTIR spectrum does, however, show evidence of copper-resin acid and copper-oil interactions. It seems likely that the paint film was pigmented with verdigris but, since there are no acetate bands in the FTIR spectrum, it appears to have reacted completely with the binding medium.[24] A very small amount of chlorine was also detected by EDX analysis, as well as a calcium-containing layer above the glaze.[25] Previous studies have sometimes found calcium, probably in the form of calcium carbonate, in or above copper-green glazes in paint samples, which could be interpreted as being a yellow lake pigment on a chalk substrate.[26] In this painting, however, residues of a calcium-containing material were also seen at the surface of samples from other colours, so it does not seem to be part of the original paint.

Other areas which were originally green, distinguishable from the browned purple paint by their darker appearance in the infra-red photograph and by examination under the stereomicroscope, include the brown robe of the man sitting on the steps in front of Christ, the brown circle pattern on the floor tiles, the cloak of the bearded figure near the left edge, and the robe of the small figure sitting in the background just to the left of the Virgin. The brown glaze on the standing figure from which a sample was taken is thinner than on other green areas, suggesting that it was intended to be a lighter green.

Reconstruction of the altered colours by digital imaging

The pigment degradation on *The Conversion of the Magdalen* has destroyed the balance of colours on the painting, but has to be accepted as an irreversible change. Some impression of how it would have

PLATE 6 Painted-out strips of colour imitating the pigments and layer structure of the pink and blue draperies in *The Conversion of the Magdalen*.

appeared if the pigments had not deteriorated was attempted, however, by applying image-processing techniques to a digital image of the painting.[27]

Since there were no well-preserved areas of the unstable pigments on the painting, colorimetric measurements on painted-out samples matching the pigment mixtures and the layer structures were used as a reference (PLATE 6). For the smalt and red lake pigments this posed some problems. Smalt manufactured to a nineteenth-century recipe is available today, but contains a higher percentage of cobalt than smalt in sixteenth-century paintings and none of the impurities that are commonly found in the glass.[28] The modern smalt is much stronger in colour, so for the reconstruction it was extended with finely ground alumina, to try to simulate the colour of sixteenth-century smalt. In fact this is a difficult judgement to make, since in paintings of the period smalt has always degraded. It is better preserved in some seventeenth-century paintings, however, particularly where mixed with lead white, and these served as a guide.[29] The smalt was also ground to reproduce the average particle size of the smalt in the painting, as this also has an influence on the colour. A red lake prepared to an old recipe with dyestuff from the cochineal insect was painted out mixed with varying proportions of lead white.[30] Comparison with the deep shadows on Christ's red robe, which retain their red colour, made it clear that the hue of the test plate was more purple than the red lake used in the painting. This highlights a subtle change towards a more yellow hue that occurs relatively quickly in red lakes on ageing.

Reconstructed images of the figure groups on the left and right side of the painting, and of the figure of Christ, are illustrated in PLATES 7, 8 and 9. The deep saturated colours which replace the deteriorated brown, although rather flat because of the loss of modelling which cannot be reconstructed, balance

PLATE 7 Digital image showing the reconstructed colours of the draperies of the principal figures on the left of the image.

PLATE 8 Digital image showing the reconstructed colours of the draperies of the figures at the right of the image.

well with the well-preserved draperies painted with vermilion and ultramarine.

Discussion

The National Gallery painting in its current state is very different in appearance from the painting of the same composition in the Borghese Collection in Rome, which was made from it soon afterwards – certainly not more than a few decades later. It is not an exact copy, so there can be no certainty that its creator felt obliged to follow the colour scheme of his model. Nevertheless, analysis of the pigments in the discoloured paint, and the digital reconstruction of the colours in the National Gallery painting made on the basis of this information, suggests that in most of the figures the draperies were originally the same colour. But in the Borghese version they are well-preserved – there are no dead greys and browns where brilliance would be expected, and no sudden transitions to deep shadow. An unexpected consequence of the comparison was that it drew attention to some other colour changes in the National

Gallery's painting that had not been suspected – most notably, the yellows are rather grey. A closer look at a sample from a yellow drapery showed that there is a thin greyish layer on the surface of the paint, probably a residue of an old surface coating.[31] This residue is also present over the sky and architecture, and was seen on the surface of samples from the browned greens and purples, although it is unlikely that it has a significant visual effect on these darkened colours.

The fact that the colours in the two paintings were for the most part originally the same does not mean that the same pigments were employed. The artist of the National Gallery's painting used smalt for Christ's cloak (an aesthetic choice rather than an economy measure since he used ultramarine elsewhere) whereas ultramarine was, it seems, used for this area in the Borghese painting, explaining the difference in the state of preservation. However, the better condition of areas painted in red lake in the Borghese painting is strong evidence that it has not been subjected to such harsh environmental conditions as the National Gallery painting. Different red

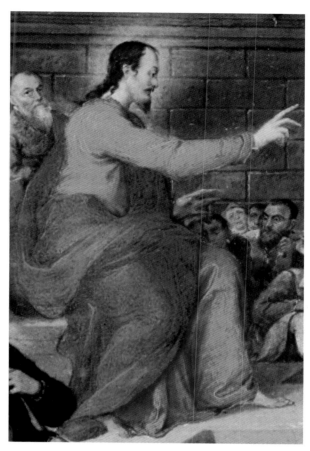

PLATE 9 Digital image showing the reconstructed colours of Christ's drapery.

lake pigments are not so spectacularly different in stability, nor has a particularly fugitive dyestuff been used to make the red lake in the National Gallery painting.[32] The Borghese picture has spent almost all its life in two collections in the same city, whereas the National Gallery's picture has belonged to at least half a dozen collections and has passed on at least three occasions through the art trade, but too little is known about the conservation history of these paintings, and the conditions in which they have been kept, to explain the difference in preservation.

Conclusion

The detailed technical examination of *The Conversion of the Magdalen*, and the process of reconstruction of the colours in the digital image, has produced some deeper insight into how the deterioration of pigments has affected the colours in the painting. Although the strong and deep colours of the reconstruction initially seemed rather startling, they receive strong support from comparison with the Borghese version of the painting – which is espe-

cially gratifying since the reconstruction was made before the transparency of the Borghese painting was available to us. The reconstruction is not, of course, an accurate portrayal of the original appearance of the painting – the lost modelling in some of the draperies cannot be recreated, and the colour was only reconstructed in the most seriously affected principal figures. It does, however, give some idea of the original balance of colour of the National Gallery painting, showing that the colours in the two paintings must originally have been very similar, and provide a striking illustration of what can happen to blue, pink and green in a sixteenth-century Italian painting.

Acknowledgements

Clare Richardson carried out the computer reconstruction of the colours in the painting and painted test panels simulating the painting technique, a major contribution to the paper. We would also like to thank Jo Kirby and Catherine Higgitt for their contributions to the analysis of the paint samples.

Notes and references

1 The panel is approximately one centimetre thick and is painted on pear wood, identified by B.J. Rendle of the Forest Products Research Laboratory in a letter of 20 September 1945 in the Gallery's archive and confirmed as such in a recent examination.

2 This was first noticed by Philip Pouncey (without knowledge of Grimani's will) – see the addendum to Paola della Pergola's article, cited below in note 11, in *Bollettino d'Arte*, XL, 1995, pp. 83–4.

3 For Federico Zuccaro in Venice see W. Roger Rearick, 'Battista Franco and the Grimani Chapel', *Saggi e Memorie di Storia dell'Arte*, II, 1958–9, pp. 122–35, and Hermann Voss, 'A Project of Federico Zuccari for the "Paradise" in the Doges' Palace,' *Burlington Magazine*, June 1954, pp. 172–5.

4 *Disegni degli Zuccari*, Galleria degli Uffizi, Florence 1966, cat. 47, pl. 34, no. 47; also E. James Mundy, *Renaissance into Baroque. Italian Master Drawings by the Zuccari*, catalogue of exhibition held at Milwaukee Art Museum and elsewhere, Milwaukee 1984, pp. 173–5. What appears to be the artist's final composition is the Uffizi drawing (sent by Federico to Vasari) but it is clear that Zuccaro's earlier idea for the composition was closer to that seen in the National Gallery's picture. The latter may have been based on a drawing rather than on the fresco.

5 Archivio di Stato di Venezia, Notarile testamenti, Busta 658, no. 396 (Vettor Maffei), 29 August 1592. Michel Hochmann kindly provided a transcription of the relevant patronage and Carol Plazzotta made a fuller tran-

scription of his will for the Gallery's dossier. The will is published and the connection with the National Gallery's painting was first pointed out by M. Mantovanelli Stefani, 'Il testamento di Giovanni Grimani patriarca d'Aquileia. Glosse a una fonte per il collezionismo veneziano rinascimentale' in *Idem, Arte e committenza nel Cinquecento in area veneta fonti archivistiche e letterarie*, Padua 1990.

6 Full details of the provenance will be supplied in Nicholas Penny's forthcoming catalogue. It is noteworthy that John Young in his *Catalogue of the Pictures at Leigh Court*, London 1822, no. 29, p. 16, recorded (or himself invented) the idea that the picture included portraits of Francis I, Queen Elizabeth, Bembo, Titian, etc. – nonsense repeated in the Leigh Court sale catalogue (Christie's, 28 June 1884, lot 8) which does, however, acknowledge the interpolated character of the portraiture and the fact that some of the hairstyles and dress date from earlier in the century.

7 The attribution is found in Luigi Lanzi, *Storia Pittorica dell'Italia*, Bassano 1795–6 (see edition of Florence 1968, I, p. 319). Lanzi seems to have known of Grimani's patronage of the artist and of Grimani's will. He may then have looked for a suitable Pieter among documented Flemish artists. He refers only to Palomino, which would suggest that he was searching for an artist who had worked in Spain, and that he already had the name Campaña. The problem of how Lanzi came up with Campaña's name is a major obstacle to acceptance of Meijer's hypothesis discussed below.

8 Cecil Gould, *National Gallery Catalogues; The Sixteenth Century Italian Schools*, London 1975, pp. 333–5, classified the painting as by a 'pasticheur' of Zuccaro – the style used by Neil Maclaren (*National Gallery Catalogues; The Spanish School*, London 1970, p. 144), whose dismissal of the connection with Campaña is recorded in notes in the National Gallery's dossier.

9 For Campaña see Nicole Dacos, 'Fortune Critique de Pedro Campaña', *Revue belge d'archéologie et d'histoire de l'art*, 53, 1984, pp. 108–16. It should be said that the attempts to reconstruct an Italian period in Campaña's production based on the dubious and contradictory claims made by his Spanish biographers by Dacos and other authors are highly conjectural.

10 Bert W. Meijer, 'Pieter Cornelisz.van Rijck and Venice', *Oud Holland*, 113, 3, 1999, pp. 137–52, especially p. 141.

11 The painting entered the Borghese Collection from that of the Aldobrandini. It was recorded as by Taddeo Zuccari (and the panel is endorsed with this attribution) at least as early as the inventory of Olimpia Aldobrandini's paintings in 1682. Adolfo Venturi (*Catalogo della Galleria Borghese*, Rome 1893, p. 103) proposed Carletto Caliari as the artist; Roberto Longhi (*Precisioni: la galleria Borghese*, 1928, p. 192) preferred 'un manierista venezianeggiante' of the period 1570–90; Paola della Pergola ('Contribuiti per la Galleria Borghese', *Bollettino d'Arte*, XXXIX, January–March 1954, pp. 135–6) made the case for Luca Longhi.

12 B. Mühlethaler and J. Thissen, 'Smalt', *Artists' Pigments. A Handbook of Their History and Characteristics*, 2, ed.

A. Roy, Washington 1993, pp. 113–30.

13 J. Plesters, 'A Preliminary Note on the Incidence of Discoloration of Smalt in Oil Media', *Studies in Conservation* 14, 1969, pp. 62–74. Joyce Plesters demonstrated that leaching of alkali from smalt pigment occurs when it is immersed in water. Her observation that a sample of smalt-containing paint from *The Adoration of the Shepherds* (NG 232 Italian, Neapolitan) is more deteriorated near the surface suggests that atmospheric moisture plays a part. Water is known to be a primary environmental agent causing deterioration of the glass itself, see R. Newton and S. Davison, *Conservation of Glass*, Oxford 1989, p. 135. Water causes alkali extraction, resulting in a leached layer at the surface of the glass, with an associated reduction in volume. Eventually the silica network is attacked by the alkaline surface that develops and other ions can migrate out.

14 R. Giovanoli and B. Mühlethaler, 'Investigation of Discoloured Smalt', *Studies in Conservation*, 15, 1970, pp. 37–44. Giovanoli and Mühlethaler propose that a change in the environment of the cobalt ion causes a loss of colour. This could occur with or without migration of the cobalt into the medium.

15 Mühlethaler and Thissen, cited in note 12.

16 Newton and Davison, cited in note 13, p. 7.

17 An attempt at quantitative analysis of a smalt particle in a sample from this painting gave concentrations of approximately 7wt% As, 4wt% Co, 3wt% Fe, 1wt% K, 1wt% Bi and 0.5wt% Ni. This serves only as a rough guide to the relative quantities of these elements, however. Very few quantitative analyses of smalt particles on paintings have been published.

18 D. Saunders and J. Kirby, 'Light-induced Colour Changes in Red and Yellow Lake Pigments', *National Gallery Technical Bulletin*, 15, 1994, pp. 79–97.

19 We are grateful to Jo Kirby for identification of the dyestuff as cochineal by HPLC analysis.

20 G.B. Armenini, *De' veri precetti della pittura*, Ravenna 1587, Libro Secondo, p. 193.

21 H. Kühn, 'Verdigris and copper resinate', *Artists' Pigments. A Handbook of Their History and Characteristics*, 2, ed. A. Roy, Washington 1993, pp. 131–58.

22 K.J. van den Berg, M.H. van Eikema Hommes, K.M. Groen, J.J. Boon, B.H. Berrie, 'On Copper Green Glazes in Paintings', *Art et Chimie, la couleur*, Actes du congrès, Paris 2000, pp. 18–21.

23 For example the stripes on the tablecloth in Giampetrino's *Salome* (NG 3930). See L. Keith and A. Roy, 'Giampetrino, Boltraffio, and the Influence of Leonardo', *National Gallery Technical Bulletin*, 17, 1996, pp. 4–19.

24 Addition of a little pine resin and sandarac to the linseed oil seems to be standard throughout, as the same results were obtained for GC–MS analysis of the organic components of white paint. The FTIR spectrum is broad, with an intense broad band centred at 1640–50 cm^{-1}. Deconvolution of the FTIR spectrum reveals bands for copper–resin acid salts (1608–18 cm^{-1}), copper–fatty acid salts (1584–7 cm^{-1}), as well as bands ascribed to the car-

boxylate of resin acids (1698 cm^{-1}) and bands at 1778, 1745–30 and 1710–12 cm^{-1} corresponding to various absorptions of the drying oil. The breadth of the band centred at 1640–50 cm^{-1} seems to suggest the presence of additional species absorbing in this region. The presence of unsaturated condensation products could account for the observed features. The band at 692 cm^{-1} present in fresh verdigris in oil is entirely absent, and, unlike the major IR bands in verdigris, is not likely to be obscured by bands from any other components in the film.

25 EDX analysis detected a certain amount of silicon and potassium, as well as calcium in this layer. FTIR analysis suggested the presence of protein. Fine black particles can be seen in this layer when examining it under the optical microscope. It is this layer that is responsible for the rather grey appearance of the yellow draperies in *The Conversion of the Magdalen*, although it is unlikely that it has much of an optical effect on the brown discoloured areas. It is not at all clear what this layer is; the inorganic material could be residues of dirt and dust that have become embedded in an old surface coating, possibly an egg-white varnish.

26 Van den Berg et al., cited in note 22.

27 The technical details of the process of reconstruction of the colours by image processing on the digital image will be described elsewhere.

28 The smalt pigment was supplied by Kremer-Pigmente. EDX analysis indicated that it contains a higher proportion of cobalt than is found in samples from sixteenth-century paintings, and no impurities at all.

29 The skies in the landscape paintings of Aelbert Cuyp are invariably painted with smalt, which in most cases is exceptionally well preserved.

30 For the method used to make the red lake pigment see Saunders and Kirby, cited in note 18, pp. 96–7 (cochineal lake CDⅠb).

31 The painting was recently cleaned by Martin Wyld. The greyish residue in these areas was left, as it could not be removed without possible damage to the paint layer.

32 The dyestuffs most commonly found in red lake pigments do differ to some extent in their stability to light. Cochineal, the dyestuff found in the red lake in this painting, is of intermediate stability, being more stable than madder, but less stable than brazilwood. See Saunders and Kirby, cited in note 18.

A Survey of Nineteenth- and Early Twentieth-Century Varnish Compositions found on a Selection of Paintings in the National Gallery Collection

RAYMOND WHITE AND JO KIRBY

IF, IN THE YEARS AROUND 1850, anyone had solicited the opinions of restorers and those in charge of major collections of pictures on the most suitable picture varnish, the majority would have given one answer: mastic varnish. In fact, such opinions were canvassed as part of the evidence given to the 1853 Select Committee on the National Gallery and presented to the House of Commons, and the answer is summarised in one sentence in the resulting Report. 'The species of varnish which has long been generally preferred in this country, and throughout Europe, as best calculated both to protect the surface of a picture, and to preserve its colour and cleanliness, is that called mastic varnish, consisting of the gum or resin of the mastic tree, combined with spirits of turpentine.'[1] A study of printed sources, from handbooks for restorers or amateur painters to books on the technology of varnish manufacture, suggests that mastic retained its position as the principal resin from which picture varnishes were made, through the nineteenth century and into the twentieth. However, alternative varnishes, based on other resins, were available and preferred by some.

In a short handbook for painters published by the colourman George Rowney in 1859, Charles Martel summarised the essential qualities of a good picture varnish: transparency; durability and hardness; freedom from colour; speed of drying.[2] As these properties depend on the resin and solvent used, the popularity of the basic mastic varnish is easy to understand. It was described as brightening or giving lustre to the colours and preserving the paint surface from dirt, pollution and what nineteenth-century authors describe as 'atmospheric changes'. Other varnishes, such as that prepared from copal resin, melted, or 'run', and heated with drying oil, would do this, but the varnish of mastic in turpentine had the advantage that it was easy to prepare, it dried quickly and, above all, it was relatively easy to remove, either by friction or solvent action.[3] It was also thought to darken less. The painter William Dyce, giving evidence to the Select Committee, agreed that mastic varnish would yellow, but not to the same extent as a varnish containing oil.[4]

Those giving evidence to the 1853 Select Committee, and most writers on picture conservation, were united in their criticism of copal/oil varnish. The restorer John Seguier, employed by the National Gallery from 1843, told the Committee that it should not be used as it was almost impossible to remove.[5] In his evidence, the 'picture cleaner' Retra Bolton commented that an oil varnish discoloured more quickly and had a greater tendency to disfigure a picture than mastic varnish, as it became browner and attracted more dust. Unlike mastic, it required the use of alkali to remove it.[6] Charles Dalbon, writing rather later, in 1898, thought copal and drying linseed oil varnish should never be used: it was always yellowish-to-brown, a colour accentuated by time. As the varnish lacked fluidity it was hard to spread and formed a rather thick coat (a comment also made by Bolton). It also provoked cracking and to attempt removal was dangerous to the picture.[7] On the other hand, a few nineteenth-century writers thought the very hardness, toughness and permanence of copal/oil varnishes to be an advantage; the relatively thick varnish film was also thought to be helpful if the painting had an irregular surface.[8]

It seems that dammar varnish was not widely known in England in the early 1850s. The dried residues of varnish in a bottle found in the studio of J.M.W. Turner after his death in 1851 were identified as containing dammar, but Turner was interested in trying different materials and it is impossible to know how typical his use of the varnish was.[9] The restorer Henry Farrer, who made his own dammar varnish, told the Select Committee that he knew nobody in England who used it, apart from himself. He had first heard of dammar on the Continent and found it preferable to mastic, not least because he thought it less liable to 'chill' (bloom), a common problem with mastic varnish.[10] According to the Baron de Klenze, Chamberlain to the King of Bavaria, who presented comparative evidence on the Munich galleries, only the use of mastic in

1. tirucallone 2. tirucallol 3. nor-β-amyrone 4. β-amyrone 5. β-amyrin 6. moronic acid
7. oleanonic acid 8. ocotillone type 9. trisnorlactone 10 & 11. (iso)/masticadienonic acids
12. 11-oxo-oleanonic acid

FIG. 1a Total ion chromatogram of mastic varnish from *A Family Group* (NG 1699), attributed to Michiel Nouts; the varnish was applied in 1915. Small amounts of residual tirucallol and some of the corresponding ketone are present as well as traces of β-amyrone. Moronic acid appears as the major component, with oleanonic acid; traces of masticadienonic acids still persist.

FIG. 1b Total ion chromatogram of mastic varnish showing more advanced oxidation, taken from Fra Filippo Lippi's *Saint Bernard's Vision of the Virgin* (NG 248); the varnish was applied in 1856. The principal components are as in FIG. 1a. Traces of β-amyrone remain and the corresponding nor-compound is now seen clearly; no masticadienonic acids can be detected. Some ocotillone-type components and a trace of 11-oxo-oleanonic acid can be seen.

FIG. 1c Chromatogram given by a highly degraded mastic varnish, obtained from Leandro Bassano's *Tower of Babel* (NG 60); the varnish was applied after 1853 and in or before 1855. Moronic acid dominates the chromatogram and 11-oxo-oleanonic acid has become quite susbtantial.

turpentine spirits had formerly been permitted. However, for the last ten years or so a varnish of dammar in turpentine spirits, with a little alcohol, had been used in preference to mastic: it was less likely to cause cracks in the paint and he thought less liable to darken. Dammar was also about nine times cheaper, which must have been a significant factor. The varnish was also used elsewhere in Germany and had recently been introduced into Florence.[11] This was confirmed by another Select Committee witness, W.B. Spence, who had observed restorers in the Uffizi, Florence, filtering the dammar varnish which they obtained from France; they had used it for about a year.[12] This would suggest that dammar varnish, the use of which was apparently first reported by Lucanus in 1829, was in use in Germany in the early 1840s, while its introduction to other parts of Europe may have been more gradual.[13] It is interesting, therefore, that dammar was identified (with mastic and fir balsam) in the discoloured varnish on *The Adoration of the Shepherds* (NG 1858), by an unknown follower of Jacopo Bassano, bequeathed to the National Gallery by Sir John May in 1847, but not exhibited

until many years later (see Table, p. 82).[14] If, as seems probable, the varnish was applied before the painting entered the National Gallery, this would be a relatively early use for the resin. From the 1850s, the sources and properties of dammar are discussed with markedly greater authority: Ulisse Forni, for example, writing in 1866, was able to write with some conviction that dammar was preferable to mastic as a varnish (or as a retouching varnish) for tempera paintings as it yellowed less.[15] One may even speculate that Forni, who had worked as a restorer in Florence for twenty years by the time his book was published, was one of those questioned by Spence.

Many restorers commented in their writings on materials other than varnishes that might have been applied to a painting to improve its appearance, some of which were difficult to remove once aged. These included drying oil, animal fat and egg white and it seems they were still in use.[16] 'Refreshing' the paint surface (or even a decaying varnish) was a common practice during restoration. Forni discussed the use of oil of spike lavender to refresh tempera paintings and it is interesting that the use of a similar

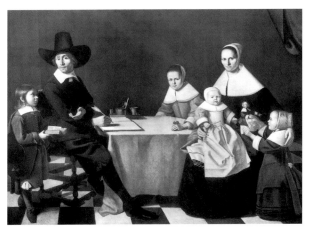

FIG. 2 Attributed to Michiel Nouts, *A Family Group* (NG 1699), *c.*1655. Canvas, 178 × 235 cm.

PLATE 1 Attributed to Michiel Nouts, *A Family Group* (NG 1699). Detail of right foot of man. The varnish layer is discoloured, but not otherwise deteriorated.

material has occasionally been observed on paintings in the National Gallery.[17] One example is Fra Filippo Lippi's *Saint Bernard's Vision of the Virgin* (NG 248), which was in the collection of E. Joly de Bammeville, Paris, by 1850 and bought from its sale in 1854.[18] Beneath layers of mastic varnish applied in 1856 and 1882, traces of a polyterpene material (now oxidised) were present immediately above the paint. These probably derived from a layer of spike oil, or something very similar, applied to the rather lean paint at some point before it entered the National Gallery.

The prevalence of mastic varnish suggested by the literature is confirmed by a survey of results obtained from the examination of varnishes applied to pictures in the National Gallery during the nineteenth and early twentieth centuries, the analytical methods used being gas chromatography–mass spec-

troscopy (GC–MS) and Fourier transform infrared spectroscopy (see Table, pp. 81–4). In some cases results were obtained from residues of one or more earlier varnishes beneath the existing surface coating. Many of these varnishes were applied before the painting concerned entered the collection and it can be deduced from what is known of the history of individual paintings that some varnishes were European in origin. Both analytical results and written sources indicate that the basic recipe of mastic dissolved in spirits of turpentine was often modified by the addition of other resins or oil with the aim of altering the characteristics of the final varnish.

Mastic varnish

By far the most common varnish composition found in this survey was that based on mastic resin, that is, resin derived from a *Pistacia* sp. source. As with any organic natural product, exposure to light, air and other atmospheric conditions inevitably causes changes to the chemical constituents originally present.[19] However, the range of variation in the composition of the mastic terpenoids observed is surprising given that all the varnishes examined are similar in age: 100–150 years old. Three examples of the chromatograms obtained are shown in FIG. 1. In each, moronic acid, the principal identifying indicator of mastic, is abundantly evident; in some cases traces of the more vulnerable masticadienonic and iso-masticadienonic acids remain, while in others they are entirely absent.

FIG. 1a exhibits the typical characteristics of a moderately aged fairly thick mastic varnish film, from *A Family Group* (NG 1699), attributed to Michiel Nouts (FIG. 2, PLATE 1); the varnish was applied in 1915. Small amounts of residual tirucallol and some of the corresponding ketone are present. Moronic and oleanonic acids predominate, with only minor amounts of masticadienonic acid and its isomer, as well as the corresponding O-acetyl analogues. A minor amount of 11-oxo-oleanonic acid is apparent at higher retention times. Small amounts of components usually referred to as ocotillones, because of their predominant base peak at $m/z = 143$ and very weak higher mass spectral region, are also evident.[20] In this article the term 'ocotillone-like' components is preferred, and it is proposed that they will be the subject of another paper. FIG. 1b shows the total ion chromatogram (TIC) of a mastic varnish layer from Lippi's *Saint Bernard's Vision of the Virgin*, which was applied in 1856 by John Bentley. This layer exhibits a somewhat more advanced state

FIG. 3 Attributed to Girolamo da Treviso, *The Adoration of the Kings* (NG 218), probably 1525–30. Wood, 144.2 × 125.7 cm.

of oxidation. Here, moronic acid is quite evident, but oleanonic acid content has been reduced and a significant increase in the proportion of the 'ocotillone types' has occurred. Tirucallol has entirely disappeared and a minor trace of tirucallone, the principal oxidation product of tirucallol, and β-amyrone can be detected. 11-oxo-oleanonic acid content is quite pronounced. The chromatogram in FIG. 1c shows the results from a highly degraded residue of mastic varnish, where the structure of the upper surface of the varnish film has partially disintegrated. The sample was obtained from Leandro Bassano's *Tower of Babel* (NG 60), painted after 1600; the varnish was applied at some time after 1853 (and possibly in or before 1855) over an even earlier varnish, composed of mastic and heat-bodied linseed oil, applied between the acquisition of the painting in 1837 and 1853.[21] These variations between the three varnish films may perhaps have been caused in part by factors such as their different thicknesses, differences in their immediate environments – in other words, the constitution of the paint or varnish layers immediately below and above them – or even the different ambient conditions to which the paintings were exposed before they came into the collection.

Probably the only source of mastic available for conservation purposes during the nineteenth and early twentieth centuries was that derived from *Pistacia lentiscus* var. *chia*. It was usually obtained in

a characteristic form resembling tears, produced as the resin trickled down the tree from cuts in the bark and solidified. Resin that fell to the ground was also collected and was known as common mastic.[22] As a triterpenoid-based material, mastic resin is for the most part composed of non-polymerising molecular species and must thus be classed as a 'soft' resin.[23] Whatever the source of the mastic resin, some relatively low molecular weight isoprene-related polymer is present.

The importance of allowing mastic, and, indeed, all varnish preparations, to mature for at least six months to a year was often emphasised. In his evidence to the Select Committee, W.B. Spence, for example, said that he never trusted people who sold varnish ready prepared as it was often sold before it was seasoned: 'All varnish, especially mastic, if not kept, has a very deleterious effect upon pictures.'[24] Probably the maturation period would bring about two important changes in the composition of the resin varnish formulation. First, it would allow unstable oleanonic aldehyde to oxidise to the corresponding acid; secondly, it would afford time for the production of more polymeric material. The effect, as far as the restorer was concerned, would be to allow any cloudiness to clear or to settle out and to improve brushability: the increased polymer content would improve the rheological properties of the varnish.

Mastic/oil varnishes

In the varnishes examined, the mastic was sometimes used without any additives, but often it had been plasticised with a little drying oil. Several examples are given in the Table (pp. 81–4), a typical instance being that from *The Adoration of the Kings* (NG 218), attributed to Girolamo da Treviso (FIG. 3), which was composed of mastic resin mixed with heat-bodied linseed oil. This varnish was probably applied in 1849 and certainly before 1853. In most cases, the palmitic/stearic ester ratios in the picture varnishes examined were indicative of the use of linseed oil, sometimes heat-bodied or partially so, sometimes not. In only one varnish examined was a plasticising drying oil other than linseed or walnut oil employed, and that appeared to be poppy-seed oil.

The addition of a small quantity of pre-polymerised, or bodied, oil to the varnish would have been expected to make it more resistant and also to improve its ability to level out minor uneven areas in the paint surface. As long as this addition was indeed

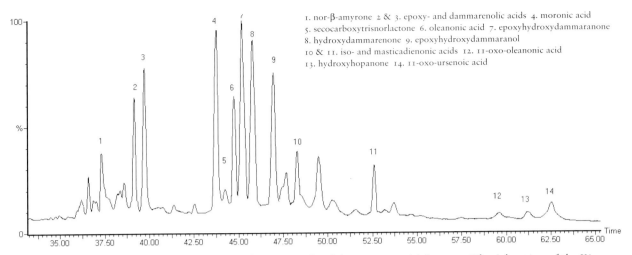

1. nor-β-amyrone 2 & 3. epoxy- and dammarenolic acids 4. moronic acid
5. secocarboxytrisnorlactone 6. oleanonic acid 7. epoxyhydroxydammaranone
8. hydroxydammarenone 9. epoxyhydroxydammaranol
10 & 11. iso- and masticadienonic acids 12. 11-oxo-oleanonic acid
13. hydroxyhopanone 14. 11-oxo-ursenoic acid

FIG. 4 Total ion chromatogram (TIC) obtained from a sample of the upper varnish layer on *The Adoration of the Kings* (NG 218), attributed to Girolamo da Treviso, applied in 1887. Hydroxy- and epoxy-hydroxy-dammarene-related ketone and acid components dominate this TIC, suggesting the presence of dammar resin. The significant content of moronic acid points to admixture of the dammar with mastic resin.

small it would not have rendered the varnish markedly difficult to remove, as the solubility properties of the mastic would have overwhelmed those of the oil. The use of heat-bodied oils to strengthen and toughen the varnish film seems logical in view of their reduced propensity for yellowing, if properly made, and reduced shrinkage on drying. In the laboratory, at least, it has been observed that non-bodied oils mixed with triterpenoid resin have less satisfactory rheological properties and the films have a greater tendency to wrinkle, although this has never assumed severe proportions. Certainly, non-bodied oil/soft resin formulations appear to have inferior levelling effects when applied to a more textured surface and appear to be more prone to sinking in absorbent passages than varnishes with additions of bodied oil, and, surprisingly, even more so than mastic alone.

Another reason put forward for the addition of oil was to reduce the tiresome tendency of mastic varnish to bloom, that is, to develop a cloudy appearance. This was the reason given by John Seguier, the restorer employed by the National Gallery from 1843, to the Select Committee for his use of a mastic varnish mixed with linseed oil, originally at the suggestion of his brother William, Keeper of the National Gallery until 1843. However, in the words of the 1853 Report, 'The effect of this mixture is stated to be, that it renders the mastic more liable to discoloration, and that it imparts to it a greater tendency to attract dirt and noxious effluvia.'[25] It was also said to become hard and difficult to remove. The explanation for this lay in the amount of oil present. John Bentley, who was subsequently employed by the

Gallery on the care of the pictures, said that he had been informed that the so-called 'Gallery varnish' consisted of approximately half mastic varnish and half 'light drying oil' stirred together and left to

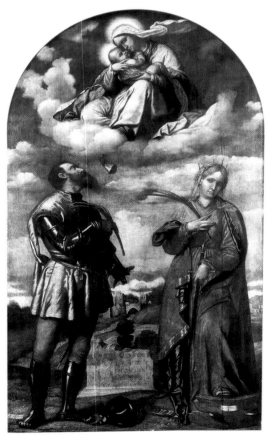

FIG. 5 Moretto da Brescia, *The Madonna and Child with Saints Hippolytus and Catherine of Alexandria* (NG 1165), *c*.1538–40. Canvas, painted surface 229.2 × 135.8 cm.

1. α- and β-amyrins 2. α- and β-amyrones 3. moronic acid 4. oleanonic acid
5. tetracyclic elemi acids 6. oxidation products of elemi acids

FIG. 6 Total ion chromatogram of the upper varnish layer on *The Madonna and Child with Saints Hippolytus and Catherine of Alexandria* (NG 1165), by Moretto da Brescia; the varnish was applied in 1891. The presence of significant amounts of moronic acid shows the presence of mastic resin in this varnish; however, it is clear from the amyrin/amyrone content and acids derived from the euphane group that a Burseraceous resin is also present. Elemi resin is the most likely candidate.

stand; spirits of turpentine were then added and it was stirred again, at repeated intervals. It was, in other words, a variety of the painting medium megilp ('maguylp'), which Seguier, who had no idea of its formulation, bought ready-made.[26] Indeed, its formulation may well have varied from batch to batch, but the traces of darkened, oil-containing mastic varnish found on, for example, Leandro Bassano's *Tower of Babel* and other paintings that came into the collection before 1853 (see Table) are probably remnants of 'Gallery varnish'.

Mastic with triterpenoid resins: dammar and elemi

Several mastic-based formulations were identified in which at least one other resin had been incorporated. Broadly these may be divided into those containing a triterpenoid resinous addition, such as dammar, and those where a diterpenoid resin, such as pine resin, fir balsam, Venice turpentine (larch resin), sandarac or copal, had been added.

An example of the first type is shown in FIG. 4, the chromatogram given by a sample of the upper varnish layer from *The Adoration of the Kings*, attributed to Girolamo da Treviso. The painting was varnished around the time it came into the collection in 1849 with 'Gallery varnish';[27] this was confirmed by GC–MS analysis of traces of a lower varnish layer, adjacent to the paint, discussed above. This varnish was largely removed during cleaning and repair by Dyer in 1887, at which time the painting was revarnished. In this later varnish, mastic resin has been mixed with a significant quantity of dammar, indicated by the presence of dammarenolic acid, traces

of hydroxydammarenone I and II, ursonic acid and various ocotillones; in addition various nor-compounds are present, showing that some degree of degradation has taken place over time.[28] For the dammar this composition seems reasonable for its age, but the degradation of the mastic has been partly inhibited by the presence of the dammar: the chromatogram shows not only the characteristic moronic and oleanonic acids of a *Pistacia* resin, but also that some measure of protection appears to have been afforded to the masticadienonic acids, which generally would have been expected to disappear when applied in such a thin film. When other triterpenoid resins, such as dammar, are found to have been mixed with mastic – in varnishes, for example – often the mastic components appear to have fared much better than in the case of mastic alone. It is possible that, under normal ambient conditions of ageing, some components within the dammar triterpenoids are acting as mildly stabilising elements, perhaps by sacrificial oxidation, setting up a local disproportionation or redox system. Curiously this appears not to be the case for artificially aged regimes.

One may speculate upon the reason for this mixture: perhaps insufficient made-up mastic was available so it was topped up with dammar. That this component was detected in combination with mastic on several occasions would seem to speak against the 'top-up' conjecture. The aim may have been to produce enhanced colour saturation by, in effect, increasing the refractive index of the coating. Compositions including a resin with a high refractive index are typical of so-called 'Crystal varnishes',

prized for their high refractive index, transparency and low colour; some late nineteenth-century recipes for Crystal varnish specified fir balsam, but some were based on mastic and dammar.[29] It is worth remembering, however, that earlier in the century mastic was often adulterated because of its high price, commented upon by the Baron de Klenze in his evidence to the Select Committee (mentioned above). The restorer Henry Farrer gave the adulteration as a reason for his preferring dammar.[30] By the late 1850s, it appears that dammar was increasingly being substituted for mastic and mastic varnish was much adulterated with it.[31] Consequently, if a mixture of mastic with another resin is present in the varnish, and the other resin has similar properties to mastic but is markedly cheaper, the possibility of adulteration cannot be ruled out.

The Madonna and Child with Saints Hippolytus and Catherine of Alexandria (NG 1165, FIG. 5), painted by Moretto da Brescia around 1538–40, was varnished by Horace Buttery in 1891, seven years after it was given to the National Gallery and after cleaning to remove the existing varnish; the earlier varnish is discussed below. Buttery's varnish was spirit-based and found to contain mastic resin, with an addition of another triterpenoid component, but, unlike the varnish found on *The Adoration of the Kings*, discussed above, the additive was not dammar. The total ion chromatogram (TIC) is illustrated in FIG. 6 and shows residual traces of elemonic acids, together with residual traces of amyrins and their oxidation products, indicating the presence of a resin produced by a member of the family Burseraceae. In the nineteenth century, the most widely available resin of this type in commerce would have been that from a tree of the genus *Canarium*, and in particular *C. luzonicum*, which produced the resin known as gum elemi. This tree grew mainly on the island of Luzon and some of the other islands of the Philippines and as it was exported via Manila it should, technically, be called Manila elemi. Other elemis also exist. Brazilian elemi, for example, was sometimes brought to Europe with other resins and balsams, such as *Copaifera* spp. products (copaiba balsam) and *Hymenaea* spp. resins (Brazil or Demerara copal), but it was probably never traded regularly. Similarly, Burseraceous resins from *Protium guanense* and *Amyris* spp., such as *Amyris elemifera* (Central American and Mexican elemis), as well as West Indian elemi (from *Dacryodes hexandra*), were brought to Europe intermittently, but not on a regular basis.[32]

Apart from the resin derived from *Canarium*

FIG. 7 Jan Both, *Muleteers, and a Herdsman with an Ox and Goats by a Pool* (NG 957), c.1645. Oak panel, 57.2 × 69.5 cm.

PLATE 2 Jan Both, *Muleteers, and a Herdsman with an Ox and Goats by a Pool* (NG 957). Detail of goats to left of ox, showing thick, yellow, glossy varnish. Some milkiness is apparent in the varnish over the shoulders of the foreground goat and it shows a rectangular pattern of cracks in the region of the face of the rear goat.

strictum, misleadingly known as 'black dammar', which was much used in India, all elemis derived from the Burseraceae are soft, unctuous substances, with a slightly granular quality. They owe these soft, malleable characteristics to the high proportion of sesquiterpene essential oil present in the fresh resin. As a result they were frequently used as plasticising components to give elasticity and toughness to varnishes in the nineteenth and early twentieth centuries.[33] Unfortunately, the sesquiterpenes (principally the hydrocarbon β-elemene) slowly evaporate; the solid resin remaining is chiefly composed of α- and β-amyrins, which co-crystallise, forming a mass of interlocked crystals, and the material sets hard, like cement. This may account for the rather cloudy

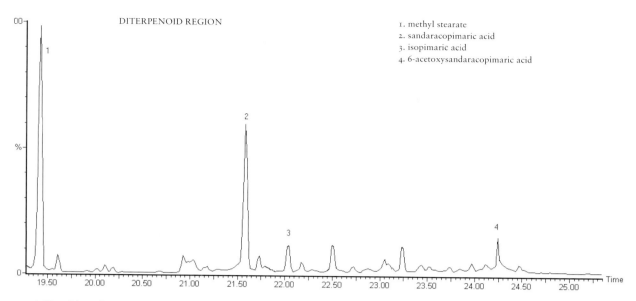

FIG. 8 Total ion chromatogram of a sample of varnish from Jan Both's *Muleteers, and a Herdsman with an Ox and Goats by a Pool*, applied in 1882. In addition to the moronic acid-rich mastic (*Pistacia* spp.) resin, the presence of pronounced residues of sandaracopimaric acid indicate the inclusion of a sandarac-type (Cupressaceae) resin.

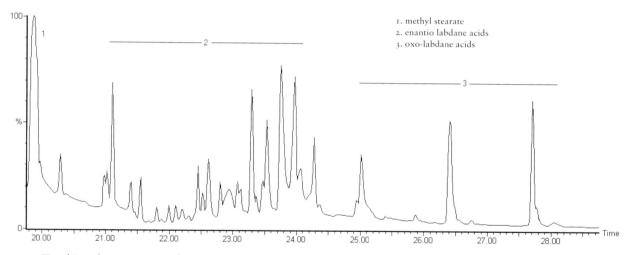

FIG. 9 Total ion chromatogram of the lower varnish layer on Moretto da Brescia's *Madonna and Child with Saints Hippolytus and Catherine of Alexandria*, applied in 1884. A linseed drying oil is present. From the ratio of suberic to azelaic acids, it has clearly been heat pre-polymerised and seems to have been combined with a diterpenoid, Leguminosae-derived hard copal. This mixture has been incorporated with mastic resin, presumably to toughen it and inhibit its natural tendency to bloom. The pattern of diterpenoids is similar to those of a 'run', aged Sierra Leone copal.

appearance of the varnish in places and the light-scattering micro-craquelure that has developed in patches.

Mastic with diterpenoid resins: sandarac and copal

Several examples of composite varnishes based on a mixture of mastic resin and diterpenoid resins were found in the paintings examined. Jan Both's *Muleteers, and a Herdsman with an Ox and Goats by a Pool* (NG 957, FIG. 7) was cleaned and varnished

in 1882. The TIC obtained from a sample of the varnish, following work-up and derivatisation (FIG. 8), indicates the presence of sandaracopimaric acid, suggesting that the varnish is composed of mastic resin and sandarac, or, more accurately, a Cupressaceae resin from the genera *Tetraclinis*, *Juniperus* or, possibly, *Cupressus*. There was no evidence for the presence of a plasticising drying oil and it seems likely that the formulation was made up as a spirit varnish.[34] It is likely that the sandarac-like resin was added in an attempt to toughen the mastic film:

in chemical terms, by the inclusion of some dissolved polycommunic acid. The vehicle in which the resin was dissolved would have been alcohol or, more probably, oil of spike or some other flower-derived essential oil. This would be sufficiently polar to take up most of the sandarac polymer (polycommunic acid) without being so polar that the less function-alised polymer component of the mastic resin pre-cipitated out. The varnish has a high gloss finish, explained by the polar nature of the resin acids and the polymer present in the diterpenoid component. It is also markedly yellow, giving an orange-yellow tone over the light areas, particularly in the sky. Some degree of blanching is apparent, particularly notice-able in the darks. The varnish is relatively hard and shows slight reticulation in some patches where it is a little thicker (PLATE 2).

Other polymer-containing resins might be used with mastic to toughen the varnish. The mastic/elemi varnish Buttery used on Moretto da Brescia's *Madonna and Child with Saints Hippolytus and Catherine of Alexandria* in 1891 has already been discussed; beneath this varnish, however, were residues of a dark varnish, trapped in undulations in the paint surface. The painting was cleaned and var-nished following its acquisition in 1884. At this time it was described as damaged and abraded on the right-hand side.[35] From the chromatogram (FIG. 9) it is clear that the 1884 varnish contains both mastic and copal, together with pre-polymerised linseed oil. As discussed below, the copal varnish would proba-bly have been prepared by melting the copal and mix-ing it with heated linseed oil.[36] This could then have been mixed with ready-prepared mastic varnish in turpentine, or the mastic may itself have been in the form of an oil varnish.[37]

The copal appears to derive from the Leguminosae group (for example, African copals) and not the sandaracopimaric- and agathic-rich Araucariaceae group, which includes Manila copal. Within the Leguminosae family there are many good, resin-producing species of tree, mostly located in tropical climes; botanically they are all members of the tribe Detarieae within the sub-family Caesalpinioideae. Geographically they are found in the continents of Africa and South America and the bulk of copal supply has originated from Africa. In general not only is the chemistry of these resins poorly studied, but also the origins of the various copals in trade in previous centuries is obscure. Such copals have always been prized for their hardness: that is, the durability and toughness of the varnishes which may be made from them. Because these resins

are highly polymerised and insoluble in solvents like spirits of turpentine – defining characteristics of a 'hard' resin – they are almost invariably formulated as oil varnishes, where the resin is 'run' by heating it to its fusion point for a brief period and is then mixed with hot (pre-polymerised) drying oil.

The West African copals originate from a stretch of coast some 700 miles in length, from Cameroon in the north to Luanda in Angola in the south. Most of the resin was collected as 'semi-fossilised' material,[38] being buried in soil up to depths of ten feet and dug up by local people in the rainy season. It is quite likely that the resin originated from more than one botanical species, but by the end of the nineteenth century there was no resin-producing tree growing on that coast which could be the source of the buried material. Some of the semi-fossil resin was collected from river beds and their surrounds; this leads to the conclusion that either the source trees grew inland and the resin had been washed down to the coast, or the resin-producing trees had completely receded from the coastal regions by the end of the nineteenth century. After collection, the resin was then sent to various ports for export to Europe and it was from the names of these collection/export ports that the copals took their own names. Angola copal included white and the harder red varieties, the latter being among the hardest of all West African copals, giving a high-quality, durable and brilliant varnish, com-manding a higher price. Loanga copal also came in red and white forms, in cylindrical pieces, the red being harder and more expensive; Benguela copal was yellow. Gaboon (now Gabon) was the darkest of this group of copals, being sherry-coloured; it was not homogeneous. Other varieties include Accra, Benin, Congo and Sierra Leone copals.[39]

On balance, the copal in the varnish strongly resembled authentic samples of Sierra Leone copal. A survey of the African copals conducted in this lab-oratory suggested that there was often no clear qual-itative distinction between some of the commercial types. However, Sierra Leone copal appeared to be deficient in copalic acid and its possible oxidation products, as was the case here (FIG. 9). Sierra Leone copal was a colourless or pale yellow product, found in two forms in Europe, one of which is as rounded pieces of various sizes, called 'Pebble copal'. Clearly this variety is one that has been washed down and collected from river beds and their environs. More frequently, it was in the form of irregular angular pieces. It was thought to be the hardest of all West African copals and, once selected and graded, it was the most highly prized and expensive copal product

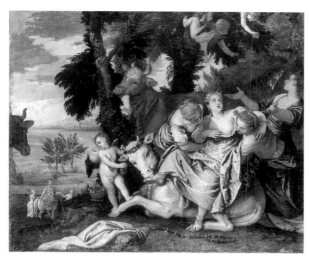

FIG. 10 Paolo Veronese, *The Rape of Europa* (NG 97), 1570s. Canvas laid down on wood, 59.4 × 69.9 cm.

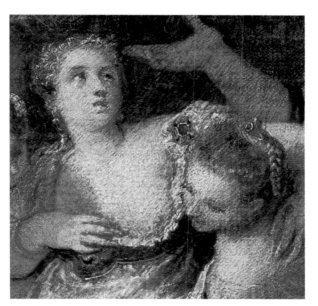

PLATE 3 Paolo Veronese, *The Rape of Europa* (NG 97). Detail of Europa and the left-hand attendant before cleaning, showing warm brown varnish containing mastic and 'African copaiba'.

from this region. It makes a very pale and durable varnish, which has little tendency to wrinkle and is excellent for producing a good uniform finish on textured and uneven surfaces; it also has a lower tendency to 'sink' on paint areas of variable absorbency. This is the likely reason for its incorporation in the mixture with mastic: to attempt to even out the damaged surface of Moretto's painting, although it is likely that the varnish would have darkened. Indeed, the fact that it was cleaned and revarnished seven years later suggests that it may already have darkened to an unacceptable extent.

Not all Leguminosae-derived oleoresins solidify into hard, copal-like material. The genus *Copaifera* produces a balsam-like product in pockets under the bark and in other parts of the tree; the principal sources were *Copaifera langsdorfii* and *C. multijuga* Haynes. The oleoresin contains a considerable amount of sesquiterpene material and little in the way of polymerising diterpenoids. Copaiba balsam is largely collected from the Amazon basin and was popular at one time as an additive to solvents used for the removal of old varnish and in the reforming of old varnish in the Pettenkofer process.[40] A balsamic material similar in appearance and properties, known as 'African copaiba', or illurin (illorin) balsam, was produced by the wood oil tree, *Daniellia oliveri* (Rolfe) Hutch. & Dalziel. This was identified in a sample of heavily discoloured varnish from Veronese's *The Rape of Europa* (NG 97, FIG. 10), painted in the 1570s. Above this varnish was an ordinary, slightly discoloured mastic varnish, presumably that applied in 1881.[41] The painting came into the collection in 1831 and the earlier varnish may have been applied before 1853, although it does not resemble the usual 'Gallery varnish'. It was found to contain mastic with the resinous matter from 'African copaiba'. It seems likely that this was added to the mastic both to make it less brittle and to give a warm tone to the varnish; unfortunately, however, it tends to darken relatively rapidly from an attractive reddish hue to a dark brown (PLATE 3). Copaiba balsam, in contrast, is relatively colourless when fresh, though it too darkens in the long term. It was also used as a plasticiser for varnishes.[42]

Copal varnishes

Many of the varnishes whose residues were examined during this study must have been applied before the paintings concerned came to the National Gallery. A number of these pictures were previously in Italian or French collections. Because it is quite impossible to date these earlier treatments and because the number of pictures studied is at present small, it is difficult to draw many conclusions about varnishes used by restorers in these countries. Some differences are apparent, however. One example studied is *The Nativity with Saints* (NG 1849), painted by Pietro Orioli between 1485 and 1495, which was in the Cerretani collection, Siena, before 1858, and bought for the National Gallery from Agnew's in 1901.[43] At this time the painting was cleaned and a few minor repairs were carried out. A local application of a mastic/elemi varnish was found in one area,

perhaps disturbed by a repair, and this may have been used in other similar areas; the painting was then varnished with a mastic varnish. However, during examination of the paint surface heavily browned remnants of an earlier varnish could be seen in isolated patches in the textured hollows of the paint. This was identified as an oil-containing varnish, based on a variety of copal and Venetian turpentine (larch resin), with heat-bodied walnut oil: quite different to any of the varnishes discussed so far. The copal component appeared not to be one of the Leguminosae-derived 'hard' African varieties described above. From its agathic acid content, still extant, the source of the resin was an *Agathis* sp., from the family Araucariaceae, perhaps Manila copal.[44]

Manila copal was also identified in remnants of varnish on a North Italian School painting, *The Adoration of the Shepherds* (NG 1887, probably painted early in the seventeenth century), under a later mastic varnish containing a little walnut oil. It is likely that both varnishes were applied before the picture was bought with other pictures in the Beaucousin collection in 1860 as it was lent to the National Gallery of Ireland, Dublin, in June 1860, shortly after it was acquired, only returning to London in 1926. No oil was present in the copal varnish, only a little polyterpene, indicating that the varnish was based on something like oil of spike lavender, or some other similar solvent. Given the difficulty of preparing pale copal/oil varnishes, it is hardly surprising that attempts were made to produce a pale, relatively tough varnish in a spirit-based vehicle. Spirits of turpentine alone are not suitable as a solvent for the relatively polar polymeric acids; alcohol or flower-derived essential oils, such as oil of spike or oil of rosemary, are, however, effective solvents, dissolving a substantial part of the resin. An artificial equivalent of the more heavily functionalised (that is, more alcoholic and ketone groups are present) flower oils was produced by dissolving camphor in the less polar spirits of turpentine.[45]

Varnishes with 'soft' conifer resins

A great many nineteenth-century recipes mention the inclusion of oleoresins such as fir balsam and larch resin (Venice turpentine), which were thought to toughen or plasticise the brittle varnish film produced by, for example, simple dissolution of mastic in turpentine spirits.[46] This is understandable in view of the balsamic, treacle-like consistency of the fresh oleoresin. All the turpentines, according to the

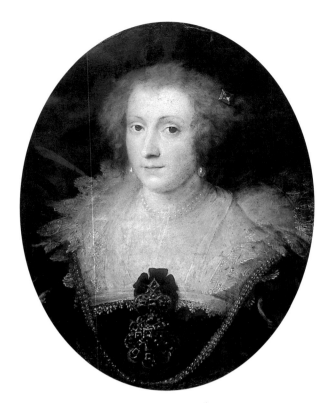

FIG. 11 Style of Van Dyck, *Portrait of a Woman* (NG 3132), after 1635. Copper panel, 59.7 × 47.2 cm.

PLATE 4 Style of Van Dyck, *Portrait of a Woman* (NG 3132). Detail of sitter's cheek, neck and ruff, below her right ear, showing discoloration and wrinkling of the varnish layers.

FIG. 12 Gaspard Dughet, *Landscape with a Storm* (NG 36), about 1653–4. Canvas, 135.9 × 184.8 cm.

PLATE 5 Gaspard Dughet, *Landscape with a Storm* (NG 36). Detail of foliage and light sky to left of mountains, showing very dark, wrinkled varnish.

Italian restorer Ulisse Forni, were widely used and were very important for varnishes used in restoration. By this, he would have meant particularly Venice turpentine (which, according to him, tended to be mixed with the spirit turpentine of other pines and firs) and fir balsam.[47]

The cheapest and most widely available soft resin was that derived from various species of pine (*Pinus* spp.). Distillation of the oleoresin (common or Bordeaux turpentine) gave spirits of turpentine; the solid residue, known as rosin or colophony, was soluble in both spirit and oil and was widely used in the production of cheap varnishes. Pine rosin was a frequent component in the formulation of varnishes; it may also have been an adulterant of other, more expensive resins. It was a convenient and versatile material.[48]

Venice turpentine was derived from larch trees, in particular *Larix decidua* Miller. It tends to produce a rather brittle varnish if made up as a spirit varnish on its own, similar, but more slowly drying and less yellowing than an equivalent pine resin varnish.[49] There is little evidence that it was used in this way at this time; it was, however, a frequent ingredient in recipes with other resins.[50] Because of its lack of polymerising components, Venice turpentine is liable to cause defects in any varnish film in which it is incorporated if present in excess, although when used in great moderation, no ill effects seem to occur. This appears to be the case with the varnishes present on two works by Adolphe Monticelli: *Still Life: Oysters, Fish* (NG 5013) and *Still Life: Fruit* (NG 5014). In both pictures the varnish was found to consist of mastic resin, mixed with an ocotillone-rich triterpenoid resin (possibly a dammar), pine resin, heat pre-polymerised linseed oil and a little larch resin – Venice turpentine. Apart from some discoloration of the varnish, there is no evidence of major varnish film defects.

However, extensive wrinkling of the varnish surface can be seen on *Portrait of a Woman* (NG 3132), a painting on a copper panel in the style of Van Dyck, dating from after 1635 (FIG. 11 and PLATE 4). Investigation of the composition of this varnish showed that two layers were present, the lower of which consisted of a mixture of mastic and dammar resins with a significant amount of larch resin. It seems that the film structure afforded by the other resin components is overwhelmed by substantial quantities of the Venice turpentine, resulting in wrinkling of the film. Above this layer was another, consisting of mastic resin with a little heat-bodied linseed oil. The tendency of larch resin to cause wrinkling is even more marked in the case of the varnish from Gaspard Dughet's *Landscape with a Storm* (NG 36, FIG. 12, PLATE 5), where wrinkling of the varnish has been compounded by excessive darkening. The painting was bought in 1824 and is known to have been varnished with mastic and drying oil ('Gallery varnish') before 1853.[51] Traces of this varnish, consisting of mastic with a linseed-based stand oil, were indeed identified, together with thin traces of similar mastic varnishes applied subsequently in 1868 and 1888, the last being applied by Horace Buttery. Below these layers were traces of an earlier varnish, perhaps dating from before the picture entered the National Gallery in 1824. Here, analysis indicated the use of a mixture of mastic resin with larch resin, toned with asphaltum, which would itself contribute to the dark appearance and perhaps the wrinkling.

Fir balsams are the oleoresins tapped from various fir trees (*Abies* spp.). There were two main

FIG. 13 Follower of Tintoretto, *Portrait of a Lady* (NG 2161), *c*.1550. Canvas, 98.4 × 80.7 cm.

PLATE 6 Follower of Tintoretto, *Portrait of a Lady* (NG 2161). Detail of sitter's bodice to left of pearl trimming, showing reflection in the markedly glossy varnish.

sources at this time: that from Europe was the product of *Abies alba* and was commonly known as Strasbourg turpentine, *olio d'abete* in Italian. In the sixteenth century the Italian writer and painter Giovanni Battista Armenini had referred to this material, known as *olio d'abezzo* in his day, as a useful and delicate varnish, and this was well known to nineteenth-century Italian restorers (and, incidentally, to some giving evidence to the 1853 Select Committee).[52] From the mid-nineteenth century a product known as Canada balsam, collected from trees of the species *Abies balsamea*, was imported

into Europe. Unlike rosin and Venice turpentine, there are polymerising monoterpenes and diterpenoids in fir balsams. This means that the varnish film is not formed purely by evaporation of volatile essential oils alone, but by the joining together of components such as β-phellandrene (a monoterpene oil component) and *cis*-abienol (a solid diterpenoid component). This results in a much tougher and more resilient final varnish film if the resin is used alone to make a varnish, as it was in the case of some varieties of 'Crystal' varnish, for example.[53] Interestingly, Forni mentioned that the spirit distilled from fir balsam was superior to the usual variety distilled from pine.[54] If this spirit was indeed prepared, it would tend to produce a bodying polyterpene fraction during drying and oxidation, either on its own or in any varnish with which it was incorporated, due to its high content of β-phellandrene. Some American species of pine oleoresin yield a β-phellandrene-rich turpentine spirit, though these would not be generally available to Europe until the advent of the twentieth century.

Like Venice turpentine, fir balsam was also incorporated into varnishes on the assumption that it would toughen the film. It also has a high refractive index, which would add to the gloss of the varnish. This is demonstrated in the case of the *Portrait of a Lady* (NG 2161, FIG. 13), by a follower of Tintoretto, where the varnish was found to contain mastic resin with dammar and fir balsam, both of which have a high refractive index. This combination probably accounts for the marked gloss associated with the varnish of this work (PLATE 6). The fir balsam-containing varnishes identified in this study appear to show no particular film defects, unless they have been applied very thickly. In such cases the same problems occur as would be expected in thick applications of drying oil, resulting in wrinkling.[55]

Conclusion

As the number of results obtained from the analysis of nineteenth- and early twentieth-century varnishes increases, it becomes possible to know something of the practice of individual restorers, or the restoration practice in particular regions or countries. If the present-day restorer is faced with a picture treated a hundred years ago by one of these restorers he or she will have a very good idea of the type of varnish likely to be present and its probable characteristics. For example, the names of the Buttery family of restorers recur in the National Gallery archival records through the second half of the nineteenth

century and into the twentieth. Those pictures restored by Horace Buttery in the late 1880s and 1890s examined during this survey showed that, like many English restorers, he preferred a mastic-based varnish. He had an account with the colourman Roberson and Company from 1895 into the 1920s and many purchases of ready-made mastic varnish are recorded in their ledgers.[56] A feature of the National Gallery collection is that it includes several purchases and bequests of collections formed both in England and abroad; these too could show similarities in the restoration treatment of the pictures, but in most cases too few pictures from any one source have been examined for any clear pattern to emerge. Occasionally the owner of the collection is known to have used the services of a particular restorer: this is the case with the collection originally formed by Sir Austen Layard, bequeathed to the National Gallery in 1916. Layard used the services of the Milanese restorer Giuseppe Molteni, who also did work for Sir Charles Eastlake.[57] One example examined for this study is Bono da Ferrara's *Saint Jerome in a Landscape* (NG 771), restored by Molteni in Milan between 1860 and 1862;[58] another is Vittore Carpaccio's *The Departure of Ceyx* (NG 3085). Molteni, who died in 1867, is not the only Italian restorer known to have worked on National Gallery pictures: Raffaelle Pinti is another, but he was based in London and, judging from the short times needed for his assignments, may have done more retouching and similar work than revarnishing. It does appear, however, that most of the varnishes examined that can be related to Italian restorations of the 1860s or thereabouts have been found to contain fir balsam; this includes what is probably Molteni's work on the two paintings mentioned above.[59]

In general, it can be said that there was an overall preference for the use of mastic resin varnish, up until the first two decades of the twentieth century at least. This appears to support the views and opinions expressed in the Select Committee proceedings and the opinions of European restorers generally. Nevertheless, it is evident that the deficiencies of mastic, that is, its brittleness and tendency to bloom, were of some concern to restorers; as a result, drying oils, polymerising resins and balsamic additives were incorporated, presumably in an attempt to offset them. Such additions or modifications might also be made in response to a particular problem with the surface of the painting undergoing treatment. It is curious that, given that most of the varnishes examined were applied since the 1850s, there were few instances of the use of varnish composed of dammar

resin alone. Although many English restorers may have been slow to recognise its good qualities, it was clearly available in London by 1859, when it was used, with a little poppy oil, as a retouching medium by Raffaelle Pinti on Crivelli's *Dead Christ supported by Two Angels* (NG 602).[60] This is particularly puzzling in view of dammar varnish's transparency, high refractive index, slower yellowing and lack of any tendency to bloom. Above all, it was also cheaper than mastic resin. On the other hand, the higher gloss given by a dammar varnish may not have been thought desirable in England. In his evidence to the 1853 Select Committee, Seguier commented that French varnish (which would have been based on mastic at this date, presumably) was 'more glossy than is generally approved of in this country'.[61] The lighting conditions prevailing in the room where the picture was displayed at the time it was varnished – whether this was in the National Gallery or in the previous owner's collection – may have influenced the restorer's choice. Dammar was found occasionally in combination with mastic and other resins, however, perhaps to increase the transparency or saturation of the underlying colours; or an enhanced gloss might have been desired.[62]

Few instances of the application of copal/oil-based varnishes were encountered in this survey. This tends to confirm the expressed opinion of nineteenth- and early twentieth-century restorers that, in spite of their toughness and resilience, their relatively rapid darkening and the extreme difficulty of removal of mature copal/oil varnishes without risk to the painting, rendered them unsuitable.

Acknowledgements

The authors wish to thank the Hamilton Kerr Institute, Cambridge, for access to the Roberson Archives; Jill Dunkerton and Larry Keith of the Conservation Department for advice and useful discussions during the examination of the paintings; and Rachel Billinge (Conservation Department) and Astrid Athen (Photographic Department) for photography of details of the paintings to illustrate the varnishes.

Notes and references

1 *Report from the Select Committee on the National Gallery, together with the Proceedings of the Committee, Minutes of Evidence, Appendix and Index*, ordered to be printed by the House of Commons, London, 4 August 1853, p. xii.

2 C. Martel, pseud. [i.e. Thomas Delf], *On the Materials used in Painting, with a few Remarks on Varnishing and Cleaning Pictures*, London 1859 (1860 on cover), p. 47.

3 See, for example, S. Horsin Déon, *De la conservation et de la restauration des tableaux*, Paris 1851, pp. 61–3; H. Merritt, *Dirt and Pictures separated in the Works of the Old Masters*, London 1854, p. 29; M. Holyoake, *The Conservation of Pictures*, London 1870, pp. 20–1, 32–3; C. Dalbon, *Traité technique et raisonné de la restauration des tableaux*, Paris 1898, p. 117. Henry Merritt was one of the restorers used by the National Gallery from the late 1850s until the 1870s.

4 *Report from the Select Committee on the National Gallery*, 1853, cited in note 1, No. 3770, p. 232.

5 Op. cit., No. 500, pp. 32–3.

6 Op. cit., Nos. 988–92, p. 57.

7 Dalbon 1898, cited in note 3, pp. 116–17.

8 A.E. Dinet, *Les fléaux de la peinture: Observations sur les vernis, les retouches et les couleurs*, Paris [1904], pp. 16–17. Martel believed that 'a good varnish does not become discoloured by age', thus if all substances that might deteriorate were excluded, there should be no need for its removal: Martel 1859, cited in note 2, pp. 57–61.

9 N.W. Hanson, 'Some painting materials of J.M.W. Turner', *Studies in Conservation*, 1, 1954, pp. 162–73; and 'Some recent developments in the analysis of paints and painting materials', *Official Digest*, No. 338, 1953, pp. 163–74,: J.S. Mills and A.E.A. Werner, 'Partition chromatography in the examination of natural resins', *Journal of the Oil and Colour Chemists' Association*, 37, 1954, pp. 131–42.

10 *Report from the Select Committee on the National Gallery*, 1853, cited in note 1, Nos. 9419–29, p. 659.

11 Op. cit., Nos. 9376–82, p. 656; Appendix VIII, pp. 758–9, and IX, p. 767, Extract from letter from Baron de Klenze to Colonel Mure MP, Chairman of the Committee, 3 August 1853.

12 Op. cit., Nos. 10069–80, p. 709.

13 R.L. Feller, 'First description of dammar picture varnish translated', *Bulletin of the I.I.C. American Group*, 7, 1, 1966, pp. 8, 20, citing Lucanus's description of the varnish in *Schweigger's Journal*, 55, 1829, pp. 60–6; according to Feller, dammar was an ingredient of Crystal Varnish sold by the London colourmen Winsor and Newton in 1846. See also Fr. G.H. Lucanus, *Vollständige Anleitung zur Erhaltung, Reinigung und Wiederherstellung der Gemälde*, 3rd edn., Halberstadt 1842, pp. 34–5 (1st edn. 1828, in which dammar is not mentioned); Lucanus wrote that thirteen years of experience showed that a subsequent yellowing of the varnish appeared not to be a matter for concern. The paucity of information in other, slightly earlier, German handbooks suggests that details on the sources and properties were not yet sufficiently widely known to be discussed in much detail: see, for example, J.K. Stöckler, *Praktisches Hülfsbuch des Kunstfreundes*, Pesth/ Leipzig 1838, pp. 170 (on cat's eye dammar) and 179. This is, if anything, confirmed by the description of so-called '*dammar blanc*' or '*dammar-puti*' given by Guibourt, a pharmacist who was usually well-informed: the properties and solubility of the resin he describes are those of dammar, but the supposed source tree, a conifer, is certainly wrong. However, it grew in the right region (the Moluccas), so the confused botanical information Guibourt was given could have come originally from the local people gathering the resin, the trader who exported it or the person from whom he obtained it. See N.J.B.G. Guibourt, *Histoire abrégée des drogues simples*, 3rd edn., Paris 1836, Vol. 2, pp. 535–7.

14 C. Gould, *National Gallery Catalogues: The Sixteenth-Century Italian Schools*, London 1975, p. 23; the picture is described as having been 'withdrawn from exhibition' in 1929, and as 'never having been exhibited' in 1901 (MS Catalogue, National Gallery Archive).

15 Martel 1859, cited in note 2, p. 51; U. Forni, *Manuale del pittore restauratore*, Florence 1866, p. 91. The author had been trained by the well-known nineteenth-century restorer Giovanni Secco-Suardo; it seems from the foreword to Forni's book that there was some disagreement between the two on their respective books: the first edition of the first part of Secco-Suardo's own book, *Il restauratore dei dipinti*, appeared later the same year. Forni, who died in 1867, claimed that his book was based on practice, not on what he had learned from his teacher. The second part of Secco-Suardo's book was completed in the year of his death, 1873, but only published in 1894. Both parts appeared in a considerably re-worked third edition in 1918; a fourth edition appeared in 1927.

16 Horsin Déon 1851, cited in note 3, pp. 79–80; Dalbon 1898, cited in note 3, p. 43; Forni 1866, cited in note 15, pp. 124–5, 127–8; T.H. Fielding, *On the Theory and Practice of Painting in Oil and Water Colours*, 4th edn., London 1846, pp. 165–6.

17 Forni 1866, cited in note 15, p. 94. Oil of spike was also suggested as the solvent for a retouching varnish, with copaiba balsam and fir balsam (*olio d'abeto*), pp. 95–6.

18 M. Davies, *National Gallery Catalogues: The Earlier Italian Schools*, London 1961 (1986 reprint), pp. 291–3. It should be noted that at present it is not possible to identify the sources of polyterpenes securely: while oil of spike lavender is a good candidate, fir spirits, if these were indeed distilled from the oleoresin (see note 54, below), would also be a possibility, particularly in Italian restorations.

19 J.S. Mills and R. White, *The Organic Chemistry of Museum Objects*, 2nd edn., London 1994, pp. 105 B8; J.S. Mills and R. White, 'The Identity of the Resins from the Late Bronze Age Shipwreck at Ulu Burun (Kas)', *Archaeometry*, 31, 1, 1989, pp. 37–44; G.A. van der Doelen, *Molecular Studies of Fresh and Aged Triterpenoid Varnishes*, PhD thesis, University of Amsterdam, Amsterdam 1999, pp. 20–2.

20 Van der Doelen 1999, cited in note 19, pp. 16–19.

21 *Report from the Select Committee on the National Gallery*, 1853, cited in note 1, Appendix 4, p. 747. After listing pictures varnished, or presumed to have been varnished, with a simple mastic varnish, the Report states that the other paintings then in the collection, which would include the Bassano, 'have been, from time to time, varnished with mastic varnish mixed with oil'.

22 See, for example, P.F. Tingry, *The Painter and*

Varnisher's Guide, 2nd edn., London 1816, pp. 10–11; G.H. Hurst, *Painters' Colours, Oils and Varnishes: A Practical Manual*, 2nd edn., London 1896, pp. 439–40; A. Livache, *The Manufacture of Varnishes, Oil Crushing, Refining and Boiling and kindred Industries*, trans. J.G. McIntosh, London 1899, pp. 35–7 (the original French edition, *Vernis et huiles siccatives*, Paris 1896, was unavailable); Guibourt 1836, cited in note 13, Vol. 2, pp. 556–7; Martel 1859, cited in note 2, pp. 50–1; Forni 1866, cited in note 15, p. 229.

23 Mills and White 1994, cited in note 19, pp. 99, 106–8; M. Serpico, 'Resins, Amber and Bitumen', in P.T. Nicholson and I. Shaw, eds., *Ancient Egyptian Materials and Technology*, Cambridge 2000, pp. 430–74, esp. Table 18.2, p. 432, and pp. 434–6.

24 *Report from the Select Committee on the National Gallery*, 1853, cited in note 1, No. 10082, p. 710. Similar advice appeared in conservation literature: see, for example, Martel 1859, cited in note 2, p. 51.

25 *Report from the Select Committee on the National Gallery*, 1853, cited in note 1, p. xii, Nos. 2915–27, p. 171. 'Gallery varnish' was apparently also used on pictures in private collections. For an account of the problems with atmospheric pollution in the National Gallery during the nineteenth century see D. Saunders, 'Pollution and the National Gallery', *National Gallery Technical Bulletin*, 21, 2000, pp. 77–94, esp. pp. 77–81.

26 *Report from the Select Committee on the National Gallery*, 1853, cited in note 1, Nos. 1946–51, p. 106, Nos. 2952–4, p. 173. It is not known who the 'very old varnish-maker in Long Acre' (No. 2954) patronised by Seguier was: several colourmen had premises in Long Acre at this time. In 1843, for example, the list includes E. Wood, varnish maker and colourman (no. 5), C. Roberson and Co., artists' colourmen (no. 51), their former partner Thomas Miller, colourman (no. 56), and G. and T. Wallis, varnish and colourmakers (no. 64). We are most grateful to Clare Richardson, Department of Painting Conservation and Technology, Courtauld Institute of Art, for this information. There is no indication in the Archive of the Roberson Company (now kept at the Hamilton Kerr Institute, Cambridge University) that Seguier was one of their customers. For the recipe see, for example, Fielding 1846, cited in note 16, pp. 166–7; G. Field, *Chromatography; or, A Treatise on Colours and Pigments, and of their Powers in Painting*, London 1835, pp. 208–9.

27 *Report from the Select Committee on the National Gallery*, 1853, cited in note 1, Appendix 4, p. 747: see note 21, cited above.

28 Mills and White 1994, cited in note 19, pp. 106–7; A. Burnstock and R. White, 'A preliminary assessment of the aging/degradation of Ethomeen C-12 residues from solvent gel formulations and their potential for inducing changes in resinous paint media', *Tradition and Innovation: Advances in Conservation. Contributions to the IIC Melbourne Congress, Melbourne, 10–14 October 2000*, eds. A. Roy and P. Smith, London 2000, pp. 34–8; van der Doelen 1999, cited in note 19, pp. 86–103.

29 See, for example, *Recipes for the Colour, Paint, Varnish, Oil, Soap and Drysaltery Trades*, London 1902, p. 144.

However, Hurst 1896, cited in note 22, p. 485, includes a Crystal Varnish recipe using Canada balsam (North American fir balsam).

30 *Report from the Select Committee on the National Gallery* 1853, cited in note 1, Nos. 9419 and 9430–3, p. 659; see also note 10. The price of mastic was still described as high at the end of the nineteenth century: see Livache 1899, cited in note 22, p. 202.

31 Martel 1859, cited in note 2, p. 51.

32 Mills and White 1994, cited in note 19, p. 108; R. Pernet, 'Phytochimie de Burseracées', *Lloydia*, 35, 1972, pp. 280–7; J.S. Mills and R. White, 'Natural resins of art and archaeology: Their sources, chemistry, and identification', *Studies in Conservation*, 22, 1977, pp.12–31; Tingry 1816, cited in note 22, pp. 12–13; Guibourt 1836, cited in note 13, Vol. 2, pp. 537–40.

33 Hurst 1896, cited in note 22, p. 445; elemi and mastic are included (with sandarac or other ingredients) in recipes for white hard spirit varnish, paper varnish and white varnishes, pp. 482–3. See also Forni 1866, cited in note 15, pp. 229–30.

34 Martel 1859, cited in note 2, p. 50; Forni 1866, cited in note 15, pp. 228, 261–3: most sandarac recipes include a plasticising ingredient (Venice turpentine, for example); Hurst 1896, cited in note 22, p. 482, white hard spirit varnish; see also the recipes cited for elemi. Dalbon commented that varnishes in alcohol should be proscribed as they yellowed quickly and, as they very easily became incorporated with the paint, they were hazardous to remove: Dalbon 1898, cited in note 3, p. 117.

35 The comment appears in the conservation dossier for the picture, copied from the MS Catalogue in the National Gallery Archive. See also Gould 1975, cited in note 14, pp. 161–2.

36 See, for example, Livache 1899, pp. 343–51, 355–60; Hurst 1896, pp. 464–71, 473–6; Tingry 1816, pp. 98–9; 107–8, all cited in note 22.

37 A preparation of this type was perhaps available ready-made, although not necessarily described as a varnish; there are several mentions of so-called copal preparations in recipe books in the Roberson Archive (see note 26), which were intended as vehicles for painting: for example, HKI MS 788-1993, f. 55v: '4 G[allons?] Copal and 1 G Mastic. Try small quantities first to see if they will mix(?) clear'; see also HKI MS 789-1993, f. 34v; HKI MS 778-1993, f. 26v. In all cases the resins were already in solution.

38 Fossil resins, such as Baltic amber (succinite), 65 million years old, and Claybourne amber, 5 million years old, are indeed genuine fossil resins. A semi-fossil resin is one that has fallen off a tree within historic times, become covered by soil and detritus, then dug up perhaps 100–1000 years later. This is typical of kauri.

39 Mills and White 1994, cited in note 19, pp. 103–5; A. Tschirch and E. Stock, *Die Harze*, 3rd edn, Berlin 1933–6, pp. 798–856; Tingry 1816, pp. 89–108; Hurst 1896, pp. 430–2; Livache 1899, pp. 14–30, all cited in note 22; Guibourt 1836, cited in note 13, Vol. 2, pp. 523–9; Martel 1859, cited in note 2, pp. 51–2; Forni 1866, cited in note 15, pp. 231–3, 267–9, 273–5.

40 Mills and White 1994, cited in note 19, p. 105; M. von

Pettenkofer, *Über Ölfarbe und Conservirung der Gemälde-Gallerien durch das Regenerations-Verfahren*, Braunschweig 1870; S. Schmitt, 'Examination of paintings treated by Pettenkofer's process', *Cleaning, Retouching and Coatings: Preprints of the Contributions to the IIC Brussels Congress, 3–7 September 1990*, eds. J.S. Mills and P. Smith, London 1990, pp. 81–4; L. Keith, 'Andrea del Sarto's *Virgin and Child with Saints Elizabeth and John the Baptist*' in this *Bulletin*, pp. 42–53.

41 Conservation dossier, held in the National Gallery Conservation Department.

42 Forni 1866, cited in note 15, pp. 225–7. Forni categorised Copaiba balsam as a variety of turpentine. He commented on its darkening, and noted also that it was falsified by admixture with drying oil or common turpentine and adulterated with castor and poppy oils.

43 Davies 1961, cited in note 18, pp. 399–401; here the painting is ascribed to Giacomo Pacchiarotto.

44 Mills and White 1994, cited in note 19, p. 103; Hurst 1896, cited in note 22, p. 440.

45 Tingry 1816, pp. 80–90; Livache 1899, pp. 186–92; Hurst 1896, p. 483 (with other ingredients), all cited in note 22.

46 A.H. Church, *The Chemistry of Paints and Painting*, 3rd edn., London 1901, p. 114. For a discussion of all the soft conifer resins and spirits of turpentine see Mills and White 1994, cited in note 19, pp. 95–102; Tingry 1816, cited in note 22, pp. 17–21; Guibourt 1836, cited in note 13, Vol. 2, pp. 574–85.

47 Forni 1866, cited in note 15, pp. 223–7.

48 See, for example, the recipe for mastic varnish including pine resin in a recipe book in the Roberson Archive, cited in note 26: HKI MS 788-1993, f. 47r.

49 Mills and White 1994, cited in note 19, pp. 100–2.

50 See, for example, Forni 1866, cited in note 15, pp. 261–2; Hurst 1896, cited in note 22, pp. 482–3.

51 *Report from the Select Committee on the National Gallery*, 1853, cited in note 1, Appendix 4, p. 747: see note 21 cited above.

52 G. B. Armenini, *De' veri precetti della pittura*, Ravenna 1587, pp. 128–9; Forni 1866, cited in note 15, pp. 223–4; *Report from the Select Committee on the National Gallery*, 1853, cited in note 1, nos. 7525–63, 7645–6, pp. 536–9, 543.

53 Forni 1866, cited in note 15, p. 266; Hurst 1896, cited in note 22, p. 485.

54 Forni 1866, cited in note 15, pp. 234, 246.

55 L. Campbell and J. Dunkerton, 'A famous Gossaert rediscovered', *The Burlingon Magazine*, CXXXVIII, no. 1116, March 1996, pp.164–73, esp. p. 168.

56 See, for example, entries for 'Horace Buttery, 173 Piccadilly W.', HKI MS 121-1993, April 1895 to December 1899. This is followed by entries for A.H. Buttery from 1900 to 1908, HKI MS 133-1993 (and so forth): see note 26.

57 J. Anderson, 'Layard and Morelli', *Symposium internazionale: Austen Henry Layard tra l'oriente e Venezia, Venezia 26–28 ottobre 1983*, eds. F.M. Fales and B.J. Hickey, Venice 1987, pp. 109–37.

58 J. Dunkerton, 'L'état de restauration des deux Pisanello de la National Gallery de Londres', *Pisanello,*

Actes du colloque, musée du Louvre, 1996, Paris 1998, pp. 657–81; J. Dunkerton, 'Cosimo Tura as Painter and Draughtsman: The Cleaning and Examination of his *Saint Jerome*', *National Gallery Technical Bulletin*, 15, 1994, pp. 42–53, esp. pp. 42–6.

59 Dunkerton 1994 and 1998, cited above in note 58. It is therefore likely that similar fir balsam-containing varnishes were used on Tura's *Saint Jerome* (NG 773) and Pisanello's *Virgin and Child with Saint George and Saint Anthony Abbot* (NG 776), both restored by Molteni at the same time. No analysis of his varnish on these pictures has been carried out, although an earlier varnish on the *Saint Jerome* was found to contain an African copal (probably Congo copal) and linseed oil: see Dunkerton 1994, p. 46. See also J. Dunkerton and R. White, 'The Discovery and Identification of an Original Varnish on a Panel by Carlo Crivelli', *National Gallery Technical Bulletin*, 21, 2000, pp. 70–6, esp. p. 70. For another Molteni restoration see J. Dunkerton, 'The Technique and Restoration of Bramantino's *Adoration of the Kings*', *National Gallery Technical Bulletin*, 14, 1993, pp. 42–61, esp. pp. 43–4: the varnish was not analysed.

60 Dunkerton and White 2000, cited in note 59, p. 70.

61 *Report from the Select Committee on the National Gallery*, 1853, cited in note 1, No. 495, p. 32.

62 It is notable that British varnish literature of the later nineteenth century contains very few recipes in which dammar is even a minor ingredient. Dammar is not mentioned in the recipe books held in the Roberson Archive (see notes 26 and 37, cited above), and dammar varnish is not mentioned by name in a selection of colourmen's catalogues (published by Winsor & Newton, George Rowney and James Newman) consulted, dating from 1849 to the early twentieth century. Crystal Varnish and White Spirit Varnish are listed, but these did not necessarily contain dammar.

Table of varnish compositions

Picture	Date of acquisition and previous owner	Varnish composition i) lower varnish ii) upper varnish	Date(s) of treatment (approximate)[1] and source
NG 36 Gaspard DUGHET, *Landscape with a Storm*, c.1653–4	1824; J.J. Angerstein collection	mastic + larch + asphaltum mastic + a little heat-bodied linseed oil mastic + a little heat-bodied linseed oil	pre-1824 1824–53 1868, 1888
NG 60 Leandro BASSANO, *The Tower of Babel*, after 1600	1837; Lt.-Col. J.H. Ollney	mastic + linseed oil mastic only	1837–53 after 1853
NG 218 Attributed to GIROLAMO da Treviso, *The Adoration of the Kings*, probably 1525–30	1849; Edmund Higginson	mastic + heat-bodied linseed oil mastic + dammar	1849 1887
NG 248 Fra Filippo LIPPI, *Saint Bernard's Vision of the Virgin*, probably 1447	1854; E. Joly de Bammeville, Paris	oxidised polyterpene on the tempera paint mastic mastic + heat-bodied linseed oil	pre-1854 1856 1882
NG 269 Imitator of GIORGIONE, *A Man in Armour*, probably 17th century	1855; Samuel Rogers	Manila copal + heat-bodied linseed oil mastic, tinted (with accroides)	pre-1856 pre-1856
NG 624 Workshop of GIULIO Romano, *The Birth of Jupiter*, probably 1530–9	1859; Duke of Orléans	mastic + fir balsam + heat-bodied walnut oil[2] mastic, yellowed strongly dammar, less yellowed	pre-1859 1859[3] 1889
NG 644.1 Follower of GIULIO Romano, *The Rape of the Sabines*, c.1555–75	1860; Edmond Beaucousin collection, Paris	mastic + Manila copal + walnut oil, partially heat-bodied mastic + dammar + toning (aloes?)[4]	pre-1860 1887
NG 644.2 Follower of GIULIO Romano, *The Intervention of the Sabine Women*, c.1555–75	1860; Edmond Beaucousin collection, Paris	mastic + walnut oil, partially heat-bodied mastic mastic + dammar, but no toning[6]	pre-1860 1877 1887
NG 750 ITALIAN, VENETIAN, *The Virgin and Child with Saints Christopher and John the Baptist, and Doge Giovanni Mocenigo*, 1478–85	1865; Conte Alvise Mocenigo di S. Eustachio, Venice	some fir balsam + mastic + linseed oil mastic + linseed oil, partially heat-bodied	1866[7] 1890
NG 771 BONO da Ferrara, *Saint Jerome in a Landscape*, perhaps 1440–50	1867; Lady Eastlake	mastic polyterpene mastic + some dammar + fir balsam	pre-1860–2 pre-1860–2? 1860–2
NG 819 Ludolf BAKHUIZEN, *An English Vessel and a Man-of-war in a Rough Sea off a Coast with Tall Cliffs*, probably 1680s	1871; Sir Robert Peel Bt	mastic + some heat-bodied linseed oil mastic + a little elemi	pre-1884 1884

NG 868, Adriaen van de VELDE, *Peasants with Cattle fording a Stream, c.1662*	1871; Sir Robert Peel Bt	mastic + a little dammar	pre-1871
NG 957 Jan BOTH, *Muleteers, and a Herdsman with an Ox and Goats by a Pool, c.1645*	1876; Wynn Ellis Bequest	mastic + Cupressaceae resin (i.e. sandarac-type)	1882
NG 1165 MORETTO da Brescia, *The Madonna and Child with Saints Hippolytus and Catherine of Alexandria, c.1538–40*	1884; Francis Palgrave	mastic + African copal + heat-bodied linseed oil	pre-1884
		mastic + elemi	1891
NG 1206 Style of Salvator ROSA, *Mountainous Landscape with Figures*, after 17th century	1886; Mrs. F.L. Ricketts	mastic	pre-1886
		mastic + some heat-bodied linseed oil	1886
NG 1308 Attributed to Ignacio de LEON y Escosura, *A Man in 17th-Century Spanish Costume*, 1850–90	1890; Charles Henry Crompton-Roberts	mastic + toning (accroides?)	pre-1890
		dammar + trace of heat-bodied linseed oil	1890
NG 1699 Attributed to Michiel NOUTS, *A Family Group,*[8] *c.1655*	1900; left half: Charles Fairfax Murray 1910; right half: bought	left half: mastic + traces of dammar + fir balsam	pre-1900
		mastic	1915
		right half: mastic	1915
NG 1849 Pietro ORIOLI, *The Nativity with Saints*, probably *c.1485–95*	1901; Cerretani collection, Siena	Manila copal + larch resin + heat-bodied walnut oil	pre-1901
		mastic	pre-1901
		mastic + elemi locally	probably 1901
NG 1858 Follower of the BASSANO, *The Adoration of the Shepherds*, 17th century	1847; Sir John May	mastic + dammar + fir balsam	pre-1847?
NG 1879 After Caspar NETSCHER, *A Musical Party*, after 1665	1847; Sir John May	mastic	1892
NG 1887 ITALIAN, NORTH, *The Adoration of the Shepherds,*[9] probably *c.1600–25*	1860; Edmond Beaucousin collection, Paris	Manila copal + polyterpene	pre-1860
		mastic + a little poppyseed oil	pre-1860
NG 2161 Follower of TINTORETTO, *Portrait of a Lady,*[10] *c.1550*	1855; Heirs of the Signori Capello	mastic + dammar + some fir balsam	pre-1855
NG 2292 Michiel van MIEREVELD, *Portrait of a Woman*, 1618	1908; George Fielder collection	mastic + partially heat-bodied linseed oil	pre-1908
		mastic + dammar[11]	1908
NG 2544 Isack van OSTADE, *A Landscape with Peasants and a Cart*, 1645	1871; Sir Robert Peel collection	dammar + mastic + larch resin	pre-1910
		dammar	pre-1910?
NG 2608 After Robert CAMPIN(?), *The Virgin and Child with Two Angels, c.*1500?	1910; Salting Bequest	Leguminosae (African) copal and oil (probably linseed)	pre-1910
		mastic + a little heat-bodied linseed oil	pre-1910

NG 2903 ITALIAN, *A Concert*, mid-1520s	1912; Bequeathed by Lady Lindsay	heat bodied linseed oil + pine resin + larch(?)	pre-1872[12]
		pine resin + mastic + some polyterpene(?)	pre 1912
NG 3080 Style of Ambrogio BERGOGNONE, *Saint Paul*, late 15th century	1916; Layard Bequest	mastic	pre-1916
		polyterpene (varnish refreshment)	1916
		dammar	post 1916
NG 3081 Style of Ambrogio BERGOGNONE, *Saint Ambrose(?)*, late 15th century	1916; Layard Bequest	See NG 3080	
NG 3085 Vittore CARPACCIO, *The Departure of Ceyx*, probably *c.* 1500	1916; Layard Bequest	mastic + pine resin + some fir balsam	pre-1867
		mastic	1916
NG 3099 Attributed to Gentile BELLINI, *The Sultan Mehmet II*, 1480	1916; Layard Bequest	mastic + larch resin + fir balsam	pre-1865
		mastic + fir balsam	*c.*1866?[13]
		polyterpene (varnish refreshment)	1916
		mastic + linseed oil	post-1916
NG 3100 Attributed to Gentile BELLINI, *Doge Niccolò Marcello*, probably 1474	1916; Layard Bequest	polyterpene	pre-1916
		polyterpene + mastic + a little dammar(?)	pre-1916
NG 3132 Style of Anthony van DYCK, *Portrait of a Woman*, after 1635	1916; Layard Bequest	mastic + dammar + larch resin	pre-1916
		mastic + a little heat-bodied linseed oil	pre-1916?
NG 5013 Adolphe MONTICELLI, *Still Life: Oysters, Fish*, c.1878–82	1939; Tate Gallery; transferred 1956 to National Gallery	pine + larch + mastic + a little heat-bodied linseed oil[14]	pre-1939
NG 5014 Adolphe MONTICELLI, *Still Life: Fruit*, c.1878–82	1939; Tate Gallery; transferred 1956 to National Gallery	See NG 5013	

Notes to Table

1 Dates of treatment are those recorded in the conservation dossier for each picture, occasionally amplified by information from the Manuscript Catalogue in the National Gallery Archive, unless otherwise indicated.

2 An adjacent, more light-scattering, area had just mastic and non-bodied linseed oil in place of the mastic, fir balsam and heat-bodied walnut oil varnish. This varnish layer was probably removed locally for blister treatment; revarnishing was then carried out using mastic and linseed oil.

3 C. Buttery was paid £25 for the restoration of the picture in September 1859; the account is dated 11 October 1859: see the private diary of the then Keeper, Ralph Wornum, entry for 25 September 1859 and National Gallery Account Book entry for 11 October 1859. As this was not recorded in the Manuscript Catalogue it was not transcribed into the conservation record. The diary and the Gallery Account Books are kept in the National Gallery Archive.

4 Mastic alone was present in less glossy areas, perhaps applied during local repairs carried out in 1877.

5 No copal could be detected with certainty.

6 The 1877 mastic varnish was thick and rather yellow, the chromatogram showing extensive oxidation. It is interesting that this picture has less of an orange-yellow tone than NG 644.1 and that no toning element was present in the 1887 varnish, unlike that on NG 644.1. It seems plausible that the restorer (Dyer) had to tone the varnish used on NG 644.1, which was not varnished in 1877, apart perhaps from local repairs, and was therefore less yellow than its companion piece, NG 644.2.

7 The picture was restored by Raffaele Pinti between 18 January and 28 March 1866: this is recorded in entries in Wornum's diary and the National Gallery Account Books, cited in note 3 above.

8 The left half was presented in 1900. The right half was purchased in 1910, at which time it was given the National Gallery number of 2764. The two halves were joined in 1915 and given the number 1699.

9 This picture was lent to the National Gallery of Ireland, Dublin, from June 1860 to March 1929.

10 This picture was lent to the National Gallery of Ireland, Dublin, from February 1857 until 1925. The thickness and discoloration of the varnish were noted during a technical

examination of the picture; see J. Plesters, 'Tintoretto's Paintings in the National Gallery (Part III)', *National Gallery Technical Bulletin*, 8, 1984, pp. 24–35, esp. pp. 32–3.

11 In less glossy areas mastic alone was found, instead of mastic + dammar.

12 The conservation dossier refers to a note in Russian on the back 'transferred from wood'. Analysis by GC–MS suggested the presence of heat-bodied linseed oil with pine and larch resins; the latter is indicated by the appearance of larixol in the TIC. It has been claimed that the resin from the Siberian pine, *Pinus russica*, contains larixol, surprisingly, and that this component is virtually absent in *Larix sibirica*. This varnish may date from the time the picture was in St Petersburg. Above this is a varnish containing pine resin, mastic and some polyterpene, unlike any varnish known to have been used by National Gallery restorers. It probably also pre-dates 1912.

13 The picture was relined by C. Morrill and restored by Raffaelle Pinti, presumably in London, probably shortly after the painting had been bought by Layard, so around 1866. It is not clear whether it was varnished at this time and the varnish is perhaps not of the usual kind used in England. We cannot say, therefore, whether this varnish may not also pre-date Layard's purchase of the picture.

14 Seemingly some other, degraded triterpenoid resin also included: this is ocotillone-rich and is possibly a dammar.

The Mechanical Behaviour and Environmental Response of Paintings to Three Types of Lining Treatment

CHRISTINA YOUNG AND PAUL ACKROYD

Introduction

THIS STUDY INVESTIGATES the mechanical response of canvas paintings before, during and after three different vacuum-lining processes with the following adhesives: glue-paste, wax-resin and BEVA 371. The purpose is to compare physical changes in a painting during lining and to assess the durability of a lined painting over a wide humidity range – 5%–85% relative humidity (RH) at ambient temperatures. Understanding the change in response of the lined painting will aid the assessment of a lining's ability to protect a painting from physical damage caused by changes in environmental conditions, in particular relative humidity.

Background

Since the nineteenth century, one of the principal reasons for lining has been to preserve and protect a painting from future physical deterioration, an entirely separate consideration from the actual repair of structural damage such as tears, flaking paint or raised and distorted cracks in the image. It is not unusual to find paintings lined in the nineteenth century, and indeed within the twentieth century, that show virtually no signs of damage and seem to have been treated for no obvious reason. It is probable, however, that these treatments were carried out as precautionary measures to prevent future degradation and to prolong the painting's life expectancy. Statements from numerous nineteenth-century restoration manuals testify to the importance of this aim. In 1854 Henry Merritt, for example, stated that 'it has only been by lining old canvases upon new that the chief pictures of the great masters now hang on our walls entire ... To line a picture properly, is to renew the lease of its existence for a century'.[1] It was this kind of justification that led to the lining of pictures purely as a matter of course, an attitude reflected in the literature of the time. J.M. Fielding in 1839, for instance, comments that 'In almost all cases, if the picture has not been already lined, it would be best that this should be done before any other operation takes place.'[2]

Nineteenth-century British glue-paste liners took the protective aspect of the treatment to extremes by producing excessively rigid supports, sometimes incorporating two lining canvases, with thick adhesive layers containing large amounts of animal glue, to render the picture solid and robust enough to withstand future hardship. It is fair to say that practitioners at this time acted on an empirical knowledge, but a more recent understanding of the mechanical functions of lining may lend support to the belief that a certain degree of stiffness in the lining may deter physical deterioration. In theory, a stiff, rigid support enables the transfer of tensile load away from the painting to the lining, thereby reducing the likelihood of mechanical failure through the development of cracks in the painting. It has been assumed that glue linings offer this kind of protection at ambient humidity and below but may be less effective in more humid environments.

The lining stiffness is one way to prevent mechanical damage in a painting. The other means of achieving this goal has been to protect the picture from climatic change by making it less hygroscopic. Hence, the aim of wax-resin lining, developed from the mid-nineteenth century, was to impregnate or embalm paintings in a non-hygroscopic material so as to render them completely inert. It has always been assumed that wax-based adhesives perform well in most environmental conditions, offering greater protection over a wide range of humidity, thereby restricting the development of stress and dimensional changes in paintings. The *Manual on the Conservation of Paintings*, published in 1940, with reference to wax adhesives, reiterates the idea that lining can have a preservative effect on paintings: 'Relining is often carried out as a preventive measure for paintings that are still in good condition, on the assumption that all canvas paintings will, sooner or later, have to undergo this treatment ... There is not much to be said against relining as a preventive measure, if it is properly executed...'[3] Confidence in the

ability of wax-resin adhesives to safeguard against deterioration in paintings, combined with the seemingly perfect means of performing the operation through the introduction of the vacuum hot table from the late 1950s, again led to an indiscriminate use of lining. It is interesting to note Helmut Ruhemann's comment, written in 1968, some 120 years after Fielding had expressed his belief in the practice: 'Some restorers do not recommend lining unless it is urgent, others line every valuable picture that comes into their hands as a precaution – and now that modern methods have excluded practically all risks, there is little to be said against this'.[4] Despite the progress in lining technology there appears to have been no significant change in attitude at this time. Recent advances in lining have also lent credence to the belief that lining may preserve the longevity of the painting.

The reasons behind the introduction of BEVA 371 by Gustav Berger in 1968 were to supplant the use of wax-resin with an adhesive that also remained relatively inert to moisture, particularly when used with synthetic lining canvases, such as fibreglass or polyester sailcloth.[5] In effect, BEVA 371 is a synthetic wax and resin formulation, but unlike traditional wax-resin adhesives it is capable of providing a non-impregnating, strong nap-bond with the painting. In the early 1980s Berger sought to improve the protective abilities of BEVA linings by increasing their stiffness, incorporating interleaf materials, such as thick polyester sheets, sandwiched between the lining and the painting.[6]

More minimal forms of lining developed from the early 1970s, those employing acrylic dispersion adhesives have tended to avoid the term lining but refer to the process as the 'stabilization' of the painting. [7] Nevertheless, the implied intention, to ensure the permanence of the painting by making it resistant to future deterioration, is not dissimilar to that of traditional lining.

Since the early 1970s there has been a certain amount of disillusionment with lining, largely due to a progressive acknowledgement of the limitations and detrimental effects of most treatments. This has led to a dramatic reduction in lining activity, but many practitioners continue to have faith in its preventive aspects. The Canadian Conservation Institute Lining Project has provided much-needed data on some aspects of the mechanical properties of linings.[8] Berger has also examined the response of BEVA linings to temperature and humidity.[9] The aim of the present study is to examine the physical protection given to paintings by a selection of the above

FIG. 1 Modern copy of Velázquez's *Surrender of Breda*, before treatment.

lining methods in tensioning conditions which simulate real situations, during the lining process and while on display.

Paintings for lining

The paintings used in the tests were a series of four previously unlined works by an unknown artist. They are copies of paintings by Velázquez in the Prado, Madrid (FIG. 1). The exact date of the pictures is unknown but, judging from analyses of the paint and ground and the types of commercially prepared canvas used, they were most probably made in the middle of the twentieth century.[10] As the paintings had aged naturally for approximately fifty years and had no intrinsic value, they were invaluable materials for comparative testing. Though they are by the same hand, not all of the canvases and their preparations are identical. Each canvas, however, has a plain weave pattern and has been commercially manufactured. Additionally, cross-sections through the paint, size and canvas layers show that there is a similar amount of proteinaceous size in each painting. Brief descriptions of their constituent materials and condition are given in Appendix 1. A piece from the copy of the *Equestrian Portrait of the Count-Duke of Olivares* was used in the glue-paste lining and another piece from the *Cardinal Infante Ferdinand* was lined with wax-resin. Two pieces from the *Surrender of Breda* were used for the BEVA 371 linings with linen and with polyester sailcloth, thus enabling direct comparisons to be made between both forms of this lining.

Samples for tests

Prior to testing, the paintings were prepared for lining. Once removed from their stretchers the reverses were cleaned and knots in the canvas pared away. The

un-tensioned pictures were treated in a moisture chamber with the humidity controlled at between 72–78% RH and 20–22°C using a saturated salt solution for approximately 60 hours. They were then flattened on a low-pressure table at 40°C and 25 mbar pressure.

An area which showed minimal physical damage was chosen from each painting. A 330 mm-square sample was then cut from the painting and the corners removed to produce a cruciform-shaped sample that could be held in the grips of the testing apparatus. The distance between the grips in the two directions was 280 mm with a 270 mm central square section. The selected areas from the paintings are outlined in FIG. 1. After the load extension characteristics of the paintings had been established the cruciform arms were cut leaving 270 mm-square pieces of each painting to be used for lining. In effect, the painting samples simulated pictures that have had their tacking margins removed, a common practice during the nineteenth and early twentieth centuries.

Lining materials and adhesives

Fine linen canvas was employed in all three different types of lining [11] and, in addition, a BEVA lining was carried out with polyester sailcloth. The latter fabric required no initial preparation, but the linen was wetted and pre-stretched three times before use. This practice is commonly used in order to give the material a more isotropic response. A good deal of testing has already been carried out on these two lining fabrics and their mechanical properties are well established.[12]

A glue-paste lining was chosen for testing because large numbers of paintings in public collections have been glue-paste lined in the past, and the method continues to be widely practised, especially within Europe. Also, being a hygroscopic material, it was likely to provide an interesting comparison with the two non-hygroscopic adhesives. The glue lining adhesive consisted of one part refined gelatin and eight parts wheat flour (wt./wt.) with the addition of hydrogen peroxide as a preservative (2% by volume). This recipe contains relatively low quantities of animal glue and has been found to perform better than other formulations.[13]

A natural wax-resin adhesive was also selected, consisting of seven parts bleached beeswax, four parts dammar resin and one part gum elemi (wt./wt.). This was the wax-lining recipe used at the National Gallery from the early 1960s to the late 1970s. Although little practised nowadays, wax-lin-

ing was extensively used in the last century in some European countries and in North America. As the adhesive penetrates the bodies of both fabrics it is likely to produce a different pattern of behaviour to the other adhesives.

BEVA 371 was selected because it is probably the most widely used synthetic lining adhesive.

Lining procedures

Tests were initially carried out to establish the individual behaviour, tension versus extension, and tension versus relative humidity response, of the unlined paintings. The response during each stage of the lining process was also monitored and finally the behaviour of the lined painting was measured. Each lining was performed on a small portable suction table, specially adapted for the purpose of these tests.[14] The lining table and tensile tester set-up is described below under Equipment and the tests are described in detail under Test Methods. Where possible, the linings followed what were considered to be typical practical procedures. These are described below and are summarised in Appendix 2.

Glue-paste lining

A traditional hand-lining method was not chosen for the paste lining because the action of ironing would have interfered with the tension results recorded during the process. Instead, a low-pressure table technique, comparable with the wax-resin and BEVA 371 lining method, was selected. Although hand-lining methods are more commonly employed, glue-paste linings have been performed on vacuum tables by a number of practitioners.[15]

The painting was first faced with a dammar resin and beeswax adhesive in white spirit and Eltoline tissue. One thin coat of glue-paste was spread onto the back of the painting and made more even by rolling. The painting was then positioned centrally onto the lining canvas already tensioned in the tensile tester. The table surface had been previously covered with a release layer of polyester sailcloth. Vacuum pressure was applied at 25 mbar and the heat maintained at 40°C for 20 minutes, after which time the heaters were switched off and the lining left to dry for 90 minutes while maintaining 25 mbar pressure. Before further testing the facing was removed.

Wax lining

The wax lining was also carried out using a vacuum

hot-table procedure rather than a traditional hand-lining method. The lining was performed in three stages: firstly, the lining canvas was impregnated with adhesive, secondly, the painting was impregnated in the same manner, and finally the lining was carried out. Saturating the lining canvas and painting separately with wax-resin prior to lining not only provided an even adhesive layer but also ensured that the entire laminate, both lining canvas and painting, was thoroughly impregnated.

Throughout the three stages the table surface was covered with silicon-coated Melinex to prevent the canvases from sticking to the metal plate. The adhesive was first melted and brushed onto the linen lining canvas tensioned on the tensile tester. The canvas was covered with Melinex and the vacuum established at 25 mbar throughout. The heaters were then switched on and the adhesive layer was made more even by rolling. After a temperature of 70°C was achieved the lining canvas was then cooled for two hours to ambient conditions.

The back of the painting was brushed with the molten wax-resin. It was not held in the tensile tester during this operation but was subsequently tensioned face up over the vacuum table and covered with Melinex. Pressure was maintained at 25 mbar, and while being heated, the surface was rolled. Once the temperature had reached 65°C the picture was cooled for two hours.

The painting was then lined having been placed onto the lining canvas that was tensioned on the tensile tester. Heat was applied until a bonding temperature of 65°C had been reached, and then cooled for two hours. Pressure was regulated at 25 mbar throughout.

BEVA linings

The linen canvas was placed under tension in the tensile tester and was first sized with a thin coat of the warm adhesive diluted in white spirit (one part BEVA 371 gel: four parts white spirit, v/v). Once this coat had dried three subsequent coats were applied, consisting of two parts BEVA: one part white spirit, allowing time for drying between each coat.

The preparation of the BEVA lining onto sailcloth was carried out in the same manner except that the sailcloth was not given an initial sizing. Throughout the preparations of the lining canvas and the actual linings the table surface was protected with a sheet of silicon-coated Melinex.

Both BEVA linings were carried out following identical procedures. The prepared lining canvases

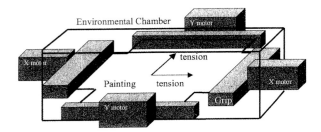

FIG. 2 The tensile tester with integral environmental chamber used for the tests before and after lining.

were tensioned on the tensile tester and the painting samples placed on top of the dried adhesive films. A covering sheet of Melinex was put in position, the pressure was then applied at 25 mbar and the heating switched on until a bonding temperature of 70°C was attained. Thereafter, the linings were allowed to cool on the testing rig for two hours.

Equipment

The biaxial tensile tester

The tests were performed on a biaxial tensile tester fitted with an integral environmental chamber developed specifically for investigating the mechanical behaviour of canvas paintings and the effectiveness of structural conservation treatments (see FIG. 2). The tensile tester measures the load and extension in two directions simultaneously, in these tests the weft and warp of the material. The tensile tester consists of ball and screw translation stages each driven by a stepper motor via a gearbox. There are stepper motors in both the weft and warp directions and tensioning of the canvas is achieved by displacement of the stage. A load cell in each axis measures the in-plane tension and compression. The stages are attached to grips which, for these tests, have rubber faces to prevent damage to the paintings. The translation of each stage is measured by a linear variable differential transformer, from which the extension is calculated. The control and data acquisition is controlled by a 16-bit data acquisition board.[16]

The environmental chamber and conditioning unit

The grips of the tester are enclosed within an insulated steel chamber fitted with a glass lid. The conditioning unit consists of a chiller for dehumidification, an ultrasonic humidifier for increasing the air moisture content, and a ceramic heater element for heating. The air within the chamber is exchanged with the unit via tubes and fans. Manual valves control the air flow. Two Vaisala SM50Y temperature

FIG. 3 The testing set-up with the small vacuum table and tensile tester used during lining.

and humidity probes are positioned inside the chamber: one underneath the sample and one on an inside wall of the chamber. These probes send signals back to the programme controlling the environmental conditioning unit and tensile tester. The environmental chamber can be programmed to increase the relative humidity within the chamber at a specified rate in discrete steps, or to remain constant.

Testing arrangement

For the tests, before and after lining, the tensile tester was used with its environmental chamber, with the RH and temperature sensors positioned as described above. For tests on the lining preparations and during the actual lining, the tensile tester, without its chamber, was bolted to a separate frame. On a support frame below the tester, a small vacuum hotplate was placed underneath the central area of the sample (see FIG. 3). The front face of the 330 mm-square vacuum plate was positioned in-line with the centre of the grips. It was found that, with the vacuum at 25 mbar, the plate would not provide adequate temperature for the wax and BEVA linings. The temperature also varied from the centre to the edge of the plate. Additional heating was provided, by placing four 150W compact halogen flood lamps directly beneath the plate, facing upwards onto its back face. This provided an even temperature up to a maximum of 80°C at the top of the plate with a pressure of 25 mbar applied across its surface. The temperature of the plate and painting face were spot-checked using thermocouples. In practice, it was impractical to have the Vaisala probes close to the surface of the painting or lining because they obstructed the application of adhesive and the rolling of the linings. Instead, the probes were taped to the top of the grips. This gave an indication of the temperature and humidity in the vicinity of the painting during the whole process and helped in identifying when equilibrium had been achieved with the ambient conditions.

Test methods

Two main tests were performed on the lining supports, the unlined paintings, and the lined paintings. These were:

a. Measurement of the biaxial (warp and weft) tension resulting from extension at constant humidity and temperature. Three cycles of tensioning then un-tensioning the samples were performed.

b. Measurement of the biaxial tension due to step changes in relative humidity as a function of time.

During the preparation of the linings and adhesion of the lining to the painting the procedure was monitored by:

c. Measurement of the biaxial tension as a function of time.

All these tests are described in detail below.

Tests on paintings before and after lining
Test a(i)

The cruciform painting sample was first positioned in the grips of the tensile tester with the warp direction in the x-axis and weft-direction in the y-axis of the tester. The lid of the environmental chamber was closed and the sample was left to reach equilibrium at 55% RH for two hours. (Ambient conditions varied from 45% to 55% RH in the room in which the paintings were stored.) The painting was tensioned and then un-tensioned in the warp and weft directions from 5N to 100N back down to 5N by equal displacement of the grips. This cycle was repeated three times.

Test a(ii)

The painting was re-tensioned to 20N in the warp and weft and then conditioned to 5% RH. The tension in the warp and weft direction, the relative humidity and temperature were measured during conditioning of the sample. Test a(i) was then repeated at 5% RH.

Test b(i)

The painting was re-tensioned to 100N in the warp and weft. The relative humidity in the chamber was raised in 10% increments from 5% RH to 65% RH for the paintings and 85% RH for the lining supports. Each RH value was maintained for three hours. The tension in the warp and weft direction,

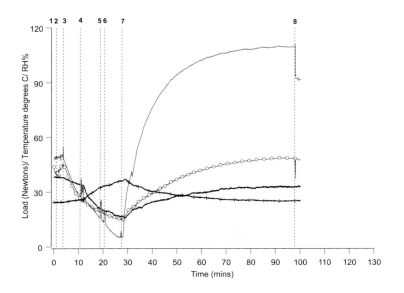

a. Lining canvas
1. Initial loads
2. Liquid wax applied
3. Heat on
4. Temperature 47°C
5. Temperature 63°C
6. Rolling
7. Temperature 74°C. Vacuum on. Heat off
8. Vacuum off

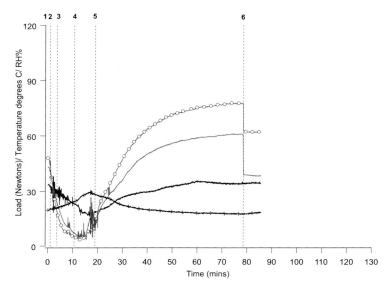

b. Painting
1. Initial loads. Liquid wax applied
2. Heat on
3. Temperature 63°C
4. Vacuum on. Heat off
5. Temperature 28°C
6. Vacuum off

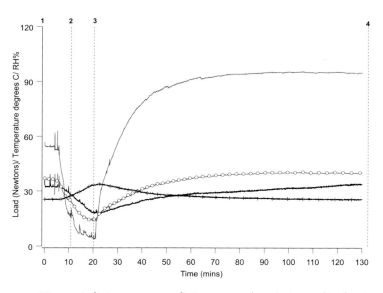

c. Lined painting
1. Initial loads. Place painting on top. Heat on
2. Temperature 52°C
3. Temperature 78°C. Vacuum on. Heat off. Rolling
4. Vacuum off (200 mins.)

FIG. 4 Wax-resin lining process: a. lining canvas, b. painting, c. lined painting.

the relative humidity and the temperature were measured throughout the conditioning of the sample. The lid of the chamber was removed to allow the sample to return to equilibrium with the ambient conditions.

Tests during preparation and lining

Where possible the preparations of the lining canvases and the linings themselves were performed on the tensile tester, effectively using it as a loom. All processes, including application and rolling out of the glue, the vacuum and the response of the sample itself, were measured throughout the various procedures by the load cells sensing changes in tension. All lining canvases and paintings in the tensile tester were initially tensioned to 40N in warp and weft. After the painting samples had been cut to 270 mm squares they were carefully positioned in the middle of the lining fabrics that had been centred on the vacuum plate. The lining preparations and procedures are described above and are summarised in Appendix 2.

Results

Tension response during lining

FIGS. 4–7 include the curves for temperature and RH% values just above the surface of the canvas and provide an indication of the conditions close to the painting. The temperature values given in the 'listing of events' are from the thermocouple placed temporarily on the painting surface. Tension in the graphs is expressed in Newtons (N).

The wax-resin lining process

FIGS. 4a, b and c show the change in tension in the warp and weft directions during each of the three stages of the wax-lining process for the lining canvas (4a), painting (4b) and final lining (4c). Each process causes similar tension changes as the adhesive melts or solidifies during the application of vacuum pressure. Rapid solidification of the liquid wax occurs once it has been applied to the lining canvas. On heating, the wax starts to melt again causing a reduction in canvas tension (FIG. 4a); this occurs throughout all the stages of the wax lining as the adhesive begins to melt at around 40–45°C. Over a 22-minute period the tension is lowered from 50N and 45N, to 16N and 6N in the warp and weft directions respectively. There are two mechanisms that contribute to the tension reduction. Firstly, there is thermal expan-

sion of the canvas caused by the direct application of the hot liquid wax. Secondly, lubrication by the liquid wax of the yarns in the linen canvas reduces friction at the points where the yarns cross over one another in the weave. This enables the yarns to move easily, thereby allowing a relaxation of the stresses created during the pre-wetting and pre-stretching process and possibly some residual stress induced during manufacture. On cooling, with the vacuum on, there is an initial and immediate increase in tension that is associated with a visible and rapid solidification of the wax. Both tension response and fall in temperature are approximately exponential. As room temperature is reached, after 75 minutes, tension stabilises to 48N in the warp and 100N in the weft. Tension is reduced by approximately 10N when the vacuum pressure exerted on the painting is removed.

As the wax-resin, applied to the reverse of the painting, melts there is a similar decrease in tension, from 48N and 43N before wax application to 5N and 7N in the warp and weft respectively (see FIG. 4b). This occurred more quickly than for the lining canvas, taking only 11 minutes because the painting was heated more rapidly. The tension eventually stabilised to 61N in the warp and 78N in the weft after approximately 70 minutes.

FIG. 4c shows the tension response during the final lining process. The initial peaks in tension occur as the painting is placed on top of the prepared lining canvas tensioned in the tester. As heat is applied and the adhesive (wax-resin) melts, the tensions drop from 38N and 53N to 14N and 4N in warp and weft respectively. Tension stabilises at 40N in the weft and 95N in the warp after approximately 70 minutes. This large discrepancy between the warp and weft final tension, when compared to the preparation of the painting, is probably because the behaviour of the lined painting was dominated by the characteristics of the lining support rather than that of the painting.

For all of the above stages there was an increase in tension once the wax-resin had solidified. This is caused by a combination of contraction of the wax-resin with decreasing temperature and an associated locking of the canvas weave which will reduce residual creep.

Glue-paste lining process

FIG. 5a shows tension change in the warp and weft directions during the lining operation. A new piece of linen without adhesive was tensioned and the painting, with the wet paste having been applied to

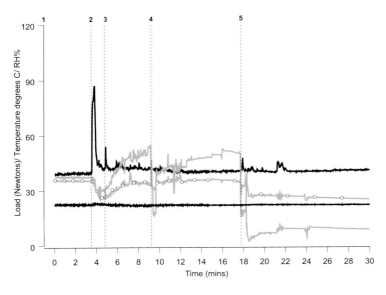

a. **Lining canvas**
1. Initial loads
2. Place painting on top
3. Rolling. Heat on
4. Temporary loss of vacuum
5. Vacuum off

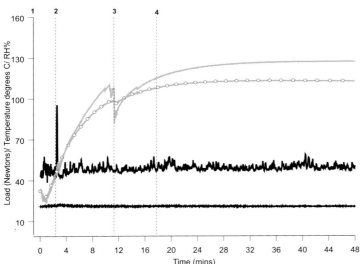

b. **Lined painting**
1. Initial loads. Glue-paste applied
2. Rolling
3. Temporary loss of vacuum
4. Leave to dry at room temperature

	RH%
—o—	warp load
	weft load
—▲—	Temperature

FIG. 5 Glue-paste lining process: a. lining canvas, b. lined painting.

its reverse, was positioned on top of the lining canvas. An initial decrease in the tension of 11N in the warp and 6N in the weft was observed. After rolling the surface and application of heat the tension reached 34N in the warp and 54N in the weft. (Although a temporary loss of vacuum occurred, the tension stabilised at around these values.)

FIG. 5b shows tension change in the warp and weft directions during the application of glue-paste to the lining. The sample was used for comparison in the environmental tests. As the glue-paste is applied to the lining canvas there is an initial but small loss in tension of 10N in both warp and weft, followed by a steady rise in tension as the adhesive dries in room conditions. Tension stabilised at 113N in the warp and 127N in the weft after 40 minutes.

The increase in tension on drying of the glue-paste results from the contraction of the glue and, as with the wax-resin, a locking of the canvas weave.

BEVA and sailcloth lining process

FIGS. 6a and b show tension change in the warp and weft directions during the two stages of the BEVA/sailcloth lining process. As the first layer of BEVA was applied to the sailcloth there was an immediate loss of 10N in both weave directions (see FIG. 6a). The tension then stabilised at 37N in the warp and 45N in the weft as the solvent in the BEVA evaporated. Further applications of BEVA had a negligible effect on the tension in either weave direction. The prepared sailcloth was then re-tensioned and the painting positioned onto the lining fabric (FIG. 6b).

As the lining was heated an immediate reduction in tension from 38N and 35N to 15N and 7N occurred in the warp and weft respectively. This tension loss occurred as the BEVA softened at around 45–50°C and continued until a temperature of 70°C was reached, at which point the lining was then cooled and the vacuum applied. The tension rose as the BEVA solidified and stable values of 25N in the warp and 43N in the weft were attained after 40 minutes.

BEVA and linen lining process

FIGS. 7a and b show tension changes in the warp and weft directions during the two stages of the BEVA/linen lining process. As the BEVA sizing layer was applied to the linen there was a loss in tension of 23N in the warp and 12N in the weft (see FIG. 7a). It is difficult to distinguish between tension lost due to the application of the BEVA from that caused by creep, as both occurred simultaneously in the linen. Subsequent application of coats of BEVA produced smaller tension changes in the order of 10N in both warp and weft.

Once the lining canvas had been prepared it was re-tensioned and the painting positioned on top (FIG. 7b). As heat was applied, tension in the warp and weft reduced at a slower rate than that seen in the prepared lining canvas on its own because the vacuum slowed the rate of heating. After the picture surface had reached 70°C, the lining was cooled, producing a rise in tension, which stabilised after 40 minutes from 5N to 30N in the warp, and from 10N to 100N in the weft.

Interestingly, the BEVA/linen and wax-resin/linen lining processes result in a lining that has a large difference in the warp and weft tension when compared to the glue-paste/linen process. It is possible that this has occurred because these lining processes allowed a complete crimp redistribution, which was locked in when the adhesive solidified, rather than it being the sole action of the adhesive contracting. However, it is unclear why this should be the case.

Comparisons of stiffness before and after lining

Measurement of the thickness of the materials, using a micrometer, before and after lining show that the overall thickness after lining was less than the combined thickness of the lining and painting before lining. Hence, during the lining processes the materials had been compressed (see Appendix 3). This is because the pressure induced by the vacuum and the impregnation with adhesive altered the weave structure and packing of the yarns in the canvas. Calculations in terms of stress (force per unit area)

are meaningless in this instance because the area of painting or lining canvas under tension cannot be accurately defined. Thus, comparisons have been made in terms of the tension experienced by each painting (all the same size) and the strain (extension compared to the original length). The biaxial tension versus strain, and the tension/RH versus time, have been compared for the unlined paintings, the lined paintings and the prepared linings.

FIGS. 8a–d shows the graphs for the unlined painting, the prepared lining and the lined painting. Each graph gives the tension versus % strain, for both weft and warp on the third cycle between 0–100N at 55% RH at 20°C. The steeper the gradient of the tension versus strain curve the stiffer the material. The stiffness in the 50N–100N tension region has been calculated at the third cycle for the paintings before and after lining at both 5% RH and 55% RH. These values are summarised in Appendix 4.

By comparing the gradients of the curves it is evident that in all cases the painting is stiffer than its associated lining. All the paintings produced strains in the region of 0.08% to 0.16% for a biaxial tension of 100N. The linings, on the other hand, produced strains above 0.23% for the same tension. All the lined paintings produced strains somewhere in between those of the lining materials and the unlined paintings with values in the region of 0.12% to 0.27%.

On first consideration it might be assumed that lining these paintings would produce a final composite that is stiffer than the painting on its own, since the tension is shared between both lining and painting. Furthermore, the amount of material under load in the lined painting has increased even though the measurable loading area has not. However, in these tests on the lined paintings, only the lining canvas was held by the grips and, therefore, the tensioning configuration is equivalent to a lined painting without its original tacking margins which could be attached to its stretcher. Consequently, the combined in-plane tensile stiffness is not as high as one would expect because there has not been complete load transfer through the adhesive layer. In other words, the lining and painting do not act as a continuous solid. The adhesive and the adjacent weave form a relatively flexible layer between the two and consequently high shear strains must be occurring at the interfaces with the adhesive (FIG. 9). Although the lining procedure has produced a composite with greater flexural stiffness this does not necessarily mean that the tensile stiffness has increased. If the painting and lining were gripped together, as is the

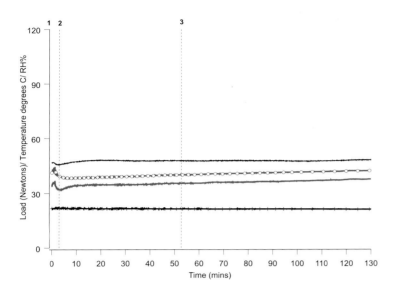

a. **Lining canvas**
1. Initial loads. BEVA 371 size layer applied
2. Left to dry at room temperature
3. Second coat of BEVA 371 applied

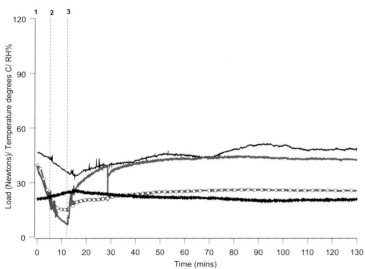

b. **Lined painting**
1. Initial loads. Place painting on top. Heat on
2. Rolling
3. Vacuum on. Heat off

FIG. 6 BEVA/sailcloth lining process: a. lining canvas, b. lined painting.

case in a lined picture stretched with its original tacking edges intact, then an increase in tensile stiffness should be evident. Indeed previous research using uniaxial tests support this belief,[17] but further confirmation is needed under biaxial conditions. If the lining adhesive produced a relatively flexible bond between the lining and the painting, then the painting will be free to expand and contract, to some extent, with changing humidity.

Relative humidity response before lining

The load response is similar for the three paintings; all lose tension as the RH increases from 5% RH to 55% RH. The change in RH from 55% to 64% RH, however, produces two different types of response: samples from the *Cardinal Infante Ferdinand* and the

Equestrian Portrait of the Count-Duke of Olivares continue to lose tension, while the two samples from the *Surrender of Breda* gain in tension (see FIG. 10). This initial drop then rise in tension with increasing RH has been demonstrated in previous uniaxial and biaxial tests on canvases with proteinaceous size layers.[18] The phenomenon occurs because of the expansion and loss in stiffness in the size layer with the uptake of moisture, resulting in a corresponding loss in tension. This is followed by the subsequent swelling of the canvas yarns, causing canvas contraction and an increase in tension. Weave counts for *Cardinal Infante Ferdinand* and the *Portrait of the Count-Duke of Olivares* are 15–16 yarns/cm while those for the *Surrender of Breda* are 22–23 yarns/cm. It is the higher weave density of the latter canvas that

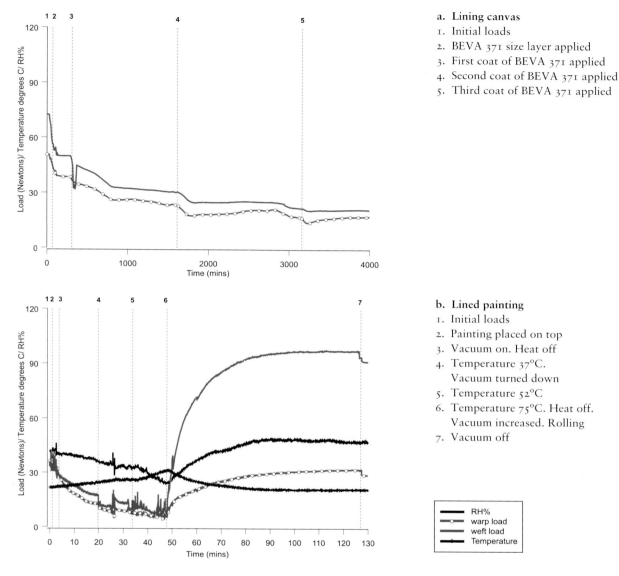

a. **Lining canvas**
1. Initial loads
2. BEVA 371 size layer applied
3. First coat of BEVA 371 applied
4. Second coat of BEVA 371 applied
5. Third coat of BEVA 371 applied

b. **Lined painting**
1. Initial loads
2. Painting placed on top
3. Vacuum on. Heat off
4. Temperature 37°C.
 Vacuum turned down
5. Temperature 52°C
6. Temperature 75°C. Heat off.
 Vacuum increased. Rolling
7. Vacuum off

RH%
warp load
weft load
Temperature

FIG. 7 BEVA/linen lining process: a. lining canvas, b. lined painting.

accounts for an earlier onset of tension increase that is associated with canvas shrinkage.[19]

Relative humidity response after lining

As stated previously, in these tests the nature of the interface between lining and painting allows some expansion and contraction of the painting which is independent of the lining. Thus, the measured tension by the tester is an indirect measure of the tension induced in the painting with changing humidity.

During the tests on the lined paintings the external ambient RH was above 50%. This created difficulties in controlling the conditions within the environmental chamber and meant that the initial RH increase from 5% to 55% RH was not performed in discrete steps. Instead, RH in the chamber rose exponentially to 55% RH followed by 10% increments to 85% RH. Therefore, in comparisons with the paintings, where step-like changes in RH were achieved, the data will be discussed in two regions: 5%–55% RH and 55%–85% RH. FIG. 11 shows the tension response and RH versus time for all the lined paintings. For comparison FIG. 12 shows the tension response and RH versus time for all the prepared linings on their own.

The 5%–55% RH region

On tensioning to 100N all the prepared lining canvases crept immediately. The lined paintings also crept but at a much slower rate. In practice, a lined painting will creep after re-stretching on its stretcher and may require further tensioning after a day or

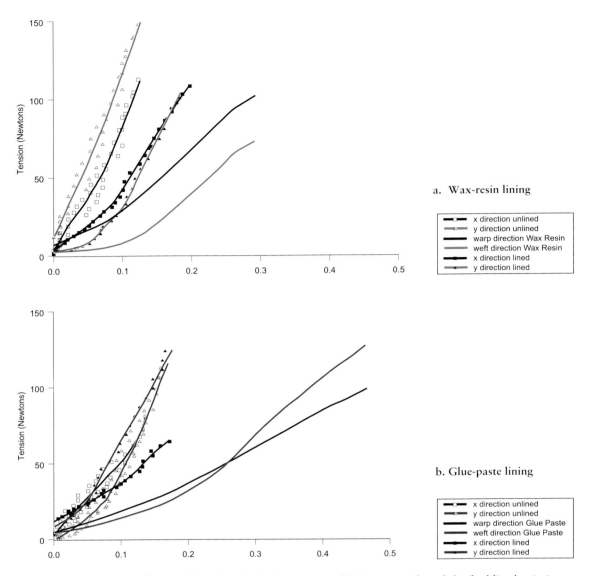

FIGS. 8a and b Relative stiffness of the unlined paintings, prepared lining materials and the final lined paintings.

two. Due to time constraints it was decided that creep could not be avoided in the load versus RH tests.

For the wax/linen and BEVA/linen (FIG. 11) it is impossible to distinguish between the initial tension loss due to creep in the linen from that caused by increasing RH. There is a very similar loss in tension for the BEVA/sailcloth resulting from creep, but this is also due to moisture uptake in the sailcloth. The response of sailcloth to moisture, although relatively small compared to linen, has been measured previously[20] and warrants further investigation. For the glue- paste/linen there is a more rapid loss in tension than that associated with the creep of the linen alone. Additionally, the glue-paste/linen has a similar response to that of glue-sized linen, suggesting that

its behaviour is associated with the glue-paste absorbing moisture, which allows the canvas to relieve stress to a point where it becomes slack. The glue-paste lining, as expected, is the most sensitive to increases in moisture content within this humidity range.

The 55%–85% RH region

In the 55%–85% RH region discreet step increases in RH% were achieved. The tension curves corresponding to those increases show similar step responses. The initial rise in tension and stabilised value are different in each case.

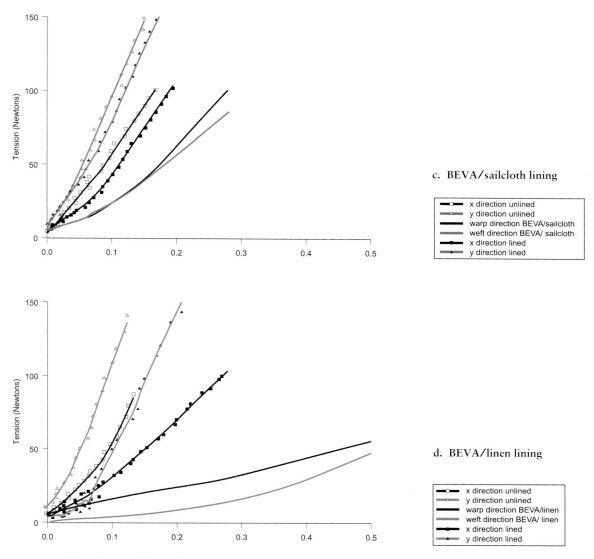

c. BEVA/sailcloth lining

⊶	x direction unlined
⊶	y direction unlined
—	warp direction BEVA/sailcloth
—	weft direction BEVA/ sailcloth
▪	x direction lined
▲	y direction lined

d. BEVA/linen lining

⊶	x direction unlined
⊶	y direction unlined
—	warp direction BEVA/linen
—	weft direction BEVA/ linen
▪	x direction lined
▲	y direction lined

FIGS. 8c and d Relative stiffness of the unlined paintings, prepared lining materials and the final lined paintings.

Wax-resin/linen

In this RH region the painting lined with wax-resin and linen shows practically no response to increasing humidity (FIG. 11). This is expected since the lining canvas and painting were completely impregnated with the adhesive. A thorough impregnation was only achieved during the final lining process and prevented the canvas from absorbing moisture.

Interestingly, the wax/linen lining canvas on its own does respond (FIG. 12). Tension increases as the RH is raised from 65% to 85% RH, but at a reduced response rate when compared to BEVA/linen.[21] This demonstrates that wax impregnation, even though incomplete, has a greater effect on retarding the humidity response of linen than a non-impregnating lining with BEVA.

BEVA/linen

The BEVA/linen lined painting (FIG. 11) shows the greatest response to moisture over this RH region, increasing in tension from 58N and 48N at 55% RH to 92N and 108N at 75% RH in the warp and weft respectively. As BEVA does not fully saturate the linen lining canvas, moisture is able to penetrate the yarns from the reverse. Thus, at high humidity (above 65% RH) canvas shrinkage will occur for a high yarn count, machine-woven canvas. As discussed above, the painting itself showed a tendency to shrink between 55% and 75% (see FIG. 10). The BEVA/linen lining on its own also started to increase in tension rising from 55N and 71N at 55% RH, to 77N and 83N at 75% RH, in the warp and weft respectively (FIG. 12). Therefore, as the RH increased,

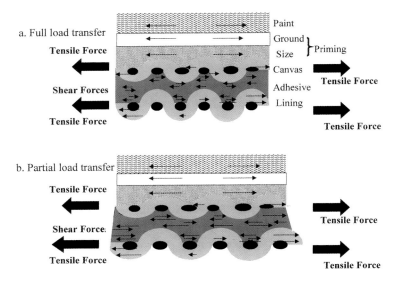

FIG. 9 Tensile load transfer.

the whole composite, painting and lining canvas, attempted to shrink (FIG. 11). There was a slightly slower response to RH change for the prepared lining canvas and the final lined painting than for the painting on its own. This indicates that the BEVA does provide a certain amount of protection against moisture even though the painting has not been saturated with adhesive. But, at 85% RH this is not sufficient to prevent severe canvas shrinkage. It can be concluded, therefore, that the BEVA/linen combination produces the least dimensionally stable lining at humidities where canvas shrinkage is likely to occur.

Glue-paste/ linen
The glue-paste/linen lined painting only started to increase in tension at 85% RH. This surprising lack of tension response at high humidity can be explained by the fact that the degree of tension increase will depend on the initial tension in the lined painting immediately before canvas shrinkage takes place. The glue-paste lined painting was at a considerably lower tension than the BEVA/linen lined painting before the onset of canvas contraction because the former lining had lost a great deal of tension as the moisture softened the glue. The BEVA/linen lining, on the other hand, maintained some tension because the adhesive is less sensitive to moisture. A painting similar in size to the samples used here would typically require a tension of around 20–60N at 55% RH to maintain it in a reasonably taut state for display. (The tension response of the BEVA/sailcloth lined painting at high humidity is therefore representative of normal loading conditions.)

Ordinarily, the glue-paste lined painting would have been stretched onto a stretcher to produce a tensioned flat painting under loads of around 20–60N at 55% RH. It therefore follows that with the onset of shrinkage in the lining canvas at around 65% RH there would be a greater increase in tension in the glue-paste lining than that presented in FIG. 12. Similarly, higher increases in tension would be expected than those seen in FIG. 11 as the RH falls from 65% RH. To confirm this idea, the glue-paste lined painting was re-tensioned to 50N at 55% RH and the RH% was increased in 10% RH steps to 85% RH. Surprisingly, the tension decreased as the relative humidity increased without showing any increase in tension even at 85% RH. Without further investigations, it is only possible to conclude that the expected tension increase did not occur because the lined painting had already been put through a high relative humidity cycle, which might have changed the strain distribution within the painting composite.

BEVA/sailcloth
The BEVA/sailcloth lining on its own showed a decrease in tension with increasing RH (FIG. 12). The painting itself had shown an increase in tension (FIG. 10). Therefore, the painting canvas and the sailcloth are moving in opposition to one another as humidity is raised. It can be seen from FIG. 11 for the 65% RH–85% RH region that the influence of the canvas shrinkage of the original painting has overridden the opposing expansion of the sailcloth and, to some extent, the restraint of the lining and adhesive.

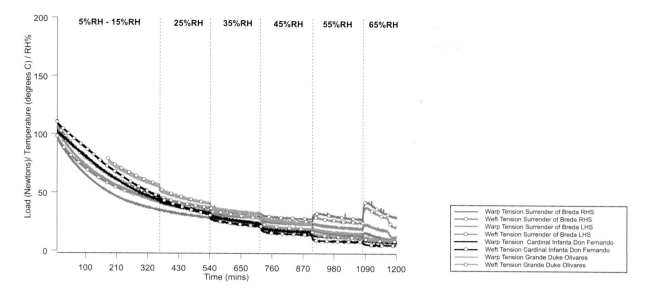

FIG. 10 RH response of the unlined paintings.

Conclusions

The speed at which the unlined paintings, lining materials and some of the lined paintings responded to moisture is extremely rapid. Even the fastest change in humidity produces an immediate tension response, although reaching equilibrium took at least three hours. The onset of canvas shrinkage at 65% RH in the *Surrender of Breda* canvas is earlier than the predictions made by previous research.[22] There were no visible signs of flaking or blistering of the paint and ground in any of the paintings even though they were exposed to 85% RH. However, some paintings may flake during exposure to these conditions, depending on their condition and history. These observations have some significance for the conditions recommended for loan and display. It would be unwise to extend the recommended upper humidity parameter to 65% RH as canvas contraction may occur in certain paintings, even though there was no actual sign of physical damage in these tests. It has been suggested that 'the key to setting safe limits of RH fluctuation is to avoid stresses that exceed the yield point for a specific environment and that would produce plastic or irreversible deformation'.[23] However, damage can occur through fatigue failure of the materials, as the tension is repeatedly altered, according to the fluctuating environmental condition. Given the fast response times of canvas paintings to humidity changes, even low amplitude, low-frequency deformations (below the materials' yield point) caused by humidity could result in fatigue in the long term.

Comparative measurements of the behaviour of different lining types during each process have not been attempted before and the results were particularly interesting. Increased tension in the glue lining as the linen lining canvas contracted was to be predicted but the large decrease in tension during the wax-resin and BEVA linings due to the melting or softening of the adhesives was unexpected. The final loads in the paintings after lining tended to be higher in the weft than in the warp direction. In practice the loading conditions can be adjusted and made more even during the subsequent stretching of the painting onto its stretcher. But equal tension in both warp and weft would be desirable immediately after the lining. Tension changes in the lining fabric during the process will undoubtedly result in alterations to the shape and structure of its weave. In turn, these movements in the yarns may have some influence on the overlying painting, for example they may contribute to textural alterations in the picture surface. It is possible that tension change may be avoided in the actual lining if the lining materials were not held under tension, as is sometimes practised in some wax-resin and BEVA lining procedures.

The protection against humidity change offered by the various linings varied considerably. The wax-resin lining proved to be unaffected by humidity change and this therefore supports the long-held view that such treatments render paintings almost inert. This state is only achievable when the entire composite is thoroughly impregnated so that a discrete layer of adhesive is visible at the back of the lining. Beeswax, however, is sensitive to relatively small

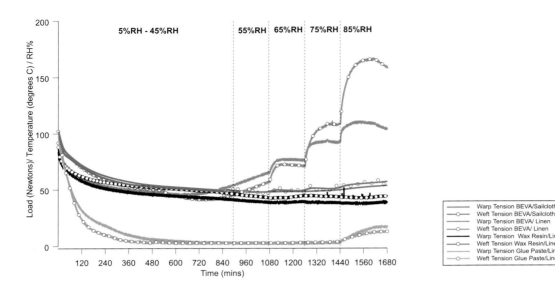

FIG. 11 Response of the lined paintings between 5 and 85% RH.

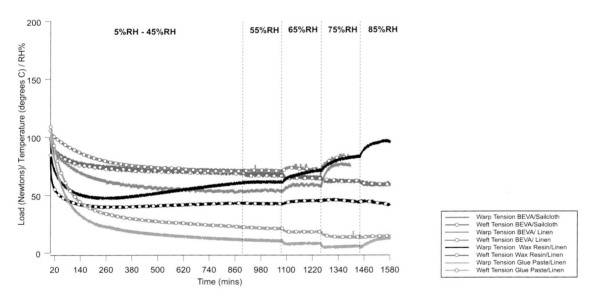

FIG. 12 Response of the prepared linings between 5 and 85% RH.

changes in temperature, and since it is usually the largest constituent of wax-resin formulations, the adhesive is unlikely to be completely inert to climatic change. The effect of temperature on the materials was outside the scope of the present study but needs further investigation.

In contrast, the BEVA/linen lining was particularly sensitive to moisture. This appeared to have only a moderate effect in protecting the lined painting from humidity change. The initial thin sizing of the linen with dilute BEVA might be effective as a moisture barrier if the canvas could be totally impregnated with the adhesive.

The BEVA/sailcloth lining appeared to offer better protection to the painting than the BEVA linen lining, but less than the wax-resin. This finding does not amount to a vindication of wax-resin lining, which results in an irreversible and, to many, an unacceptable impregnation of the painting.

Predictably, the glue-paste lining was the most responsive to moisture at low RH; below 40%, the glue lining is stiff and may enable the transfer of stress from the painting to the lining support. Consequently, if the painting had been initially placed under high tension at around 55% RH and then conditioned to a low RH, the lining adhesive

will form a brittle layer, which could lead to its eventual failure. Response times in the glue-lined painting are rapid and tension loss sudden. Therefore, in most gallery-controlled environments glue-paste linings may offer little long-term protection to paintings. It is often the case that glue-paste recipes contain larger quantities of animal glue than the particular adhesive tested here and, therefore, it is likely that many glue-lined paintings on display in museums and galleries could respond more vigorously than the results shown here. Performance of this type of lining could be improved by applying a beeswax moisture barrier to the reverse of the lining.

The protection provided by a lining through its ability to transfer tensile stress away from the picture to the lining support is more complicated than first expected. This highlights the need for further work in this area. Many liners have assessed the stiffness of their linings by tapping the surface of the stretched picture. It is not necessarily the case that this measure of flexural stiffness corresponds to the lining's tensile stiffness. In paintings where the tacking edges have been removed there is likely to be only a partial transfer of stress from the picture to the lining. The situation may be different for paintings where the tacking margins are intact. This issue is particularly relevant to paintings glue lined in the nineteenth and early twentieth centuries when it was common practice to remove the tacking margins.

There are many avenues for further research based upon the work reported here. In particular, understanding how the shear strains build up in the adhesive interface and how they influence the mechanical properties of the final lined painting.[24] Tests performed at the Courtauld Institute of Art and Tate Modern have demonstrated the fast response of paintings to changes in relative humidity even when within specified gallery conditions. This emphasises that the need to determine the exact role linings play in reducing and protecting paintings from mechanical deterioration induced by environmental parameters is still pertinent.

Acknowledgements

Stephen Hackney, Roger Hibberd, Alan Phenix, Marika Spring, The University of London Central Research Fund, The Leverhulme Trust, NERC, The Commission for the Great Exhibition of 1851, Conservation Department Tate Gallery, Mechanical Engineering Department Imperial College.

Notes and references

1 Henry Merritt, *Dirt and pictures separated: in the works of the old masters*, London 1854, p. 14. A number of other statements supporting the importance of lining as a preventive measure include: 'This [lining] is one of the most important proceedings to secure a picture from farther injury. It is performed with great ability by many persons in London, and at very moderate charges,' Henry Mogford, *Handbook of the preservation of pictures, containing practical instruction for cleaning, lining, repairing and restoring oil paintings*, eighth edition, Winsor and Newton, London 1876, p. 39. Also ' The relining of paintings is often an excellent precaution for their preservation', John Thomas Gullick and John Timbs, *Painting popularly explained: including fresco, tempera, encaustic, miniature, oil, watercolour, missal, painting on pottery, porcelain enamel &c.: with historical sketches of the progress of the art*, Kent and Co, London 1859, p. 315.

2 J.M. Fielding, *On painting in oil and watercolour*, London 1839, Chapter 10, p. 139.

3 *Manual on the Conservation of Paintings*, International Institute of Intellectual Co-operation, Paris 1940, 1940 translation, p. 212.

4 Helmut Ruhemann, *The cleaning of paintings: problems and potentialities*, London 1968, p. 153.

5 Gustav A. Berger, 'Formulating adhesives for the conservation of paintings', *Preprints to the IIC Congress*, Lisbon 1972, pp. 613–30.

6 Gustav A. Berger, 'Some conservation treatments in the light of the latest stress measurements', *Preprints to the ICOM Committee for Conservation, Eighth Triennial Meeting*, Sydney 1987, vol. 1, p. 134.

7 *Recent lining methods and related processes*, Handbook to a slide collection for teaching, Getty Conservation Institute and the Royal Danish Academy of Fine Arts, Copenhagen 1992. New methods for lining are generally referred to as 'stabilisation' processes.

8 S. Michalski and D. Hartin, 'C. C. I. Lining Project: Preliminary Testing of Lined Model Paintings', *Preprints to the ICOM Committee for Conservation, Eleventh Triennial Meeting*, Edinburgh 1996, vol. 1, pp. 288–96.

9 Gustav A. Berger and William Russell, *Conservation of paintings: research and innovations*, Archetype Publications Ltd, London 2000.

10 Analyses of the paint and ground materials were carried out by Marika Spring in the Scientific Department of the National Gallery.

11 The linen lining canvas used in the tests was a fine, medium-weight fabric manufactured by the Ulster Weavers, 44 Montgomery Rd, Castlereagh, Belfast. The fabric has, on average, 19–20 threads per cm in the warp direction and 15–16 threads per cm in the weft.

12 Christina Young, *Measurement of the biaxial tensile properties of paintings on canvas*, PhD Thesis, Imperial College, University Of London, 1996, Chapter 10, pp. 174–92.

13 Paul Ackroyd, 'Glue-paste lining of paintings: an evaluation of the bond performance and relative stiffness of some glue-paste linings', *Preprints to the UKIC Lining*

and Backing Conference, 1995, pp. 83–91. Nineteenth-century glue-paste adhesives tended to be formulated with larger proportions of animal glue. For example, Mogford recommends a recipe consisting of 'equal parts flour and glue', see Mogford, cited in note 1, p. 10.

14 A portable low-pressure suction device manufactured by Willard Developments Ltd was adapted and used to perform the linings.

15 Bent Hacke, En utraditionel metode til vacuum rentoilering af tempera maleri på lærred (An untraditional method of lining tempera paintings on canvas under vacuum pressure), Meddelelser om Konservering, edited by Nordisk Konservatorforbund, 1964, pp. 2–10. Other publications on glue-paste lining treatments using low-pressure tables include: Recent lining methods and related processes, cited in note 7, and Anthony Reeve, Paul Ackroyd and Ann Stephenson-Wright, 'The multi-purpose low-pressure conservation table', National Gallery Technical Bulletin, 12, 1988, p. 10.

16 A full description of the testing equipment is given in Christina Young and Roger Hibberd, 'Biaxial tensile testing of paintings on canvas', Studies in Conservation, 44, Number 2, 1999, pp. 129–41.

17 Ackroyd, cited in note 13, p. 88. In uniaxial conditions the stiffness of painting samples lined with glue-paste increased when compared to the stiffness of the lining materials tested on their own. This indicates that when both the painting and lining are both gripped and tensioned there is a transfer of load from the painting to the lining support.

18 This initial fall then rise in tension with increasing RH for canvas with a proteinaceous size layer has been demonstrated by G. Hedley, 'Relative humidity and the stress strain response of canvas paintings: uniaxial measurements of naturally aged samples', Studies in Conservation, 33, 1988, pp.133–48; and by Christina Young, 'The characterization and physical properties of 19th century primed loose linings', forthcoming publication.

19 Young, cited in note 18. The results reported here are consistent with other tests performed on nineteenth-century primed loose linings. The point at which the rise in tension occurs after an initial loss varies from 65% to 85% RH, depending on the nature of the canvas. If the RH% is increased to 95% there is a corresponding increase in tension but the maximum change occurs between 75% to 85% RH. From the results in this study it is therefore reasonable to assume that the Velázquez copies, if subjected to an RH greater than 65%, would all produce a tension response similar to some nineteenth-century primed loose linings. The speed of the response in the Velázquez copies is also consistent with previous tests.

20 Christina Young, 'Towards a Better Understanding of the Physical Properties of Lining Materials for Paintings: Interim Results', The Conservator, 23, 1999, pp. 83–91.

21 Hedley, cited in note 18. In uniaxial conditions the impregnation of a primed nineteenth-century loose lining with plain unbleached beeswax decreased its rate of moisture absorption but did not completely prevent it from responding. These findings, although for pure beeswax rather than wax-resin impregnation, are consistent with the results in this study.

22 Hedley, cited in note 18.

23 D. Erhardt and M. Mecklenburg, 'Relative humidity re-examined', Preprints to the IIC Congress, Ottawa 1994, pp. 32–8.

24 Further tests on lined paintings are planned using optical interferometry, to monitor the strains in the top surface of the painting compared to the strains in the lining resulting from changing the tension. Also, shear tests on lining adhesives with the associated lining material at different RH will give important background information. Additionally, direct measurement of the change in flexural stiffness of the painting using three-point bend tests, compared to the change in tensile stiffness, will help to understand the detailed function of the lining. All information from the above tests can be incorporated into an analytical model to calculate shear strains within the lined painting. Further work is also required to investigate the low RH response in controlled conditions for longer equilibrium times and different initial tensioning conditions. Direct measurement of the moisture transport through the lined painting and the associated thermal gradient requires the development of new sensors that can be incorporated into the composite.